# The F of the New Artistic Innovation in Times of Social Acceleration

Thijs Lijster (ed.)

Antennae-Arts in Society
Valiz, Amsterdam

# The Future of the New
*Artistic Innovation in Times of Social Acceleration*

Thijs Lijster (ed.)

## Contributors
Lietje Bauwens
Franco 'Bifo' Berardi
Robin Celikates
Wouter De Raeve
Elena Esposito
Boris Groys
Alice Haddad
Akiem Helmling
Bojana Kunst
Thijs Lijster
Suhail Malik
Benjamin Noys
Hartmut Rosa
Nick Srnicek
Carolyn F. Strauss
Rolando Vázquez
Alex Williams

# Contents

# Harder, Better, Stronger, Faster
## Introduction

Thijs Lijster

> Novelty is thus systematically valorized at the expense of durability, and this organization of detachment, that is, of unfaithfulness or infidelity (equally called flexibility), contributes to the decomposition of libidinal economy, to the spread of drive-based behaviors and to the liquidation of social systems.
>
> Bernard Stiegler, *For a New Critique of Political Economy*

## Make It New!

'New!' 'Improved recipe!' 'Now better than ever!' This much is clear: if you want to sell something, you have to emphasize its novelty. The driving force of history is innovation, constant progress, and improvement. That is at least what we are made to believe; it is the dominant ideology of our times. Despite the four decades of postmodernist scepticism towards the modern idea of 'progress' lying behind us and despite the downsides of 'innovation' that we are experiencing in the shape of economic, humanitarian, and ecological crises, innovation and growth remain the cardinal principles of our times.

Not so long ago this idea, or ideal, of constant innovation was most forcefully voiced and promoted by artists and art theorists. 'Make it new!', said Ezra Pound. 'Il faut être absolument moderne', said Arthur Rimbaud. 'And plunge to depths of Heaven or Hell,/ To fathom the Unknown and find the *new*!', exclaimed Charles Baudelaire. After God, morality, and even beauty had ceased to function as credible criteria for valuing the arts, all that remained were novelty and originality. The 'shock of the new', as Australian art critic Robert Hughes later called it, became the primary characteristic of modern art, the first as well as the final criterion for its valuation. Moreover, due to this preoccupation with innovation, modern art was often considered a source of social and cultural critique and an ally of social movements resisting the domination of tradition.

Throughout the twentieth century and up until today, artists and intellectuals who criticize consumer culture often invoke the 'new'. The culture of capitalism is 'infecting everything with sameness' (Horkheimer and Adorno 2000, p. 94), as the standardization of commodity production left little room for the spontaneity, creativity and individual autonomy expressed in art. Innovation should be the solution to this problem, as Nick Srnicek and Alex Williams write: 'If the supplanting of capitalism is impossible

from the standpoint of one or even many defensive stances, it is because any form of prospective politics must set out to construct *the new*.' (Srnicek and Williams 2015, p. 75)

What happens, however, if novelty and innovation themselves become the problem? Today, a dominant strand of social and cultural critique considers modernity's 'social acceleration' (Rosa) and 'short-termism' (Stiegler) as the main sources of alien ation and discontent. Bernard Stiegler, in the passage quoted at the top, points to innovation as the cause of the liquidation of social systems. Hartmut Rosa points to the paradox that despite all our timesaving technologies people hardly have the feeling that they have plenty of time. On the contrary, more and more people feel lost in a world that innovates perpetually in ways that are beyond their control. Furthermore, there seems to be an increasing a-synchronicity between the various social domains: the relatively slow-working world of politics can hardly keep pace with the world of finance, while the time needed for study and practice is often lost or lacking in a world saturated with distracting gadgets. According to Franco 'Bifo' Berardi our biological bodies cannot cope with the expansion and acceleration of digital technologies. The once provocative punk slogan 'No Future!' now expresses a widely shared feeling.

Innovation has thus become an inherently problematic notion for contemporary art and art theory. It can no longer be considered a self-evidently progressive or positive value, now that it is part and parcel of post-industrial consumer culture and capitalist production. Social movements and theorists now tend to advocate slowing the pace of capitalism, criticizing its constant demand for expansion and growth and emphasizing the need for continuity and security in people's lives. They are joined by humanitarian and environmental organizations, underlining the need for sustainable solutions to the problems caused by 'innovation'. And of course, before long the critique of acceleration was co-opted by a whole industry of lifestyle gurus and therapists who propagate slowing down through 'mindfulness', slow-cooking, slow sex, 'being in the moment', and so on.

This poses a challenge for contemporary art and art theory. Can artistic innovation still function as a source of critique? People continue to turn to the arts for critical relief from and resistance against the onrush of empty commodity novelty, once described by Walter Benjamin as 'the eternal recurrence of the

new', but how can the arts and its institutions provide such relief or resistance when they are continually forced, either by nature or habit, to be innovative? Artists themselves, as well as the art institutions, are struggling with a legitimation crisis and find it difficult to respond to the ever-growing influence of the creative and culture industries, where innovation is continuously hailed as the primary source of profit. How can the arts critically relate to the contemporary culture of change when they are themselves and by their own definition forced into innovation?

### The Future of the New

In *The Future of the New: Artistic Innovation in Times of Social Acceleration* artists, theorists, and professionals working the art field reflect on the role of the arts in a world that is speeding up and changing through joint forces of globalization, digitization, commodification, and financialization. In this book the reader will find an investigation and exploration of concepts and strategies that allow us to deal with some of the problems and challenges mentioned above. How do artists, theorists, and art organizations deal with the changing role of and discourse on innovation? Should we renounce innovation as a neoliberal ideology and turn to traditional practices (the revival of craftsmanship)? Should we look for alternative ways to innovate, or should we change our discourse and look for other (new!) ways to talk about the new? Or should we, as the accelerationists have proposed, immerse ourselves fully in social and technological acceleration, as in a gesture of over-identification, so as to speed-up even more in order to let capitalism crash against its own limits?

For *The Future of the New* I invited theorists, critics, artists, and professionals in the art field to reflect on the concept and practice of artistic innovation, and its role in various conceptions of the relationship between art and social critique. Some of the central questions are: what does innovation in general and artistic innovation in particular mean today, and can it still function as a source of social critique? Can and should we distinguish between different concepts of innovation (e.g. on the basis of their relationship to history and tradition)? How important is innovation for artistic practices? Are innovation and novelty necessarily connected to acceleration, or can we think of ways to unlink them? Can contemporary art still be

a source of social and cultural critique without having to forsake the imperative to innovate? How useful are terms such as 'avant-garde', 'novelty' and 'progressive' in the art world, now that they have become co-opted and therefore tainted by consumer capitalism? How revolutionary are the artistic revolutionaries actually, now that the modus operandi of capitalism is itself the 'permanent revolution' once dreamt of by Trotsky?

*The Future of the New* brings together debates in different disciplines: debates within art theory and sociology concerning the historical and institutional origins of artistic innovation, debates within aesthetics and philosophy of time concerning the ontology of innovation, and debates within critical social theory concerning the social, political, and cultural pathologies created by acceleration and perpetual innovation. The book addresses a theme that is highly relevant to the contemporary fields of art and art theory. It is aimed at critics, artists, researchers, students, and all those who are interested in the current state of artistic innovation or concerned about its future. Combining timely analyses of contemporary art and inspiring visions for the future, *The Future of the New* attempts to set the agenda for the debate on the function, value and future of artistic innovation.

### Outline

The first part of the book focuses on the notion of acceleration, and opens with the leading theorist of social acceleration, the German sociologist and critical theorist Hartmut Rosa. In a conversation with Robin Celikates and myself, Rosa reflects on the implications of his theory of social acceleration for the arts. Though Rosa considers acceleration to be the main source of contemporary social and political alienation, the solution, in his view, does not simply lie in slowing down. Rather, as he has elaborately discussed in his recent work, we should look into the opposite of alienation, which he calls 'resonance', a relationship of mutual recognition and transformation. The arts, in his view, have the potential to form an 'oasis' for resonance in our ever-accelerating world, and thus a model for the 'good life'.

Carolyn Strauss, founding director of the Amsterdam-based Slow Research Lab, could be said to write from such an oasis of resonance. She reports of her journey across three continents in two months, which she admits does not sound quite slow, but that nevertheless allowed her to reflect on newness from

a Slow perspective. For Strauss, the 'new' is very much entangled with the contemporary (Western) focus on growth, progress, and profit. Hence, she tries to look for alternatives, which she finds in the notion of 'emergence', in which the new is not so much thought of as the next step in a line of progress, but rather as something 'emerging' from a thick web of complex relations, like a flower from a swamp. In line with Donna Haraway's call to 'stay with the trouble', Strauss considers her Slow Research Lab a place for not-knowing, where things can evolve and emerge without the tyranny of certainty.

In many ways, the position of Alex Williams and Nick Srnicek form a counterpoint to Strauss' essay. With their 2013 published manifesto *#Accelerate*, Srnicek and Williams stirred much debate among the left by attacking head-on what they called 'folk politics', a leftist tendency to romanticize local communities and immediate action, thereby disregarding much-needed larger-scale visions towards the future. In line with the accelerationism of cyberpunk theorist Nick Land, they argued that instead of slowing down capitalism, we should accelerate even further in order to reach a post-capitalist society, a vision they further elaborated in their 2015 book *Inventing the Future*. Lietje Bauwens, Wouter De Raeve and Alice Haddad asked Srnicek and Williams to reflect on the artistic translation of accelerationism, on the difference between underground and mainstream in the artistic and cultural realm, and on the question whether it makes sense at all to envision oneself on the 'outside' of capitalism.

The interview with Srnicek and Williams is followed by two critical responses to accelerationism. In 'Accelerationism as Will and Interpretation', Benjamin Noys, author of *Malign Velocities: Accelerationism and Capitalism* (2014), argues that the question whether or how accelerationism could translate into artistic practice is beside the point, since accelerationism *is* from the outset an aesthetic rather than a political strategy. Noys distinguishes between the right-wing (reactionary) accelerationism of Land and the left-wing (progressive) accelerationism of Srnicek and Williams but argues that both of them are ways of aestheticizing politics, creating a manipulative and authoritarian vision that disregards rather than facilitates the domain of arts.

Philosopher Lietje Bauwens, in her chapter 'Accounting for Xeno: (How) Can Speculative Knowledge Productions Actually Produce New Knowledges?' reflects on some of the theoretical

and artistic responses to accelerationism. Most notably, she is interested in the prefix 'xeno' that was developed by the Laboria Cuboniks in their *Xenofeminist Manifesto* (2015) in response to Srnicek and Williams. Bauwens reports of her experiences and investigations into 'xeno' in the project 'Perhaps it is high time for a xeno-architecture to match', which she did together with architect and spatial scientist Wouter De Raeve and Alice Haddad, and during which the question arose how 'big' a blind spot can be in order to still be fruitful.

The second part of the book focuses on the historical and institutional conditions of the new. It opens with an interview with philosopher, curator, and critic Boris Groys, who wrote his seminal book *On the New* more than 25 years ago. Even though declared obsolete by postmodern discourse in the 1990s, Groys considered the category of the new 'inescapable, inevitable, indispensable' (Groys 2014, p. 7). For this volume, I asked Groys to look back at his own work and to reflect on the contemporary relevance of the concept of the new. In Groys' view, the new is always dependent on and conditioned by the archive or collection—be it a museum, a library, or a canon. This explains the continuous importance of the new, but it also demonstrates that today the new is jeopardized, since the contemporary cultural sphere is rapidly replacing the model of the archive with the model of the supermarket.

Type designer and cofounder of IKK (Institute for Art and Critique) Akiem Helmling follows up on Groys' line of reasoning in his contribution titled 'Outside the White Cube. A *Gedankenexperiment*'. Starting out from Marcel Duchamp's remarks on the possibility of an 'ascetic art', Helmling reflects on the relation between art and its contemporary institutional context, which is the White Cube. Artists such as Duchamp, but also Beuys, Hsieh, and Metzger have stretched the notion of art to such an extent that anything can be art and everyone is an artist. This leads to the interesting paradox that while the new is dependent on the White Cube, the very same White Cube today also forms a restraint on the infinite potential of art to become life.

In her essay 'The Paradox of the New Institution: On Time and Imagination' dramatist and dance and theatre theorist Bojana Kunst investigates the contemporary regime of production in art, which is tightly related to the production of the new and to what she in her book *The Artist at Work: Proximity of Art and Capitalism*

(2015) already called 'projective temporality'. This regime, Kunst argues, governs artistic subjectivity through disciplining and pre-carization, even or precisely where the artistic institutions seem all the more innovative and progressive. On the basis of an investigation into the nature of the institution and the process of institution-alizing, she calls on institutions to not only produce and exhibit the new but also to critically reflect on their own temporal logic.

Sociologist Rolando Vázquez, in 'The Museum, Decolonial-ity and the End of the Contemporary' locates the category of the new in a colonial logic that for the past centuries has considered the West as the centre of space and at the end of chronological time. Since museums played an important part in the construc-tion of such narratives establishing Western hegemony, Vázquez asks the question what it could mean to decolonize the museum. To do so, he argues, we need to develop a 'decolonial aesthesis', which revolves neither around the search for novelty nor contem-poraneity but is about breaking open and disobeying the chronol-ogy of modernity.

The third part of this volume focuses on the notion of the future. The new seems closely related to the future: it is usually under-stood as what comes next, or as a part of futurity in the present. But what happens to the new if there is no future, as Italian philoso-pher Franco 'Bifo' Berardi provocatively argued in his 2011 book *After the Future*? In the present interview with Berardi I asked him what he means with post-futurism, and what its implications would be for the arts. According to Berardi, the future that is over is the modern conception of it, which is entangled with notion of progress, growth, and expansion. Instead, we should look for the new in the present moment, disentangling the potentials hidden in the contemporary technological, social, and intellectual con-stellation that we are unable to recognize and mobilize due to its exploitation by capitalism.

In my own contribution, titled 'The Trash of History' I look at a central paradox of our time, which is that although we experience that everything is constantly accelerating and inno-vating we also feel that nothing is *really* changing. This 'petrifi-cation' of history, as I argue, is due to the temporal logic that lies at the heart of capital itself and has only grown stronger with the emergence of the debt society. Artistically, this translates into the shift from the modern to the contemporary, in which the

latter appears both as insatiable desire and as everyday banality. Contrary to the tendency within both art and theory to replace the new by the *now*, I argue that the new, understood in terms of a critical appropriation of tradition, can still have an important role in artistic discourses.

Sociologist Elena Esposito's chapter 'Predicting Innovation: Artistic Novelty and Digital Forecast' looks into the past of the new, in order to note that the new not always had the positive ring it has had in modernity. This historical contingency of the new might also mean that it could once again leave the stage. The primary reason for that today, as Esposito argues, is the increasing influence of algorithmic predictions, which saturate contemporary society and determine the future in terms of what is calculable in the present. This raises the question whether there is still any room left for the open experiment that we understand art to be.

In his chapter 'Contra-Contemporary', theorist Suhail Malik provides no less than a new theory of the new. He takes issue with the famous statement by Jameson that it is easier to imagine the end of the world than to imagine the end of capitalism. According to Malik, this statement is not only a modernist redux that paradoxically affirms the 'eternal present' of contemporaneity; moreover, he argues that it is not so much the absence of the future that is our problem today, but rather that a surfeit of futurity conditions and thus precedes the present in a risk society. The new, understood in Arendtian terms as the new-born present resulting from human action, is increasingly impossible in a postmodern condition that is contra-contemporary. Moving beyond the modern-postmodern deadlock, Malik envisions what politics and art might look like in this contra-contemporary condition.

### Bad New Things

In *On the New* Groys formulates the catch-22 logic of the new in perhaps its most elementary form: 'There is no path leading beyond the new, for such a path would itself be new' (Groys 2014, p. 7). This is why, despite or perhaps precisely because of our postmodern condition, we are not finished with the new; it continues to attract, arouse, and fascinate, or irritate, shock, and infuriate. The new is what connects the empty shimmer of commodities, fashion, and the society of the spectacle with actual breakthroughs in science, politics, and the arts. Most of all, as

the contributions in this volume show, the new, unless it is merely a slogan in management and advertisement jargon, continues to demand contemplation and critique.

Perhaps the point then is not to either embrace or reject the new, but rather to search for alternative ways to relate to it. Bertolt Brecht, in a conversation with his friend Walter Benjamin, once said 'Don't start from the good old things but the bad new ones' (Benjamin 1998, p. 121). Indeed, any artist or theorist who, like Brecht, wants to provide something more than a mere temporary relief from the accelerating world and wishes to critically reflect on their time, has to confront the new, either to determine how their time differs from earlier ones, or to envision a world beyond the present.

### Acknowledgements

Let me conclude by thanking a few people without whom this volume would not have been possible. This book is the first in the Arts in Society series that is the product of the Institute for Art and Critique (IKK) that emerged from a partnership of the research centre for Arts in Society of the University of Groningen, West Den Haag, and Valiz publishers. I thank the IKK for financially supporting this book, Astrid Vorstermans of Valiz for her confidence and advice, Marie-José Sondeijker for reading almost all of the contributions and providing useful comments, the editorial boards of Rekto:Verso and Krisis who commented on and edited earlier versions of some of the interviews, and of course I am most grateful to all the contributors.

# References

— Benjamin, Walter. 1998. *Understanding Brecht*. Translated by Anna Bostock. London and New York: Verso.
— Groys, Boris. 2014. *On the New*. Translation G.M. Goshgarian. London and New York: Verso.
— Horkheimer, Max, and Theodor W. Adorno. 2002. *Dialectic of Enlightenment: Philosophical Fragments*. Translated by Edmund Jephcott. Stanford: Stanford University Press.
— Srnicek, Nick, and Alex Williams. 2015. *Inventing the Future: Postcapitalism and a World Without Work*. London: Verso.

# Part 1

# Accelerate/ Innovate

# Beyond the Echo Chamber
## An Interview with Hartmut Rosa on Resonance and Alienation

Thijs Lijster & Robin Celikates

'If acceleration is the problem, then resonance might be the solution.' This is the shortest possible summary provided in the first line of the 800-page book *Resonanz: Eine Soziologie der Weltbeziehung* (2016). The book is the latest stage and logical next step in the analysis and critique of modernity by the German sociologist Hartmut Rosa, which started with the equally ambitious and encompassing book *Beschleunigung: Die Veränderung der Zeitstrukturen in der Moderne* (2005). There, Rosa dissects modernity as a process of acceleration, comprising the three dimensions of technical acceleration, acceleration of social change, and acceleration of the pace of life. Although his analysis is largely in line with Paul Virilio's 'dromology' and David Harvey's analysis of modernity as 'time-space compression', the underlying question and concern of Rosa is somewhat different. While Virilio seems to aim mainly at a cultural critique and Harvey at an analysis of capitalism as a system, Rosa is first and foremost interested in the question of the 'good life'. Like the earlier generation of the Frankfurt School, Horkheimer and Adorno and, with qualifications, Habermas, he considers modernity in terms of a broken promise: the very technology and social revolutions that were supposed to lead to an increase in autonomy are now becoming increasingly oppressive. In *Alienation and Acceleration* (2010) he even calls acceleration a totalitarian process, because it affects all aspects of our personal and social lives, and is almost impossible to resist, escape, or criticize. Rosa writes: 'The powers of acceleration no longer are experienced as a liberating force, but as an actually enslaving pressure instead' (Rosa 2010, p. 80). As the book title suggests, Rosa considers acceleration as the primary contemporary source of alienation, along the three axes famously described by Marx in the passage on 'estranged labour': alienation of people from themselves, from their fellow human beings, and from the world of things. While we feel the constant pressure of having to do *more* in *less* time, there also seems to be a shared feeling of a loss of control over our own life and the world, and therefore of losing contact with it.

Rosa's latest book continues on the path of *Alienation and Acceleration*. For the concept of 'alienation', which has a long tradition in modern philosophy and was recently taken up again by Axel Honneth and Rahel Jaeggi (2016), is an inherently problematic category. The concept implies that you are alienated *from* something, where this something has often been associated with

a conception of 'true' humanity or authentic life, be it Rousseau's noble savage, early Marx's 'species being', or Heidegger's *Eigentlichkeit*. Such conceptions of authenticity can easily become arbitrary or oppressive even, for who is the philosopher or critical theorist to decide whose life is 'authentic' and whose isn't? Then again, Rosa argues, if we drop the conception of the good life altogether, the concept of alienation also becomes empty; it then risks becoming a mere label for things we don't like.

This is why in *Resonanz* Rosa sets out to analyze 'resonance' as alienation's opposite, thus also aiming at a better understanding of alienation and creating a conceptual tool to criticize it. Though not so much itself a conception of the good life, resonance according to Rosa lies at the basis of all conceptions of the good life. It refers to a relation between subject and world (*Weltbeziehung*) characterized by reciprocity and mutual transformation: the subject's experience of some Other calling upon it, which requires understanding or answering but also has the ability to change the subject. Resonance, as Rosa is quick to add, is not a mere (subjective) experience belonging to the subject; he emphatically refers to the *relation between* subject and world, be it a relation between subjects, between the subject and object, or even of the subject to its own body. Not surprisingly, and in line with the first generation of the Frankfurt School, art is for Rosa an exemplary place for and medium of such relations (although religion and nature are also important examples), and indeed functions as a vestige as world-relations become increasingly alienated. Alienation, then, is precisely the impossibility or inability to enter into a relation with the other. Indeed, all problems or 'social pathologies' of modernity according to Rosa come down to this: that we are unable to form a meaningful relationship of mutual understanding and interaction, either with our material surrounding (e.g. in the case of labour) or with fellow human beings.

For Rosa as a critical theorist, the concept of resonance functions on three levels. In the first place there seems to be an anthropological undercurrent in which resonance describes what makes us human; the first chapters of his study deal with such basic animal and human behaviour as breathing, eating and drinking, speaking and glancing, laughing, crying, and love making, all of which entail relationships of resonance. Secondly, resonance functions as a theory of modernization. In line with Charles Taylor, Rosa argues that modernity is a process in which

the 'self' becomes less *porous*, hence increasingly closed-off from the world. At the same time, however, Rosa also considers modernity as a historical period of increased 'sensibility for resonance' (*Resonanzsensibilität*): since resonance is not an 'echo chamber' but a relation of questioning and answering, the subject needs a relative autonomy in order to enter into meaningful relationships with the other. The promise of modernity was precisely this, 'that we could move out into the world to find a place that speaks and alludes to us, where we can feel at home and that we would be able to make our own' (Rosa 2016, p. 599). Finally, the concept of resonance is, like we already noted, a critical tool, providing a framework to criticize both capitalist competition as source of alienation, as well as false solutions and claims to authenticity, be it some fully individualized attempt at *mindfulness*, or populist discourses of social and cultural homogenization.

### 1 Acceleration
**Thijs Lijster/Robin Celikates**: You have written extensively about social acceleration, and you convincingly link technological innovation with social change and the acceleration of personal/individual tempo. With regard to the latter, however, we are wondering to what extent the kinds of problems or 'pathologies' you are describing are happening on a global scale, and to what extent they are specific issues of the West or, to put it somewhat more bluntly, 'first world problems'. Capitalism, to be sure, affects people all over the globe, but it doesn't affect them all in the same way, does it? What space does your theory allow for what is often called 'die Gleichzeitigkeit des Ungleichzeitigen' (the simultaneity of the non-simultaneous)?

**Hartmut Rosa**: It is interesting that you mention 'die Gleichzeitigkeit des Ungleichzeitigen', which is a phrase made famous by Koselleck, for this phrase already suggests a kind of direction of history: it assumes you have things that belong to an earlier age and things that belong to a later age. What I'm trying to say is that we've reached the end of this idea of history moving forward, which means that you no longer have the simultaneity of the non-simultaneous, but you just have differences. So, some people are under a lot of time pressure while others are not.

Your question has many layers. One has to do with class: people always ask whether the speeding up of life—the increase in the pace of life—is the same for all layers of society. And the other question is, of course, on the global scale: is it the same for all parts of the world? To the second question, I would actually say: yes, very much so, wherever you have processes of modernization. Acceleration basically is at the heart of modernization. For example, I just spent quite a long time in China and there you see it happening, almost like crazy. You have this logic of competition and of speeding up, so the people there know immediately what I am talking about. And it is not just on the scale of a small elite; it is very comprehensive. And indeed, it is the same in Korea, Japan, Brazil, and other places in Latin America. Of course, there are certain places, one would think of some regions in Africa, where this change in temporal structures is not very widespread, and which I therefore call 'oases', where these forces of acceleration are not yet taking hold. So, I would say acceleration is a global phenomenon: wherever you have these processes of globalization or modernization you find acceleration. You will not always find individualization, divisions of labour, or democratization and sometimes these processes are not even clearly capitalist, but the change in temporal structures is modernity's most widespread feature.

Of course, there are always segments of the population—and this varies in different countries—that do not really struggle with the shortage of time. My claim is that when you look at the social strata, you find three different layers. The first, which you could call the elite but is actually the middle class, has completely internalized this logic of speeding up. So: saving time is saving money. It is the logic of competition, in particular, that they have internalized, and competition is always related to temporality: 'time is scarce, don't waste it'. For the second layer, further down the social ladder, time pressure is not so much internalized, but coming from the outside. Of course, that is true for most conditions of labour: shop floors in companies, construction sites, care industries, etc. The people working there are always short on time but usually it is someone

else—the boss or the clock—who creates the pressure, and it is not so much coming from the inside.

**TL/RC:** People have to do more in less time?

**HR:** Yes, always, and this is really true almost everywhere. Recently I looked into truck drivers. They are told: 'You have to deliver your load in a certain time, we don't care how you do it.' So, you either go too fast and you have to pay for the speeding ticket or you take the Autobahn, but then you have to pay for toll, or you ignore the mandatory resting periods, otherwise it is a totally impossible task. It makes me angry when colleagues claim: 'Rosa is only describing the academic elites.' I think someone who says that has no idea about empirical reality and I would actually claim that is indeed almost the same all over the world.

Nevertheless, then you have a third segment of the population, I call them 'forcefully excluded' or 'forcefully decelerated'. If you are unemployed, then you may have a lot of time on your hands, but even that is not always true. It will depend on what you do for a living, whether you're sick or depressed, and so on. But this kind of forceful or enforced deceleration is a kind of devaluation of the time you have then. The time you have is without any value and the problem is that even then you feel the pressure of acceleration, because you feel like you are lagging behind more and more, and that it is impossible to catch up. So, this is why I claim that acceleration is an almost totalitarian force, you feel the pressure wherever you are.

The distinction I've discussed, between the internalization of time pressure and time pressure as a force from the outside also raises interesting questions as to who has more resources to resist. Probably, you will find more possibilities and power to resist if the pressure comes from the outside. Once it is completely internalized you are lost.

**TL/RC:** What is your take on the more positive accounts of acceleration that have been put forward, for instance by Deleuze and Guattari, who propose that we should accelerate even more, and enjoy acceleration. Or the *#Accelerate Manifesto*, by Alex Williams and Nick Srnicek, who argue

that we should accelerate further in order to let capitalism crash against its own limits. In any case, acceleration in social and cultural theory has always had a rather ambiguous sense, of both alienating and liberating. Is there any 'jouissance' [enjoyment] of acceleration possible in your view?

**HR:** In my main book on social acceleration I first of all wanted to identify the change in temporal structure that accompanied modernity. There wasn't really a systematic account of it. What I wanted to do was to analyze what is accelerating and what is not, and what may be the consequences of it. Looking to these consequences, I was not so optimistic about them. Nevertheless, I did not say that speed per se is bad, and I didn't say that slowness is good; certainly not the latter. I do share with the accelerationists the idea that just being nostalgic about the past would be a mistake, because this leads you very quickly to the idea that the past was much better and that of course is not the case. Today you sometimes find a nostalgia for the Fordist period, while this period was of course the most alienated age ever. So, I agree that speed per se is not the problem.

**TL/RC:** Are you thinking of Richard Sennett, or would you rather not mention names?

**HR:** Yes, I was thinking about Richard Sennett, though I like his work very much. I very much liked his book on craftsmanship, for instance, because I think he has a very strong sense there of resonance with regard to work. Nevertheless, when you read people like Sennett or Zygmunt Bauman (and there are a lot of German sociologists too) and their critique of the postmodern condition, all of a sudden it sounds like the past was a great time.

I don't think speed per se is the problem, but I also don't want to just turn it around and say: well, if you cannot do anything against it then let's embrace it. That is not a sensible stance for me. What I dislike about the accelerationists is that they seem to give in and say: 'Since we cannot do anything about it let's just get on top of the movement.' They always claim that something good can come out of it, but I think that they are totally lacking the

yardsticks of how to judge the consequences. Turning the perspective around doesn't solve anything. In my book I basically say: indeed, speed is not per se bad, but it is bad when it leads to alienation. So, the question for me would be: what do the accelerationists do with this?

**TL/RC:** Perhaps some forms of alienation might not be bad. In *Inventing the Future* Srnicek and Williams argue in favour of total automation; this would in some sense be alienation, because it puts us even further from daily activities of the reproduction of life, but it also provides a lot of freedom to do other things.

**HR:** But this has always been the promise of modernization and acceleration, that it will eventually give us freedom, but there has been a betrayal on both ends. On the one hand, it didn't give us freedom: you can see the exact opposite. I really insist on that. What I try to work out is a certain temporal logic, one that has a lot to do with the logic of competition, and which I call 'dynamic stabilization'. That is really the core of my analysis of modernity. We can only keep what we have—both on an individual and collective level—if we increase speed and productivity and so on. And this increase does not come out of thin air: we have to do it ourselves. Every year we have to run a bit faster to keep what we have. So, the idea that this will eventually give us freedom is simply wrong under the present conditions. If one does not see that, one is blind to what has happened over the last 200 years.

It's not that we're only enslaved. I do think the liberating potential is there, but in this logic of dynamic stabilization there is a shift in the balance between the liberating aspects and the enslaving aspects. The promise of modernity has always been progress: let's increase production, let's come up with new innovative technologies, let's speed up and so on, in order to reach some Golden Age. But today most people no longer perceive this acceleration as progress: you have to run faster, but not to get somewhere, but to keep what you have. I think this horizon has become more and more pale; now the impression is that we have to speed up otherwise we will have much more unemployment.

**TL/RC:** Wasn't it so that up until a certain point in time, at least in the Western world, we were working less and less?

**HR:** You're right, and that is basically also what I write. But now the increase in freedom, also what you could call progress, in the end will be sucked up again. I argue that we have to invest more and more psychological energy, political energy, and material energy (resources) into the logic of mobilizing the world.

You see this very clearly with our young people. In the age that you were referring to, when freedom was increasing, so up until the 1970s, when you asked young people: 'what do you want to do?', they would talk about their dreams, or their aspirations, or their ideas. Now this has turned around. They ask: 'what can I do in order to successfully compete?' It is no longer about developing your own perspective but about fitting in.

I've noticed this myself too. For some years I've worked with young people, just before their *matura* [secondary school exit exam, TL and RC], and each year we are talking about what they are going to do next. I think there has been a shift from about 20 years ago, where they would say 'I want to do philosophy' or so, and now they come and ask: 'what could I do if I study philosophy?' All our capacities, all our energies, all our dreams are fitted into the logic of increasing productivity. As long as the accelerationists do not see that, I think that's really bad.

On one other point I would agree with them, namely that I think we are not at the end of the logic of acceleration, not in the least. Paul Virilio has said this a long time ago, and was really visionary in this respect, that we are on the verge of a fusion between computer technologies and bodies—biotechnology and computer technologies. With this, we can speed up our brains and our interactions probably much more. What I think we definitely need is an idea of 'the good life', and that is what I try to provide.

**TL/RC:** Coming back to what you said earlier, about modernity's promise of progress, we were wondering what the implications would be of your theory for what we traditionally consider leftist politics? After all, we traditionally

make the distinction between the 'progressive' left and the 'conservative' right. But what does 'progressive' mean once progress itself is experienced as catastrophe, to borrow a phrase from Walter Benjamin? And how would you see the contemporary crisis of the left, or of 'progressive politics' in general in this light?

**HR:** The problem is that 'progressive' has always been a very ambivalent term, covering a lot of things. On the one hand, of course, it has referred to technological development: progress in science and technology and so on. On the other, it refers to the emancipatory power, or the emancipatory ideals, which are probably more important when you think of the political left. The idea of progress in the latter sense was really about giving or having more autonomy: emancipating individuals so that they are liberated from traditional powers which have been repressive, such as the Church, or the patriarchal system, but were also clearly exploitative systems. There has been progress historically right up to probably our present age in many aspects, but I think there are two problems with this idea.

One problem is that this kind of formal autonomy has been counterbalanced by the logic of competition, which we were just describing. So, there is a loss as well: that people gain autonomy on the one hand, but that they lose it on the other hand because of the logic of a capitalist competition. The other problem, and you see this also in the contemporary political crisis, is that there is a longing for something *other* than autonomy, for a kind of reconnection. That is why I came up with this idea of resonance: being connected to the world in a certain sense does not just mean: I want to decide for myself. Even progressive leftists define autonomy as living according to self-given rules and principles, and of course they have a sense that these self-given rules and principles should be intersubjectively discussed and so on, but nevertheless it is principles and rules. But I think that the good life does not mean that I live according to my principles; people feel the least alienated when they are overwhelmed by something. Adorno had a very strong sense of this or think of Latour who's talking about the feeling that you are called upon, and you

answer. This kind of connection has to do with being affected and feeling self-efficacious, i.e. experiencing one's ability to achieve things. This is more than just autonomy.

I believe we have a kind of crisis of autonomy, particularly when it concerns consumer autonomy. So, one problem is that the formal or political autonomy, which we did historically realize, is sucked up by the logic of speed and competition. The other problem is that autonomy is not sufficient; it is only one side of a good life. There is a double crisis on the left, which is very problematic. Whenever you raise leftist ideas, people will ask you: 'What? Do you want to go back to the kind of state socialism we had in the past?' and if you then of course say 'no', then that's it, right? What the left is lacking is a vision of what the world could be like.

**TL/RC:** So, the concept of resonance for you is also a political category?

**HR:** It is definitely a political category and I cannot emphasize this enough, because it is often misread as an individualistic notion. The book is probably too long, but what I try to say again and again is that resonance is not just about a subjective stance towards the world, that is why it is different from the *Achtsamkeit* or the mindfulness movement and so on. I'm not saying that if you are in the right mindset, that everything is fine. Resonance is a two-way relationship, so it depends on what you relate to, a mode of being in the world. And this is not up to individuals to decide. So, I really want to turn it into a political category and also an almost institutional yardstick: how should institutions be established?

My take—which I share with Adorno and Horkheimer and the older critical theorists—is that our whole mode of being in the world, of relating to the world, is, I would almost say, screwed. We have a very instrumental relation to the world. Max Scheler, followed in this by Marcuse, called modernity the Promethean stance. The world becomes a point of aggression: I want to explore it scientifically, I want to control it technologically, I want to rule it by law and so on. It is relating to the world in order to make

it *verfügbar*—I don't really have a good word for it in English—to make it controllable, predictable, have it at our disposal, and so on. This has to change. But this way in which we relate to the world, the way we are set in the world is not an individual issue, it is a deeply political category.

**TL/RC:** You are making a clear link between technological innovations on the one hand, and social acceleration on the other. In the same way, since the nineteenth century, all kinds of artistic innovations have been linked to revolutionary politics. At certain moments in time they even had this kind of alliance in which artistic and political vanguards together would attack the status quo. But do you think these are the same kinds of novelty or innovation? Is innovation in the arts the same as in revolutionary politics, or for that matter, in the succession of innovative commodities or technologies? And, related to that question, do you think notions such as 'the new' (or related concepts such as creativity and so forth) are still of value in contemporary artistic discourses?

**HR:** There are two distinctions that to me seem important to make. One is that between technological and social progress. When today you talk with young people about the future it is very interesting that they think of it in technological terms: artificial intelligence, what will become possible to do and so on. That has changed a lot in comparison to the 1970s or 80s, when young people thought about the future in more political terms: lets shape the future politically! So, there has been a division in how we think about novelty, with a still unbroken belief—and this is not only a belief but also a fact—in the expansion of our technological capacities. We peer deeper into the universe with satellites and deeper into matter and we are more capable of controlling it, so innovation there can be clearly recognized, and there is progress.

What has been lost, however, is the promise it carried, namely that *through* these innovations in science and technology, life would become better. We would overcome scarcity, we would overcome ignorance and probably even suffering, we would finally know what the good life is and

have the chance to lead it. No one believes that anymore, right? No one believes that we will overcome scarcity; it is rather the opposite, we believe competition will result in even more scarcity, so that in the future we will have to work even harder. No one believes that with faster technologies we will solve the problem of time pressure and we know that we won't overcome ignorance. Precisely because of all the progress in science and technology, we now don't know what to eat, we don't know how to give birth—we don't know anything. This promise that everything will get better has been lost. It seems that art is kind of in between these two notions of progress, although it has always leaned more to the political and philosophical idea of progress: liberating human potentialities for the sake of human life.

When you look at the non-technological side (and that is true for art, but for science too), there has been a shift from 'progress' to 'progression'. Progress for me is the idea of moving forward; there is some element of increase, growth, or improvement. In art, as well as in science, at least the social sciences, we have given up on this idea. You see it in many spheres, but most clearly in science. In science progress meant moving towards the truth. Max Planck once said: 'You shouldn't study physics, because very soon we will know everything.' The idea is that we will move forward and forward, and even that if we will move forward forever, we will get closer to the truth. Progression means something else. I expect that if you ask students today, at least in the social sciences, why they want to be a social scientist, and what they are going to do when they are social scientists, they will say: 'I want to come up with new ideas, and new questions, and new principles and new perspectives.' There is still innovation, just as progression, in the sense of new ideas, but it is no longer moving towards the truth of the good society or whatever it is. This is also what I mean with the phrase '*rasender Stillstand*': you move very quickly, you have to be innovative and creative, original, and so on, but you've lost the idea of where you're moving to.

When it comes to the arts, this is why I am now so preoccupied with this idea of resonance. Art is not my expertise, and although I like it very much I do not consider

myself as a philosopher of art. With regard to the creation of art, the emphasis has always been on the creativity of the subject. You have to be creative and come up with something new and so on. But I believe that even in art there has to be what I call this resonance: there is something out there that you need to connect to. It is not just the subject in itself.

**TL/RC:** Does this shift from progress to progression also make, in a way, the very notion of an avant-garde superfluous or irrelevant?

**HR:** Actually, I would not give up on this idea completely. I think art is still a vitally important sphere of society because it is the one sphere, perhaps next to religion, that is least dominated by this logic of dynamic stabilization. That means that art is one sphere where we can explore different ways of being in the world and of relating to the world and I think really that this is what art is about, no matter whether we are talking about dance, painting, or literature. Exploring and experimenting with different modes of relating to the world, imagining, reconstructing, or finding other forms of relating to things and to people, coming up with new ways and possibilities. This is still an important function of an avant-gardist art.

## 2 Alienation

**TL/RC:** In the tradition of critical theory, from Marx to Rahel Jaeggi, the critique of alienation has tended to avoid making substantial claims about human nature or the good life. You seem less hesitant, especially with regard to claims about the good life. How do you think these can be justified under conditions of deep pluralism? And what is the scope of these claims, both historically and culturally?

**HR:** When you look at the history of it, alienation has been a very influential term, even up until the 1970s or 80s when sociologists strived to measure alienation in different contexts and with different methods. After that I think it disappeared into the background for some time, because we didn't know what a non-alienated way of being in the world

would be. Rahel Jaeggi puts it nicely, when she says: 'Alienation is a relationship of non-relationship', so it is a wrong form of relating to the world. I think alienation only is a powerful philosophical and sociological term if we keep the sensation, the feeling, that something is wrong here. But if you then completely refuse to think about what the right way of relating would be, then you are kind of lost, and that is why the concept has lost all power. Richard Schacht has also written about it, and he said that in the end alienation was used for everything people disliked. At that point it is no longer a useful concept, and you might as well give up on it.

What I am trying to do is think about what a non-alienated way of relating to people, to things, to yourself, and so on would be. I try to reconstruct this by looking at the tradition of critical theory. All early critical theorists had a strong sense of alienation; and even if they didn't always use exactly the same term, they would have an equivalent like 'reification' or 'instrumental rationality'. And they all had a kind of counter-sense, of a different way of relating to the world, like 'mimesis' in Adorno, or even 'aura' in Walter Benjamin's work. Aura is a very ambivalent concept but I think he basically meant that even with things or with nature, or with a landscape, there could be different ways of relating: it is looking back at you, it is speaking to you, it is somehow getting through. The concept of alienation only gains its strength when you really make the effort to think of the opposite.

Now there you have the problem you mention that you have total pluralism in the ways that we relate to the world. That is why I am very confident about the concept of resonance because it describes the nature of a relationship but it doesn't describe or prescribe the substance: it leaves open what you relate to.

**TL/RC:** Is it a formal category?

**HR:** You could say it is a formal category, although the question of form or substance in this context is actually totally confusing. It's a kind of *Vexierbild*; it shifts. I think it is substantive in terms of the quality of the relationship,

but it is formal in terms of what is at the end. I am inclined towards a relational ontology, saying that the subject and the world are actually created out of the relationship. So, I can say something about the nature of relationships, and that would be the way to reconcile the idea of resonance as an idea of the good life with ethical and conceptual pluralism or cultural pluralism.

We try to study this at the Max-Weber-Kolleg in Erfurt. We now have a long-term project, studying *Weltbeziehungen*. This is actually a difficult term to translate into English, because I would have to already introduce the subject–subject-world relationships—while I am not sure whether 'subject' and 'world' are not already secondary terms. Anyway, it is about these relationships in different cultural settings. In my book I say that resonance has three axes: social, material, and vertical, and the way they are spread out is different for every culture. For example, in the vertical sphere it will depend on whether there is a god, or if there are many gods, or whether there are Daoist entities or whatever. It is the same in the inter-subjective realm: what kinds of relationships are made resonant, to whom and for whom? It is very different in all cultures and it certainly is the same with things. I think all cultures somehow have the idea that certain places or spaces are resonant, or certain entities like the forest, or the sacred stone or whatever. But I would even go one step further and say that maybe even those three axes are culturally dependent because to distinguish between the social and the objective, the artefact, and so on, is already perhaps not necessary.

**TL/RC:** Or between artefacts and spirits?

**HR:** Yes, exactly. In animistic societies you always find axes of resonance, although they may be ordered very differently. But this is still reconcilable with the idea of resonance. I would have still one question though, and that is that I do not know whether the very idea of resonance requires a closed subject, that is whether the subject and the world maybe have to be somehow closed in order to become resonant bodies. It is the same with physical bodies: if you have a musical instrument, let's say a violin, it will

only make its sound—that is resonate—if it is closed enough to have its own voice. So, it needs to be closed and it needs to be open in order to be affected. It is a very specific form of being closed *and* open. This is why I am a bit hesitant about whether on some level maybe other cultures cannot so easily be described in terms of resonance, because the relationships between subject and world may sometimes be more porous. This might be one level where maybe we have to adjust the concept in cultural terms, but on a basic level I believe that it is really true that every human being, wherever they are born, only becomes an individual, a self, or a subject, or however you call it, through processes of resonance.

**TL/RC:** Of course, your theory is also in that sense meant as a response to and a theory about modernity, right? In that sense it already is at least historically located.

**HR:** Yes, the main emphasis of my whole book was about how did this develop in modernity. What sensibilities for resonance, what axes for resonance and what obstacles, so to speak, emerge in modernity, and what is the modern way of relating to the world? But I did have this assumption that resonance is a kind of pre-modern capacity, so there is an anthropological element there.

**TL/RC:** To follow up on that, you say at a certain point that humans have a basic need for resonance just as they have a basic need for food. That seems like a strong claim which, if you look at it from the perspective of critical theory, might raise some problems with regard to the historical and cultural variability of needs.

**HR:** Do you not think it is a plausible claim?

**TL/RC:** It may sound quite plausible, especially in the context of your book, but all the while there has been this debate in critical theory—for instance if you look at feminist scholars like Nancy Fraser, who articulate a critique of need interpretation and ascriptions in a meta-historical or meta-cultural sense. So, either it is a strong claim, or it is a

conceptual overstretch or a truism, in which a large range of different activities or relations all fall under the heading of resonance. Then it becomes more a way of constructing a theory.

**HR:** There are two problems or misconceptions with the concept of resonance, generally. The first is to think of resonance as just meaning harmony, as if I'm saying that it would be great when everything is harmonious or consonant. But I always say that total harmony or total consonance is not resonance at all, because for resonance you need different voices. The second is the conceptual overstretch, the idea that all relationship are interpreted as resonance. For example, if I punch you and you punch me back and we say: 'Well, that's resonance.' I always emphasize that this is not resonance: resonance is tied to an openness, of wanting to be affected and answering, so it is a very specific form of relationship.

Thus far I am convinced that there is good evidence on all levels that human beings—and maybe this even goes for all mammals—are forced, by everything they are, to develop such relationships. As Merleau-Ponty writes: I start with the sense that something is there, something is present. This is the first element of awareness and you can actually notice this when you wake up from very deep sleep or from being unconscious. Before you know who you are and what the world is you have this sensation that there is something, right? I think that for a human being without this sense it is totally inconceivable to develop relationships. So, I would say yes, I am fully convinced that this is the basic category.

It is similar to what Axel Honneth writes with regard to recognition: human beings need recognition of some sort. Or what people talk about with regard to the language capacity of human beings. These conceptions have a similar structure to what I want to say about resonance. On a basic level, getting into resonance, developing a sense of who you are and what the world is from moments, or processes, of resonance, is something everyone is engaged in. People need recognition and they need language, independent of the kind of recognition or the exact language they then speak. The latter is historically dependent.

So, there are two sides to what I want to say. There is an anthropological need or element of resonance, but then the specific form it takes, the specific need and the specific sensibilities you can only explain historically, which is what I try to do in the chapter on modernity, where I try to work out our modern conception of love, for example. I am not claiming that that particular conception is anthropological, not even the relationship to our children, art, or nature. Whether you believe that there is a voice of nature, that is not anthropological, but a specification that developed out of this basic anthropological need. Again, I think it is the same as when you think about language; if you reflect upon our language then of course you would have to make a lot of historical qualifications depending on whether you are talking about Swahili or German, but you can still talk about a basic need or capacity for language. I can't really see why you couldn't do both, thereby avoiding the two pitfalls that you were rightfully pointing to.

**TL/RC:** On the one hand, it seems that you are aiming to develop a notion of alienation and resonance that is not reducible to a merely subjective experience. On the other hand, your notion of resonance is still experience-based—when you claim that alienation is overcome if the subjects in question have the experience that the (natural and social) world resonates with them. However, again from a critical theory perspective, one could imagine that such experiences of resonance are very much part and parcel of the most common forms of alienation. Do you end up having to claim that the neoliberal subjects who, say, really feel resonance when they go to their yoga class or have a break in Bali or go to the wine tasting in their local hipster bar (without having a purely instrumental relation to these activities) know deep within themselves that this is not true but simulated (and thus alienation-enhancing) resonance? Your idea of simulated resonance is intriguing but it seems that you then have to refer to objective criteria in order to distinguish actual from merely simulated resonance.

**HR:** Those are tricky points. On the deepest level, there is really a very difficult question: is resonance a psychological

relation, something I experience; or is it ontological relation, something that is really going on between us. If it is ontological, then it is somewhere out there; if it is psychological, then I feel if our conversation was resonant or not. I really want to say that it is more than psychological, it is a kind of 'in between'. Charles Taylor has something similar in mind in his discussion of romantic philosophy in terms of the 'inter space'. You could also think of Bruno Latour's work. Resonance cannot just be understood along constructivist lines—as if we could construct or project it—it is a kind of 'in between'. As for the neoliberal subject and stimulated resonance: the feeling is that there is something wrong with going to Bali or the yoga class, but the question is: what is wrong? Let's take the example of an ideal neoliberal manager going to the yoga class and to Bali on holiday, about whom I think I can make two points. The first concerns the basic disposition, the disposition towards the world within which you operate and which is not just of your own choosing. In the case of the neoliberal, what he does for a living in the business sphere is characterized by a very instrumental stance towards the world and this is at odds with resonance. Why? Because getting into resonance involves a kind of not knowing when it happens, not knowing what the outcome will be. So, it requires a kind of openness, which is a different disposition from the instrumental, optimizing, efficiency-oriented rationalizing stance that you normally have to take. The basic stance you take towards the world as a neoliberal manager is one of reification and then you seek to counterbalance it through what I call an oasis of resonance, like a yoga class. So, what is wrong with the yoga class? The main problem concerns the difference between resonance and sentimentality. I use the German term *Rührung* and develop it out of the work of Helmuth Plessner. Another example would be watching Hollywood blockbusters like *Titanic,* which are very melodramatic. Let's say I cry at the end and someone says to me: 'Oh, that's what you mean by resonance.' I would respond that this is not exactly what I mean by resonance, this is *Rührung*, which does not involve encountering some Other that really has this also irritating

difference, which calls on me to answer. *Rührung* is just about having a strong sensation within myself and I only instrumentally use this Other. It is not encountering an Other to which I then answer. What is also missing here is any sense of self-efficacy, this reaching out to the Other and getting into contact with it and thereby being transformed. The vital element of resonance is tied to this encounter in which I experience a transformation of myself, I experience this other, which transforms me. And if I only have an oasis, e.g. if I meditate once in a while, then this feels totally empty, and this is not resonance. I call it an echo-chamber. Probably the same holds for the trip to Bali: it does not really involve getting into contact with something that truly transforms you, it is just for about forgetting the instrumental stance I am forced to take for a limited time.

**TL/RC:** So, it is also instrumental in that it allows you to momentarily get away from yourself?

**HR:** Yes, exactly, this is what I call the reification of resonance, the idea that you try to use these moments in order to be more successful, but the thing is that then your basic disposition towards the world, the way that you relate to it, remains instrumental, optimizing, speeding up. In this case you use remnants, or simulations or echo-chambers in order to be even more successful.

### 3 Resonance

**TL/RC:** Moving on to the theory of resonance, what also struck us as readers of Benjamin is that in your definition of resonance you speak of an instant, a 'momentum', an *Aufblitzen*, which could remind one of both the concept of aura and of now-time. Do you indeed consider this experience of resonance as so limited in time, and, if so, why? How do these instances relate to the more durable relations and axes of resonance that you refer to (do they give rise to them, keep them dynamic, undermine them?). And, following up on that, do these 'instances' suffice to counter (or answer) the problem of acceleration and the alienation that they somehow answer to?

**HR:** This is a very difficult question too. In my book I do not really focus on the temporality of resonance, which is maybe surprising given my earlier work. It is true that I write that strong experiences of resonance are only momentary, and that this kind of dynamic cannot be put on a permanent basis. But we are speaking of *experiences* of resonance—and they are unpredictable. If you look at music, which has been a paradigm case for me, but also at religious experiences or love, I think there is empirical evidence for the claim that people who go to concerts a lot only really have a strong experience one out of ten or even a hundred times, but it is strong enough to go back to it, to search for it again and again. So, it is a momentary experience but you develop it along axes and axes are more stable, so if music is important to you, you keep going to concerts and you have at least memories, reminiscences of resonance, which can permanently confirm your axes of resonance.

Rituals actually play a strong role in creating conditions for resonance. In religion this is very clear but also in rock concerts or in football stadiums there is a very clear ritualistic sense. This is something that we want to explore in Erfurt, in a research group called 'Ritual and Resonance'. The idea is that this brings you into a certain disposition. I call these preconditions axes and these axes are developed over time because they also create the experience that resonance might happen and your sense of self-efficacy. The other very important element is the disposition. You can only get into these moments of resonance or relationships of resonance, if your disposition towards the world is resonant: being open to hearing the call, being affected, and you have to have the expectation that you can reach out. What I call self-efficacy is not exactly psychological. It concerns reaching out and making these moments possible and this disposition is something that you can actually work on and that is more temporarily extended. So, you have axes of resonance, which are established over time and need a certain form of stability, and you have dispositions of resonance, and both involve long-term stability. In comparison, experiences of resonance are temporary. Still, I think it is wrong to assume that resonance

means being completely in the here and now. When you really experience resonance, the temporal horizon rather widens, it extends; it is the co-presence of the past and the future. Once you are in resonance with something it is like the past speaks to you and through you into the future. It is this extending that makes it feel as if time is running through you. This is different from the examples of the Bali vacation and the yoga class as in these cases one just wants to be in the here and now and block out what one did yesterday and what one will do tomorrow—this is not the temporal structure of resonance. In resonance the past and the present are meaningfully reconnected.

**TL/RC:** You make it very clear that 'resonance' isn't the same as harmony, and you clearly delineate resonance from concepts such as *Eigentlichkeit* or authenticity. At the same time, the very metaphor of resonance, the usual meaning of the term, might be seen as working against you. After all, something only 'resonates' if it is of the same kind, think of musical tones—this could be seen as the fundamental problem of the allegory of the tuning forks you use to clarify your notion of resonance. What space does this leave for truly dissonant voices?

**HR:** For me at least the greatest insight to gain from the concept of resonance is a way to overcome the aporetic dualism between authenticity and identity theories on the one hand, and post-structural difference theories on the other. Resonance is not about authenticity in the sense that I must be true to myself or that it confirms my authenticity, because it involves transformation: it is feeling called upon by something different that transforms me. In that sense it fits difference theories but I would argue that it is not mere difference, because I have to develop my own voice and answer the call. So, I would say that it is exactly in between those two. There are elements of dissonance, or difference, that cannot be overcome. But I cannot enter into a relation of resonance if, for example, it is a thought, or an experience, that is so different that I cannot relate to it. Of course, there are also those moments of dissonance that are tied to what I call repulsion. In my view there is no

negative resonance. There is a very clear distinction, and you can really feel it immediately or reproduce it phenomenologically, between repulsion and resonance.

Take the example of a discussion: if we all agree completely, there is no resonance; if the interlocutor always agrees, there is no resonance at all, it is just a monologue. Resonance is not consonance. With my best friends I always argue all the time about everything; it involves hearing a voice that says something different and that makes me answer, a process whereby we both shift and transform into something else. The situation might turn if you say, for example, 'You are just a racist idiot'—then closure occurs and I no longer want to be affected. That is a different stance towards the world and I want to conceptually distinguish these two elements: one is repulsion and the other is resonance. Resonance is not agreement; resonance is in between consonance and dissonance. Of course, there are moments of dissonance that are repulsion and that are not resonance at all, but in the hermeneutical tradition there is this thought—maybe first articulated by Gadamer, but you find it in Taylor as well—that an adequate answer to the claim 'I don't understand' could be 'then change yourself in order to understand it'. Resonance is natural realization of this thought. It's not so much 'I have to change myself' but rather 'let yourself be transformed by the other' by getting in touch with it. The more you already are in a resonant relationship with the world, the more your capacity widens to really get into contact with difference. Difference can become more different and it can increase if you have the expectation of entering into a resonant relationship. Then you find it interesting to encounter a Muslim or a Buddhist or whatever it is. But if you have the feeling—and I read this in the current political situation—if you feel non-resonantly connected to the world, if you feel alienated then your stance is 'I do not want these Muslims here', then you are closed to difference. I really think the political problem here might be tied to a lack of self-efficacy.

**TL/RC:** Doesn't ideology also often work through resonance? Creating a group identity or a community can also be a way of creating resonance. So of course, when you are

afraid of the world, you might say 'I do not want Muslims in my neighbourhood' but it might also be that you have a tight community, e.g. in a small village, and when someone enters you cannot form this resonant relationship because of the kind of community you are in.

**HR:** Empirically this seems wrong to me. There is research that indicates that anti-immigration feelings are not strongest in tight knit, old communities like peasant villages, but in the commuter neighbourhoods of the suburbs of big cities where people do not know each other, where they do not have a community. That is exactly the point where they may feel that they don't have a voice or collective self-efficacy and therefore they turn against strangers. If you have a well-functioning community, then taking in strangers is a rather welcome opportunity. If you have a fear of losing the community, that means you have the fear of losing your own voice. In such a situation you cannot answer, then you are overwhelmed and you feel that you have to give in to the foreigners. That is exactly the anxiety that fuels anti-immigration feelings all over the world. If you feel you have a strong community, a vibrant life, then you are not so concerned that you have to give in. Of course, there might be a point at which you lose your own voice but this is far from the situation we're in. If you have the experience of a resonant community then it is not a problem to take in foreigners.

As for ideology, in my view political ideologies are only successful if they find an axis of resonance—they have to touch on this somehow. But of course, ideologies very soon become a kind of echo chamber. Most ideologies live on resentment and resentment is the opposite of resonance. You even see this in the gestures, in the faces, you hear it in the voices: the whole attitude is repulsive towards the world. Therefore, I think that we can distinguish between a resonant attitude and an ideology which is not resonance, which is a kind of echo chamber based on resentment.

**TL/RC:** You also describe resonance as a kind of emotive response. When discussing recognition, you point out that resonance is closer to Durkheim's notion of collective ef-

fervescence, a kind of collective ecstasy in which members of the collective undergo a process of fusion that is largely beyond their cognitive and deliberative capacities and you also invoke Weber's notion of charisma. Turning to the politics of resonance, this does sound very familiar with regard to current right-wing populism and rather scary. How do you avoid sliding into an anti-rationalist collectivist politics that leaves little room for dissenting voices? Can the desire for resonance that you ascribe to citizens—including to the infamous *Wutbürger* [angry citizens]—really be an emancipatory energy?

**HR:** This question has many layers. To start with, I think that in the case of the *Wutbürger* there is a lack of resonance. The desire for resonance creates the *Wutbürger* and even right-wing populist movements. They feel that they are not heard and not seen: they are not resonantly connected with politics. That is why they say all the time that the politicians do not hear them, they do not speak to them or for them. This is a form of political alienation. Right-wing populists give the promise of resonance: 'We hear you, we see you, we give you a voice.' This is the case with Brexit, Trump, the AfD in Germany. But there is a double fallacy of right-wing populism. The first fallacy is to say that alienation is created by immigrants. If you look at East Germany or Eastern Europe, for example, there are hardly any immigrants. To believe that your deep sentiment of alienation is caused by a tiny minority of Muslims is totally idiotic, it is not a rational explanation. The second fallacy is even worse and consists in the promise of a 'resonance' that is not resonance, but fusion.

I like Erich Fromm's theory because he saw that alienation is the deepest fear of modern individuals. There are two ways to overcome it. One is through fusion: I want to overcome my isolation and fuse with all the others who are like myself and that is what right-wing populism really promises. The idea is exactly the opposite of getting in touch with the Other or some Other. Right-wing populism lives off this idea of being 'against'. Those who support it do not want to hear anyone except themselves and this is normally just one voice—that of the leader. This is an ide-

ology of complete harmony, which is not resonance at all. It is a total echo chamber based on repulsion. Jan-Werner Müller gets this right with his idea that the populists claim 'We are the people and no one else'. 'Whoever is not of our opinion, is not the people.' This is so blatantly non-resonant that I don't think it makes any sense to claim that right-wing populists create resonance.

Resonance is a multi-layered phenomenon and I insist that it is not just cognitive. In contrast to Habermas' and Forst's emphasis on reasons, and in line with William Connolly, there is a visceral and almost bodily quality to politics. So, resonance is something that is always embodied, it is emotional but it is not dissolved from the cognitive element. Resonant relationships therefore also create resonance between rationality and emotivity and the embodied side. So there has to be some kind of rational control and what I tried to develop in the book is the notion that you can only be in resonance with something that is connected to a strong evaluation: something which you are convinced is truly important to relate to and therefore there is of course a kind of rational check. You cannot get into resonance with something you cannot rationally explain as at least potentially valuable.

**TL/RC:** To conclude, here are two more questions on art. First, you already mentioned the notion of 'oases of resonance', amidst an accelerating world, and in the book you also suggest that art might be a possible example. Would the early critical theorists agree? Think of Marcuse's notion of the 'affirmative character of culture', which allows you to temporarily turn away from bourgeois society but thereby also affirms it and conditions it in a way, or of Adorno's rejection of art-as-*Sonntagsvergnügen* [Sunday entertainment]. Should art offer an 'oasis' and thereby affirm the existing order or should it not offer an 'oasis' at all?

**HR:** This is very interesting question. At least I have the intuition that I do not share Adorno's opinion here; as I said, there are moments of art that are more like Plessner's *Rührung*, the sentimentality that I described earlier. It allows us to feel good for a moment. But I also think there is

art that is neither 'high' nor 'low' culture and which is not about having fun or being entertained—I think of my heroes Pink Floyd—but where 'something is going on' or 'something comes across'. If it is only about having fun then it is like Plessner's sentimentality ... like the Hollywood blockbuster after which I want to cry or feel good or sad. This is not about resonance. Art should insist on the transformative element of resonance. You see it even in rock music, where a lot of people say that after listening to a record or going to a concert they have become a different person. Of course, this is only a rhetoric way of speaking but there is some moment of truth here, which points to the transformative effect that art needs to preserve. If it becomes only an 'oasis' like the Hollywood blockbuster then we are lost.

If you really resonate with something then the result is unpredictable. It is not that you are better off on Monday. So even though you might go to the museum on Sunday, just in order to counterbalance the alienating experiences you have during the rest of the week, there may be this one moment, this experience of touching that has a kind of excess meaning, which gives you a sense of a different way of relating to the world. If you don't have such experiences that reinvigorate your sense of the possibility of a different way of relating to the world, then you're really in a difficult situation.

In the book I claim that even on the everyday level of the shop floor work is an axis of resonance. People love to work and they feel self-efficacy in their work. Even in the industrial factory workers say they have a sense of doing good work or making things well, and then they feel the counter pressures of being fast, efficient, and cheap. It is exactly in this resonant experience of work that you develop a counterforce, even a bodily felt resistance. My colleagues in industrial sociology are really struck by this, that people on the factory level say that the problem is that they are not allowed to do their work properly, to do good work. Even under alienating conditions there is therefore this moment of resonance in art as well as in work.

**TL/RC:** You write that much art is an expression of alienation, and Schubert's *Winterreise* is one of the best examples

you give for this. On the other hand, isn't this a somehow limited (romantic or early modernist) notion of art? How about conceptual art, pop-art, and so on? Is it necessarily the goal and/or responsibility of art to offer us 'resonant' experiences? Aesthetically it seems a bit dubious to claim, as you do in the book, that atonal music, abstract art, and fragmented literary narrative show how art can lose its force—how is that more than just an expression of your own aesthetic preference? So, in line with that, how does the concept of resonance here relate to other aesthetic concepts, such as the sublime, shock, the abject, and the like, because those can also be very strong aesthetic experiences, right? Perhaps an aesthetic experience doesn't need to be resonant.

HR: I disagree. I would say that the experiences of the sublime or shock moments are moments of resonance, because you encounter something that is irreducible. Strong evaluation can arise out of the experience—there is something, even in the experience of shock, that gets through to me and even if I don't understand it, it is a voice speaking that may have something to say. Someone will have to convince me that in some contemporary art, like atonal music, there is still this element of experience. Overall, my reflections on art and aesthetic experience focus on the receptive side: how do we experience these works of art? In the moment of strong evaluation, we do not just say that an artwork is innovative, or original, but that there is something there that is truly important in itself and that speaks to us. I have the feeling that this sense is lost in many forms of contemporary art.

## Notes

1 Translated into English as *Social Acceleration: A New Theory of Modernity* (2013).
2 This interview was conducted in January 2018, on the occasion of the seminar *How to Slow Down Life without Stagnating Society: Resonance in an Accelerating World*, organized by the University of Humanistic Studies (UvH) in Utrecht. The authors would like to thank Fernando Súarez Müller for inviting us to do the interview, as well as Noelle Richardson for transcribing it.

## References

— Rosa, Hartmut. 2010. *Acceleration and Alienation: Towards a Critical Theory of Late-modern Temporality.* Aarhus: NSU Press.
—. 2016. *Resonanz: Eine Soziologie der Weltbeziehung.* Berlin: Suhrkamp.

# All in Good Time

Carolyn F. Strauss

Some mysteries can only be penetrated with a relaxed, unquesting mental attitude. Some kinds of understanding simply refuse to come when they are called. ... Knowing emerges from, and is a response to, not-knowing ... the seedbed in which ideas germinate and responses form. ... To undertake this kind of slow learning, one needs to feel comfortable being 'at sea' for a while.

Guy Claxton, *Hare Brain Tortoise Mind* (1997)[1]

### Being at Sea

As I begin this essay, I'm sitting at the edge of the Pacific Ocean, breathing in time with the rhythm of the waves washing in and out. With each breath, my nose fills with the scent of wild plants, the strong odour of kelp, and that distinct smell that is sea air. Looking out, I try to imagine the dense and immense marine ecology that is just beyond my immediate awareness, much of its depths unreachable by humans, the majority of its life forms unknown to our kind. It is an apt analogy for the vast reservoir of 'not-knowing' that Guy Claxton refers to in the quote above and feels like a good place to begin tracking my thoughts about 'the new'.

My reflections on this topic are based on my personal and professional experiences at Slow Research Lab, the creative research and curatorial platform that I founded in 2003 and continue to direct to this day.

Broadly speaking, 'Slow' theory and practice respond to the ever-accelerating physical, social, and technological landscape, offering alternative visions and variant rhythms for reflecting upon and (re-)imagining humanity's place in a complex-interdependent world. At Slow Research Lab, as in Claxton's book *Hare Brain Tortoise Mind*, we use the term 'Slow' primarily to emphasize that a wider spectrum of tools and knowledge are available to us and that cultivating 'Slower' ways of knowing and getting-to-know would serve our species well at this time in our history. The aim of our platform, therefore, is not so much to find an antidote to acceleration as it is to offer examples of—and fertile ground for growing—alternatives to the dominant ideologies and structures of today.

From a Slow perspective, the idea of 'the new' does not feel particularly helpful to contemporary discourse, because of the way it contributes to the unsustainable cultural practices that have wrought so much disruption and discord on our planet. Taken as

an absolute, the very concept implies separation, even hierarchy, a privileging of one position over another, thereby perpetuating a narrative of fragmentation that fails to acknowledge the vast web of relations (living and non-living) in which human lives and activity are embedded. Indeed, when we take up a wider, more holistic, and non-anthropocentric lens—embracing instead complexity, cooperation, and interdependence—we easily come to realize the shallowness of our (predominantly Western) notions of 'value', 'efficiency', 'productivity', 'growth', 'progress', and 'success'. Like 'the new', they are concepts that, in the words of multispecies feminist theorist Donna Haraway, 'sap our capacity for imagining and caring for other worlds'.[2]

By contrast, Slow research aims to inspire both philosophical and practical pathways for recuperating the pieces of a fragmented culture, while also helping to re-locate our existence in balance with and within other living systems and more-than-human time spans. Working with a rich mix of collaborators from a wide range of disciplines, our platform promotes Slow creative processes (and the tangible traces they sometimes yield) as sites of disruption, dialogue, and deepening of understandings. In contrast with linear design processes, ours is an approach that is less deliberate and more intuitive; less predictable, because more imaginative; less rational and more poetic; less conclusive and more friction-full, because more inclusive. All of this is, in our view, quite valuable. First because it equips people to be more at ease with the increasing uncertainty and precarity of contemporary life. And also because the extreme openness it requires is conducive to the more caring culture that we, and the worlds we might imagine, so desperately need.

We may never be able to fathom the depths of the sea, but we can be willing to embrace the unknowable, to go with its flow, and in so doing find ourselves transported to an expanded realm of being in and of the fabric of (co)existence.

> A bog doesn't give up its secrets easily, but it calls you to uncover them nevertheless. The lure of a bog-pool, which beckons you over to look down on its bright mirrored surface, the perfect blue of the sky an antidote to the relentless black of the peat. But when you stand over it (if you make it that far) all reflections disappear; there is only you, and the dark. Reach down with your fingers if

you dare. Who knows what you might touch? Who knows what mysteries you might uncover? To love a bog is to love all that lies buried beneath the surface, buried in its rich, ripe flesh.

Sharon Blackie, *Love Letter to a Bog* (2016)[3]

### Emerging Slow-ly

My perch by the Pacific Ocean where this began offered a moment of pause, an inflection point, in the midst of a densely-packed series of experiences, touching down on three continents in just under two months. As antithetical to Slowness that such a journey may seem, it was brimming with Slow qualities and resonances—not least the synchronicity of chance encounters and tremendous generosity of others (including financial support) without which these travels would not have been possible.[4] Like reaching into the dark and mysterious depths of mythologist Sharon Blackie's peat bog described in the quote above, through each encounter with people and place, I found myself slipping steadily further into the thickness of life.

I spent the better part of the first month traveling through the high desert of the southwestern United States, where I met artists and scientists, ecologists and technologists, geologists and stargazers. What took me to this area was a four-day conference I was invited to contribute to: a convergence of researchers in the sciences, arts, and literature who are in one way or another exploring diverse facets of time, including biological, technological, geological, human, and nonhuman, and more.[5] That made for intellectually rigorous days surrounded by academics and their research, listening, analyzing, debating, learning. After the conference ended, I set off on my own to points north and east. Those further travels included hours on end spent in silence, immersed in magnificent natural landscapes—another form of listening and learning. I enjoyed an intense and inspiring day with students studying humanity's history of creative relationship to the land,[6] I stayed overnight at the utopian 'urban laboratory' Arcosanti and had three days with an elder in the sacred lands of the Navajo nation. Finally, I was invited to spend a long weekend off the grid, very high in the mountains, hosted by a couple of homesteaders who have built their lives there over nearly five decades, slowly and surely, while thinking and talking, making art, raising their children, and cultivating a stunning

array of roses that tumble down the mountainside; well into their eighties and still in love.

Everywhere I went, people welcomed me into their homes, shared their work and ideas with me, fed me, gave me rides to where I needed to go next, extended invitations to come stay again and proposals to collaborate. That I was in so many places I'd never visited, encountering contexts and communities I'd never met before has the scent of 'new-ness', to be sure, and yet that concept feels inadequate to describe the richness of my experiences. Rather, as I was compelled forward by a combination of curiosity and intuition, and ushered along by the kindness of others, I felt not that I was experiencing something 'new', but rather that I was making contact with something very old: a deep sense of belonging, of being caught up in the world, and from there the possibility for a blossoming of awareness, for something as-yet-undiscovered to be revealed, for emergence.

The word 'emergence' derives from sixteenth-century Middle French *émerger* and directly from Latin *emergere*. Both describe a bringing to the light, a coming forth or coming into view, a rising up. In botany, an 'emergent' is a plant whose root system grows under water while the shoots, leaves and flowers grow above the surface—much like how 'new' ideas and insights are supported by the vast store of tacit knowledge that all human individuals carry around with them. In contrast with certain dominant (Western and modern) conceptions of 'the new', the concept of 'emergence' firmly embeds that which is 'rising up' in a thick web of visible and invisible relations. It is a function of complexity through which unexpected, not-yet-known forms or experiences are born. Growth and transformation are held as latent potential—that which has yet to be uncovered, released, activated.

Sharon Blackie's peat bog is deemed murky, inhospitable, and uncooperative by reluctant explorers who search for its 'value' only in terms of its perceived usefulness to humans or so-called 'real estate'. But for those who are willing to probe further, stories and mysteries of rich and resilient being begin to murmur. In the words of a Slow collaborator, the Dutch interdisciplinary artist Maria Blaisse:

> We listen down to a deeper level that already knows a little more than we do, and then there is a connection. All the

possibilities are there. We can enter at the smallest part. Where our expectations are small, but we are awake and listening. The discovery begins.[7]

> In the midst of beings as a whole an open place occurs. There is a clearing, a lighting...
> Only this clearing grants and guarantees to us humans a passage to those beings that we ourselves are not, and access to the being that we ourselves are.
> Martin Heidegger, 'The Origin of the Work of Art' (1935)[8]

**Disruptive Unfolding**

Another one of our recent collaborators, archaeologist and design educator Uzma Rizvi, tells the story of the moment when as an undergraduate she decided to pursue the field of archaeology. As a bevel-rimmed bowl from Mesopotamia was passed around the classroom from person to person, her fingertips slipped into the grooves carved out by the fingers of the potter who had made the artefact 5000 years earlier. In sensing the tangible presence of that 'other' body, she discovered that her own presence transported across a vast expanse of space and time. In 2016, Rizvi elaborated further on this in her essay 'Decolonization as Care', where she calls for an intersectional approach to contemporary identity:

> ... in the construction of ... knowledge, once care is invested in the landscape, a different kind of research emerges. The moment you touch a landscape, the moment you touch the soil, the moment you think about mudbrick, or work with mudbrick, you know it, and know it intimately. There is a different kind of reflexivity and criticality that enters into our understanding of ourselves. It is almost as if the mudbrick makes it okay not to know everything about it, but rather, it invites us to take it as another intersubjective reality and get to know it over time.[9]

Not surprisingly, the field of archaeology offers many such useful lessons and metaphors for knowing (and getting to know) ourselves as beings intricately interwoven within spatial and temporal relations. I seized upon the Heidegger quote above in an essay by archaeologist Matt Edgeworth that explores the parallels

between Heidegger's philosophy of *Dasein*—'being' (or literally 'being there') and the evolving nature of the self—and archaeological excavation. Edgeworth describes that meticulous, step-by-step process conducted by archaeologists in terms not only of 'unearthing', but also of 'unfolding': 'There is an unfolding of material ... of the already known and the half-expected but also of surprising and contradictory evidence—even sometimes the completely unknown.'

Here too emergence is a key concept. 'There is an ever-present feeling of imminence', Edgeworth says, 'of something about to happen, of things-yet-to-emerge shortly to come to the surface.'[10] But he takes it further, arguing that in this process there also lies the potential for a bursting into consciousness of something wholly unexpected, whereby 'objects and patterns from other cultural worlds break into our social and political space.' Using Heidegger's metaphor, he says: 'Something that was previously buried comes crashing into the light.'[11] (Heidegger referred to this as being 'struck by openness'.) And, having experienced this firsthand as a practicing archaeologist, he is emphatic about the transformative power of those unsettling moments for the one who is doing the 'digging', stating, 'It is through encountering such emergent and unfolding entities—with all the resistance, recalcitrance, and sheer otherness that they sometimes present—that we truly encounter and transform ourselves.'

Artists and philosophers alike have long been fascinated by rupture or disruption as a means through which the status quo is challenged and subverted, and whereby alternative perspectives and forms of living are revealed. More recently, many more have taken up the charge not only to disrupt, but also to embrace—and thereby leverage—the disruptive forces that surround us. One of the most articulate and persuasive purveyors of that position is Donna Haraway (already referred to earlier here), whose most recent book, *Staying with the Trouble*, was one of my companions along the journey I've been describing. Haraway points to the ways that the conditions of uncertainty and real danger posed by the times we live in also offer an opportunity for collective expansion. She compares humanity, the larger systems in which we are embedded, and the crises we face to compost: a 'tangled knot' of diverse bodies that melt and merge and heat up. A rotten pile-up that, as it decomposes, holds the key to recomposing our world together. 'We require

each other in unexpected collaborations and combinations', she says, 'We become *with* each other or not at all.'[12]

Haraway was on many people's minds and lips at the densely-packed research conference I described earlier here. Among the many people I encountered there was Brett Zehner, a graduate student in theatre arts and performance studies at Brown University. Zehner is investigating 'the performative dimensions of atmospheric sciences and the power of geophysical forces in choreographing the social'.[13] Noting that an increasing number of weather scientists who chase storms also are trained as first responders, Zehner believes that instances of natural disaster can both force a reinvention of human thought and serve as test sites for new forms of living together; specifically, he proposes that disaster events offer 'temporal breaks' within which a more conscious and caring theatre of coexistence might play out—literally in the eye of the storm. The chaser, he says, is not a 'witness', but rather a 'with-ness', joining with the storm in an embodied intimacy.

Whether or not Zehner is responding directly to Haraway's prompt, his is a variety of critical and creative project that makes the kind of 'trouble' she insists on: one with inherently unstable foundations, without known or prescribed narratives, steeped in discomfort and uncertainty. These are the ideal conditions, Haraway would say, for the kind of 'generative friction' through which processes of emergence, unfolding, and becoming are enabled: like compost that steams and stinks until it eventually gives way to nutrients and rich, fertile soil.

> cross the borders of your origins
> feel change
> lose track of time
> leave comfort
> open up to unknown plains
> with all your senses...
> Travesía Paraiba Brasil (2017), e[ad] PUCV[14]

### A Return to Not-knowing

In the midst of my travels in North America, I received an extraordinary, last-minute invitation to deliver a talk at a conference in Santiago de Chile. With this stroke of opportunity, a few weeks later I found myself on a different continent, in a different hemisphere, in a city where purple flowers filled the trees even

as winter was taking hold on the side of the planet where I normally live.

And so it was that I made my way to the Open City (*la Ciudad Abierta*) in Ritoque, Chile: a site of artistic and architectural experimentation established in 1970 by a group of architects, artists, engineers, and poets. On a 270-hectare site, situated in the dunes between sea and sky and mountains, architectural forms emerge and grow (and sometimes disappear again) in continuous dialogue with the inhabitants, with the elements, and with time. Operated as a cooperative, with no private ownership, it is a dynamic, open, collaborative system of people and place with the fundamental goal of discovering new forms of living, working, and studying. As I traipsed through the dunes one morning at sunrise, I was moved by the peaceful simplicity and yet amazing resiliency of this place, diligently maintained at a remove from contemporary society in order to, in the words of its founders, 'carry out the tasks that we consider most important for building our world'.[15]

The philosophy and practices of the Open City are the basis for the curriculum of the School of Architecture and Design of the Pontifical Catholic University of Valparaiso (PUCV), located 20 km down the coast in the city of Viña del Mar. In addition to actively engaging at the Open City site, a central part of the curriculum is an embodied practice called the *travesía*: a 'voyage of unveiling' achieved by crossing through a given area of land over a period of two weeks or more. (The first *travesía*, performed by the Open City's founders, was longer, covering a distance of 5,000 kilometres.)

The *travesía* is a creative wandering, a Slow and deep immersion in landscape, as well as an 'improvisational theatre of building'[16] undertaken by students and teachers of the school each year. As they explore sites across the South American continent, participants are invited to shed their preconceptions of what a given place might be and instead seek to 'enter' the landscape and its conditions in a more primal way, thereby re-encountering the land in its pre-colonial sovereignty. Each journey is punctuated by 'poetic acts' (*actos poeticos*), which include experimentation with language, the body, and the erection of physical structures. Those acts, like the intentionality of the archaeologist's trowel referenced earlier, are what drive the people and their project forward. In the words of one of the school's founders, 'The act

engenders the form; like a pen stroke which, put to the light, orients the normal indifference of the directions.'[17] In other words, the agency of the participants—which may include the decision not to act—has direct physical and perceptual consequences, and possibly even leads to longer-term shifts in the domain of culture and knowledge.

The *travesía* is a valuable model for all manner of creative practice, not least in that its vibrancy and unpredictability are predicated on risk and an insistence on what the Open City's founders called 'returning to not-knowing' (*volver a no saber*). Again, the emphasis on discovery and imperative to maintain the aliveness of the quest have the quality of 'newness', but the fact of this return—that every journey is 'away and back'—defies the idea of separateness and even of chronology that 'the new' might imply. Rather, creative practice is a reflexive process that serves as an instrument for deepening into an existing system that is understood as inherently dynamic: expanding and contracting, growing and changing, emerging and sometimes receding again, returning to zero. Human activity thus asserts itself not as a thing apart, but rather within an ever-evolving ecology, as a participant in its rhythmic and varied state of being. Like a dance, a continuous flow and interchange. Of intention and action. Of rigorous practice and poetic contact. Of becoming and then becoming still more.

> Situate yourself at the very end of the branch,
> the fragile new,
> the fragile to become.
> Jóhannes Dagsson, 'In the Willows' (2016)[18]

### Fragile Becomings (Becoming More)

With the quote above from Jóhannes Dagsson, I tentatively insert the word 'new' into this essay in a more forgiving light. His image of a delicate place where a tiny bud is emerging is one I'd like the reader to take away, along with the feelings it evokes of tenderness and vulnerability, anticipation and promise, patience and right timing.

A while back, I began thinking of our research platform as a 'vessel': both in the sense of a ship on which to navigate the seas of (Slow) possibility, and also in the sense of a container—a space apart—that resides outside of the pressures of acceleration, 'innovation', and the so-called creative and cultural industries.

Not to escape or shy away from the crises we face today, but rather to carve out much-needed time and space in which to nurture more holistic perspectives in relation to those challenges and an expanded palette of tools with which to respond to them.

On the opening page of *Staying with the Trouble*, Donna Haraway writes: 'Our task is to make trouble, to stir up potent response to devastating events, as well as to settle troubled waters and rebuild quiet places.'[19] Our platform answers that call by facilitating spaces and encounters that are arenas for dialogue, thereby serving (we hope) as seedbeds of emergence and catalysts to transformation. Importantly, whether a retreat, a workshop, a performance, or some other form of gathering, we aim to offer the kind of the 'quiet places' Haraway refers to. Spaces that invite people to drop out of the consensus of 'time' and into a different tempo and/or temporality. Supportive environments in which to reflect critically and poetically. Safe havens in which to cultivate ways of being and becoming beyond absolutes and the 'tyranny of certainty'.[20]

Perhaps most crucially, they are spaces to, in the words of our wonderful collaborator Alessandra Pomarico, 'Practice practice practice!'[21] Inclusion. Trust. Curiosity. Play. Intimacy. Empathy. Not-Knowing. Care. These are qualities of human being-ness that all of us need to cultivate if we desire a more positive turn in our individual and collective development. The practice of each one is like that tiny bud emerging at the tip of the willow branch, fragile and tentative at first, but then slowly growing beyond mere promise to resilience; like the willow: graceful, flexible, and deeply rooted.

And finally, when we shift our modes of being toward practice, exposing ourselves to the myriad forms of 'becoming' it enables, something essential opens up. We are gentler with ourselves and with others. We are more appreciative of what we have. We remember to move ourselves out of the centre of things every now and again, stepping aside to make way for whatever mystery might be unfurling in our midst. And we acknowledge our agency and responsibility as active ingredients in a thick brew of potentiality, with strong hints of what scholar Nathanael Mengist calls 'alchemical presence'[22]—the kind of magic by virtue of which vibrant life and possibilities for living are certain to emerge... Slow-ly.

The deadline for completing this essay is looming, even as the text itself advocates processes of unfolding. And so here it is, still slightly unformed, with room for improvement and elaboration. But now present, tangible, as a marker of my becoming, and an artefact for your reflection.

All in good time.

# Notes

1 Guy Claxton, *Hare Brain Tortoise Mind* (New York: Harper Perennial, 1997), pp. 6–9.

2 Donna Haraway, *Staying with the Trouble* (Durham: Duke University Press, 2016), p. 50.

3 Sharon Blackie, 'Love Letter to a Bog', posted on www.caughtbytheriver.net/2016/04/07/love-letter-to-a-bog-dr-sharon-blackie-irish-folklore/.

4 It should be noted that I recognize the tremendous privilege of my position, and I certainly don't take it for granted. At the same time, I have come to trust in a different kind of 'economy', one where my personal investments of time and open sharing of knowledge (without expectation of reciprocation or compensation) often come back later as wonderful opportunities such as those I'm describing here.

5 The Society for Literature, Science & the Arts 2017 programme 'Out of Time' took place at Arizona State University in Tempe (US), 9–12 November. See https://litsciarts.org/slsa17/.

6 'Land Arts of the American West' is a programme within the Department of Art and Art History at the University of New Mexico. See https://landarts.unm.edu/

7 Maria Blaisse and Siobhán K. Cronin, 'Form as Passage: A "Pas de Deux" between a Designer and a Dancer', in *Slow Reader: A Resource for Design Thinking and Practice*, ed. Ana Paula Pais and Carolyn F. Strauss (Amsterdam: Valiz, 2016), pp. 169–178, p. 173.

8 Martin Heidegger, 'The Origin of the Work of Art' (1935), in *The Continental Aesthetics Reader*, ed. Clive Cazeaux (London and New York: Routledge, 2000), pp. 80–101, p. 95.

9 Uzma Z. Rizvi, 'Decolonization as Care', in *Slow Reader: A Resource for Design Thinking and Practice*, ed. Ana Paula Pais and Carolyn F. Strauss (Amsterdam: Valiz, 2016), pp. 85–95, p. 92.

10 Matt Edgeworth, 'The Clearing: Archaeology's Way of Opening the World', in *Reclaiming Archaeology: Beyond the Tropes of Modernity*, ed. Alfredo González-Ruibal (London and New York: Routledge, 2013), pp. 33–43, p. 41.

11 Edgeworth argues elsewhere that Heidegger's notion of the clearing likely was derived from archaeological discoveries of his day, which were said also to have influenced his teacher Edmund Husserl: 'In reading and absorbing Husserl's writings, Heidegger inevitably absorbed the half-buried, largely tacit archaeological metaphors embedded therein.' Edgeworth, 'The Clearing', p. 34.

12 Haraway, *Staying with the Trouble*, p. 4.

13 Brett Zehner, 'Machine Weather: Atmospheric Media, Storm Chasing, and The Counterperformativity of the Earth', in SLSA 2017 conference programme (7 November 2017), p. 16.

14 'cruzar las fronteras de su origen | sentirse cambiar | perder la nocion del tiempo | dejar la comodidad | abrirse a llanos desconocidos | con todos los sentidos'; fragment of a poem collectively written by students during a 2017 travesía in Paraiba Brazil led by Andrés Garcés. Translation by Lotte van Gelder.

15 Official statement of the legal entity under which the cooperative is held, the Amereida Cultural Corporation (Corporación Cultural Amereida).

16 Mary Ann Steane, David Jolly, and D. Luza, 'Found in Translation? Reconfiguring the River Edge of Cochrane, Patagonia, a Travesía Project of the Valparaíso School Led by David Jolly and David Luza, November 2013', *Brookes eJournal of Learning and Teaching* Vol. 8, Issues 1 and 2 (April 2016).

17 'El acto engendra la forma; como el trazo que, al ser puesto a luz, orienta la normal indiferencia de las direcciones'; Alberto Cruz, quoted by Vittorio di Girolamo, 'Los Locos de Valparaíso', qué pasa 18 October 1972, p. 49.

18 Jóhannes Dagsson, 'In the Willows', in *Willow Project*, ed. Tinna Gunnarsdóttir (Reykjavik: Partus Press, 2016), p. 15.

19 Haraway, *Staying with the Trouble*, p. 1.

20 I first heard the phrase 'tyranny of certainty' in conversation with data scientist Siobhán K. Cronin during a 2016 Slow research retreat (CA, US).

21 Alessandra Pomarico, 'Situating Us', in *Slow Reader: A Resource for Design Thinking and Practice*, ed. Ana Paula Pais and Carolyn F. Strauss (Amsterdam: Valiz, 2016), pp. 207–225, p. 221.

22 As part of his doctoral thesis-in-process, Nathanael Mengist is working on a comparative history of alchemy. He explains, 'As an intensive, transgressive, and sublimely *ontoethical* act, believing in alchemy can reinvigorate our ways of knowing and becoming.'

# Accelerating the New

## An Interview with Nick Srnicek and Alex Williams

Lietje Bauwens,
Wouter De Raeve &
Alice Haddad

With '#Accelerate: Manifesto for an Accelerationist Politics' (2013), Nick Srnicek and Alex Williams initiated a new leftist political movement based on a critique of what they call 'folk politics'—the contemporary left-wing leitmotiv that tries to tackle global issues by scaling them down to tangible local actions, such as the collective occupation of public spaces or the promotion of self-sufficiency as the holy grail for a sustainable lifestyle, encompassing all kinds of local and horizontal resistance that stems from a desire to slow down as a medicine against an increasingly complex and faster Western society.

In their publication *Inventing the Future: Postcapitalism and a World without Work* (2015), they develop their critique further. According to Srnicek and Williams, this kind of small-scale resistance is not powerful enough to generate structural change; on the contrary, it rather appears as if those endorsing such an attitude have given up hope for global progress and have therefore downsized all their efforts to small-scale actions. 'Folk politics' aims to bypass the authority of existing power structures and institutions, but by doing so, its radicality is woefully neutralized and its stronghold tactics—protest, disruption and local action—are continually being absorbed by the system it seeks to resist.

In their manifesto, Srnicek and Williams suggest the idea of 'acceleration' as a counterproposal—an 'accelerationist politics in line with modernity, abstraction, complexity, and technology'. For actual progress to persevere, the alienating mechanisms of capitalism must be 'accelerated'. Not in order to destroy existing infrastructures, but rather to steer them into new directions. Is it possible to fathom existing power structures and understand how they can be adapted, changed, and appropriated? In other words: is it possible to overcome the existing hegemony?

Accelerationism is not only debated in theoretical realms. It has also percolated into artistic spheres struggling to define their position vis-à-vis what should be considered as 'new'. In a century dominated by mainstream and pop culture, what does 'the new' entail today? Following in—and overtaking—the footsteps of past avant-gardist movements and underground cultures, how can contemporary artistic practices be intrinsically subversive and progressive? And, more specifically, does Accelerationism offer relevant tools to interpret and reinvent such objectives anew today? In Srnicek and Williams' eyes, the arts have the potential

to endorse a political role that, beyond its fictional characteristic, is able to give form to the conditions that will transfer their visions into reality.[1]

> **Lietje Bauwens, Wouter De Raeve & Alice Haddad:** The *#Accelerate Manifesto* is both embedded in and a continuation of a long-lasting internal academic debate. With your manifesto you moved this discussion into the mainstream. The manifesto's format, as well as content, could in many ways be regarded as a provocation vis-à-vis the intellectual elite—a critique on its exclusionary circle expressed through the desire to break down its walls and include a larger public.
>
> During the last century, one characterized by Grand Narratives and radical ideologies, the manifesto was a favourite method of avant-garde and underground movements to promote their ideas. What does your choice for the manifesto as format tell us about your attitude regarding the relationship between underground and mainstream?

> **Alex Williams:** The reason we chose the manifesto in the first place was because of the powerful nature of the format. The manifesto forces you to write in a firm, bold, and polemic fashion; it doesn't allow the expression of uncertainty nor of thorough qualification. In this sense, it stands in opposition to the current situation in academia, which, even though encouraging criticality, also makes you hesitant to draw any conclusions or proposals. The format of the manifesto is interesting in that it implies a sort of certainty because you are proclaiming and demanding something. So, we had to dismiss all doubts and forms of nuance and appear more confident than we actually were. A manifesto is indeed associated with grand ideas, whether artistic, political, or social. We believe that such ideas should be presented, even if they are still precarious and uncertain. There is a real need for these big ideas today. Both our books, *#Accelerate* and *Inventing the Future*, are written in a way that aims to be accessible and understood without precognition on the subject. I think this is an important aspect of the transition from the underground to

the mainstream; presenting something that can be made your own without too much effort. The mainstream, in contrast to the underground, is within reach.

**Nick Srnicek:** The accelerate hash tag initially started as an in-joke circulating among a small group of friends in London. It was partly inspired by #Occupy and a series of other social movements that also began as hash tags, but the manifesto was a shift from this in-joke towards something much bigger. We initially presumed it would interest a reasonably self-selected audience. It only became more broadly spread when our friend Peter Wolvendale decided to put it online and promote it drastically. One could say this was its transition from the underground towards the mainstream, reaching a larger audience than we would ever have imagined. However, the continuous dispersion of information contributes to the vanishing of a clearly delineated underground. Everything becomes increasingly easier to access and thus becomes part of the mainstream much faster.

**LB/WDR/AH:** Is such a fading distinction between underground and mainstream necessarily negative? From a political perspective, you criticize folk politics as being the nostalgic leftist reaction to political complexity. With the term 'folk politics' you refer to local and horizontal forms of resistance that fail to adequately challenge and influence the institutions they are opposing, partly because their radicalism is being co-opted by the power structures they try to defeat. Could we speak of the reactionary attitude that seeks to protect a clear demarcation of the underground as 'folk underground', one could say in the sense of a fight against change?

**AW:** We use the term 'folk' to indicate an aesthetic interpretation of locality and immediacy. In other words, folk politics is the fetishization of the idea that it is possible to create a separate 'authentic' space *outside* of capitalism. 'Folk underground' could mean something similar: the longing to exist next to the mainstream culture, without being able to really influence it. Since nowadays 'underground' is being fanatically deployed as a buzzword for

commercial purposes, the effort to convulsively hold on to the underground only concedes to the neo-liberal logic. In *Inventing the Future,* we talk about food politics and the obsession with *healthy, local,* and *slow food* and this exemplifies that the folk attitude isn't limited to the political realm and draws on aesthetical and cultural understandings fuelling a nostalgic discourse on authenticity and de-scaling.

Nonetheless, I would be defensive of an artistic and cultural, rather than a political underground because of how it could enable change by putting up barriers to a broader culture. The creation of spaces where *new,* not just *different,* ideas can emerge is necessary. But this shouldn't be sufficient; the generated criticism and imaginaries need to be deployed beyond their marginal communities to bring forth progress.

**LB/WDR/AH:** Isn't such an underground where new ideas can emerge exactly the opposite of the accelerationist concept that political action can only occur from the inside out—that there can be no 'outside'?

**AW:** Eventually, I believe that actual structural change can only be accomplished from the inside out. Even though we criticize folk politics, it is a misunderstanding that we dismiss bottom-up practices altogether. All political action originates locally, but folk politics doesn't manage to go beyond this phase. We are for example invested in helping grassroots movements to become more powerful by creating a connection with top-down structures.

In order to do so it is important to bring people together and to make them aware of common interests, so that they do have a common plan of action; to create forms of self-organization under the guidance of established, and therefore more powerful, external organizations. How people self-organize is in line with existing ideas and methodologies that are available to them. By influencing this we can change how collectives arise and act. In a sense, an 'underground' is needed that functions as a (temporary) place where ideas can arise. By this I do not mean a 'pure' outside where the forces of power structures

are not applicable, but a space for experimentation within the already existing structures.

**LB/WDR/AH:** Does the creation of such an underground within the mainstream require a change of discourse in which not locality and authenticity but rather a more pragmatic and large-scale tactic is promoted? The obsession with an 'anti-attitude' is not only visible in politics but also in the art world—think of anti-fairs, DIY art collectives, an aversion to subsidies, and the continuous search for new autonomous places. As we discussed earlier, a folk underground attitude appears that tries to resist existing institutions, organizations, and forms of representation in the hope of being able to maintain a real 'outside'. Is it at all possible, and perhaps even necessary, to create an underground that does try to resist mainstream but dares to learn and benefit from its successes?

**AW:** These are indeed examples of an admiration of marginality, as if it were a goal-in-itself. This attitude is rooted partly in a fear on the side of folk politics to be eaten up by the very vertical powers it aims to resist, and, secondly, a fear of folk underground to make concessions towards the mainstream or the market. Such struggle, however, is extremely precarious. Hence, what we have to strive for is a more decisive fight where ideas aren't merely adjusted to the mainstream, but where the mainstream is on the contrary shaped by these ideas. We argue in *Inventing the Future* that folk politics can learn from neo-liberal tactics. Actually, the first meetings by those who initially elaborated neo-liberal ideas were completely underground. They evolved from marginal, even despised, figures to those who created an all-encompassing ideology. Such evolution by itself is already worth studying. This doesn't mean their methodology has to be copied as a whole but what interests us in its analysis is how it aids in defining a long-term and large-scale strategy.

**NS:** I think Adorno had a point when he was defining the mainstream as serving commercial purposes, which is absolutely true of contemporary capitalism. But the

mainstream doesn't have to be defined in commercial purposes; it can be defined in a broader sense, a sheer quantity of people for example. If you're in an artistic underground position, you can still learn from distribution tactics, branding tactics, without necessarily having to wholesale into the commercialization of these ideas and practices. Examining how this is achieved is useful; at the same time, we know that some of these tactics are inherently linked to power structures and class relations we want to get away from. So, once again, it is as important to learn from mainstream and vertical strategies as to remain critical of them.

**LB/WDR/AH:** You write in your manifesto: 'The existing infrastructure is not a capitalist stage to be smashed, but a springboard to launch towards post-capitalism'...

**AW:** Many different interpretations of Marxism argue that it is impossible to take on a critical position within capitalism, and that capitalism should therefore be completely destroyed before it becomes even possible to envision an alternative world. We view this as both not true and also practically inconceivable. We think capitalism is a series of interlocking institutions, technologies, and beliefs that together work to reinforce the dominant system, but this can potentially be investigated and changed in order to affect capitalism in different stages of development from the inside out.

**LB/WDR/AH:** In *No Speed Limit*, Steven Shaviro criticizes the concreteness of your plans and models, which according to him fundamentally opposes the speculative character of acceleration. In addition to speculation, pragmatism is also a prime ingredient of accelerationism. Do we detect some sort of contradiction here?

**NS:** Interpreting pragmatism and speculation as a contradiction is based on the binary metaphysical conception that the future is either completely uncertain or completely predictable. Reality, however, is more diffuse; the fact that we can perceive uncertain situations around us does not mean that we cannot have precise ideas about what needs

to be done and how it should be done. Climate change is a good example; we have fundamental uncertainties about ecology and the climate system, but we can still make predictions about, for example, how temperature will change in the next hundred years. Being conscious that these two are not at odds with each other is absent in the political debate. We want to combine contingency and pragmatism; it's impossible to evolve without any kind of navigation. It is necessary to make plans and proposals, even if you are not completely sure about chances of succeeding. Only ideas that are formulated can be criticized and bent into action. The creation of a speculative horizon is necessary for a pragmatic action and, at the same time, such an abstract imagination arises only when the first pragmatic step is taken.

**LB/WDR/AH:** In your manifesto you propose that change can be generated by accelerating the complex (power) structures. Accelerationism received a boost in the nineties by means of the writings of Nick Land who approached such an attitude from a right-wing perspective *against* capitalism but *in favour of* the free market.[2] You blame him for confusing speed and acceleration. However, do you in turn not confuse acceleration with innovation? In other words: acceleration implies an increase of speed in an existing direction, where innovation also can mean a complete change of direction. In her contribution to the *#Accelerate Reader*, Patricia Reed presents new formulations of 'accelerationism', which, according to her, should address a reorientation of existing energies as yet unexplored directions. She aims to crack existing dichotomies in order for countless new combinations, ideas, and constructions to arise. It is striking that in *Inventing the Future* the term 'acceleration' is not mentioned at all. Today, how do you relate to this term, the debate initiated by your manifesto, and the *Xenofeminist Manifesto* by the collective Laboria Cuboniks, which can be seen as one of its outcomes or continuations?[3]

**AW:** The term 'acceleration' has indeed proven to be very problematic. It implies that people only interpret our manifesto as a plea for acceleration, which narrows down the

debate. The manifesto, and the term 'acceleration' as such, was intended as a polemic intervention, a strategic provocation.

NS: The physical definition of acceleration is that it can also be a repetition, a complete change or new direction. But it's also regrettable to reduce the debate to a game of definition. We fully support Reed's interpretation; speculation and fictionalization are much more useful ideas for thinking about progress. The *Xenofeminist Manifesto* pushed further than we did; with their emphasis on 'alienation' they took an important step that we can only encourage.

LB/WDR/AH: Soon after the publication of your manifesto, accelerationism was picked up by the (visual) art world. Via the 9th Berlin Biennale in 2016, the New York collective DIS injected the theory into the mainstream and promoted artistic interpretations of accelerationist ideas addressing technology and the future to the general art crowd.

We already discussed a couple of misconceptions of the accelerationist theory, such as the integral rejection of bottom-up movements and the literal interpretations of 'acceleration' as speeding things up. Are you concerned that these misconceptions could be intensified by simplifying or selective translations of the theory in such 'accelerated' aesthetics?

AW: I have an aversion to the term 'acceleration art'. It assumes that one can distil a certain aspect and subsequently apply it to art. A striking example was an artist who developed a literal acceleration in a gallery. The visitors were directed to speed up every so metre, resulting in an audience that eventually was sprinting through the room at high speed. The relationship with the art world is in that sense very ambiguous. On the one hand, it is a place where the new is embraced and can be developed and, on the other hand, this obsession gets in the way of a thorough and integer relation with theory.

NS: Another example of such a short-sighted interpretation are works that solely aim to show the complexity of

systems. They enter the category of what we call 'complexity porn'. In the aftermath of the 2008 crisis many artists conceived artworks that exposed the elusiveness of the financial system. These works confirm the idea of 'over-complexity' but do not provide any tools to change this. This has a paralyzing effect and in turn can have political consequences.

**AW:** Accelerationist art should not focus on aesthetics—on creating something that merely looks different and new—but address a new way of looking at the world; reconstructing it in an imaginary way. Reflecting about this in a speculative and fictional way, especially in art or science fiction, is of great importance. Design influences the way we collectively look at the future and relate to it. The term 'hyperstition' covers this task: a combination of the words 'hype' and 'superstition' meaning as much as fictions that give form to conditions in such a manner that they make themselves into reality.

**NS:** It is not about presenting robots and 3D renders in artworks but about the creation of a new approach—an abstract alienation that makes it possible to view the world differently. The figurative far too easily falls into the pitfalls of clichés; the liberation rather lies in finding new forms of abstraction.

We would regard strategist and designer Benedict Singleton as a good example. He developed a model for a new sort of parliament in the digital age, investigated with former military operators how a shared future could be developed for tourism and terrorism, and explored the possibilities of a pilot project on universal basic income in Great Britain. Singleton interprets accelerationism as the idea that we can never completely free ourselves from the creation of plots, i.e. storylines. We are trapped in a trap that is overpowering; the only option we have is to create a new storyline—a new trap—and in that sense to 'flee' from one trap to a better one.

**LB/WDR/AH:** Isn't this exactly what the British philosopher Benjamin Noys reproaches you in his book *Malign*

*Velocities*, that accelerationism, eventually, only shows us how we are trapped?

**AW:** That would be the case if it would not be able to escape the trap at all. We have the freedom to do certain things, to withdraw ourselves from different positions, to develop a new and better reality within the traps. Mankind is embedded in this world and our idea of freedom is that certain forms of attachment and devotion are cultivated instead of trying to withdraw from them.

This matches well what possible mission a new kind of underground within the arts could entail. Srnicek and Williams believe in an interspace free of confines that does not turn away from the mainstream, but rather settles in the middle of it and thus aims to imagine a different future from within beyond fixed contradictions. Such a contemporary underground uses the power of structures just like a judoka uses the strength of his opponent. We hav e to move forward—not under the ground, but in the ground.

# Notes

1  This interview was conducted on
22 October 2016 in Brussels, on the
occasion of the seminar 'FASTER/
SLOWER/FUTURE, towards
postcapitalism' at Kaaitheater.

2  The British philosopher Nick Land
developed his thought within CCRU
(Cybernetic Culture Research Unit),
an almost mythical collective that
emerged at Warwick University in the
1990s. From a nihilistic point of view,
Land advocated an uncontrolled and
free market, which would ultimately
lead to the destruction of capitalism,
humans included.

3  In 2015, the—at the time anonymous—
collective Laboria Cuboniks published
its *Xenofeminist Manifesto* on line,
not least out of dissatisfaction with
the masculine tone of the *#Accelerate
Manifesto.* Whereas the *#Accelerate
Manifesto* searches for approaches to
deal with the accelerating tendencies
of the twenty-first century, the collective
Laboria Cuboniks focused on the
notion of an alienating 'xeno' within
the context of an ever faster and more
technological society. The *Xenofeminist
Manifesto* formulates a provocative
call to fully engage and discover what
potentialities the unknown entails, not
as something to be rejected but rather
as the fertile ground for what is yet to
imagine.

# Accelerationism as Will and Representation

Benjamin Noys

## Going Faster Miles an Hour

We are used to the argument that we live at a time of social acceleration.[1] Technological, social, and political change, we are told, leaves us living accelerated lives. In response, we often see calls to slow down so we can take back control of our lives; from the 'slow food' movement to the 'slow professor' movement, deceleration is seen as the way to return to human time. In contrast, the accelerationists have argued that we need to go faster. Inspired by the call of Gilles Deleuze and Félix Guattari to 'accelerate the process',[2] accelerationists suggest that the future is one in which we transcend the human and integrate with the machine. The aim of the accelerationists is to engage with technology and forms of capitalist abstraction so we can invent a new post-capitalist future.[3] This engagement has taken, as we will see, very different political forms. It has also resonated within the art world. The attention of accelerationists to the uses of technology and forms of abstraction has galvanized a debate about what an accelerationist art might be.[4]

The challenge of accelerationism has been one that insists we think and theorize our present moment and our practice in light of the global forces and forms of capitalism. While I have been highly critical of accelerationism,[5] this challenge remains one that deserves critical consideration. In terms of artistic practice there is, currently, little work that is explicitly accelerationist. The laptop musician Holly Herndon's album *Platform* (2015) is influenced by accelerationist ideas,[6] but the answer to the question of what an accelerationist art might be remains hanging. Steven Shaviro has suggested that we see accelerationist works as those that explore the limits of capitalism by tracing the dystopian trends of the present.[7] One of Shaviro's examples is the film *Gamer* (2009), with its vision of future videogames that involve the control of live humans as players, but we could also consider the extrapolations of Charlie Brooker's TV series *Black Mirror*.

My argument is different: that the accelerationist strategy was *already* aesthetic, and so we need to understand and criticize accelerationism as an aesthetic phenomenon. Certainly, accelerationism was, from its inception, concerned with aesthetic forms to demonstrate acceleration. The centrality of electronic dance music to accelerationism, as an example of speeding-up and innovation, is key, as is the use of science fiction and futuristic imagery. Accelerationism suggests we need such images, as neo-liberal

capitalism cannot offer us a future, only more of the same. In the words of Mark Fisher, 'the 21st century is perhaps best captured in the "bad" infinity of the animated GIF, with its stuttering, frustrated temporality, its eerie sense of being caught in a time-trap'.[8] If capitalism cannot provide us with a future neither can the left, according to the accelerationists. The left has given up on imagining the future due to its focus on a 'folk politics', a politics of 'neo-primitivist localism' that remains concerned with local or communal forms of resistance that looked to the past, according to Nick Srnicek and Alex Williams.[9] The very title of Srnicek and Williams's book, *Inventing the Future*, suggests the need to 'invent' new images of the future.[10] For accelerationism, the question of the future is a question of the image and of an aesthetic imaginary that can render a persuasive image of the future.

This notion of accelerationism as an aesthetics extends to the name itself. Patricia Reed, in a thoughtful discussion of the vicissitudes of accelerationism, has noted that 'The surging popularity of #Accelerate (in both positive and negative senses) would not have functioned under a more accurately modest label of #redesigninfrastructureinstitutions technologyideologytoward-sotherends'.[11] In fact, I would suggest '#Accelerate' and 'accelerationism' have had such success because they are aesthetically attractive terms—they provide a catchy term and a vision. The use of the hashtag also embodies the sort of technological engagement that accelerationism claims as its domain.

My argument is that accelerationism is an aesthetic that cannot think its own aesthetic form. Accelerationism, in proposing itself as a political strategy driven by images of the future, tends to a manipulative and authoritarian vision that, ironically, disregards the problems and tensions of art. To explore and criticize accelerationism I will focus on its two main variants: right (or reactionary) accelerationism, which regards the acceleration of capitalism as its main business, and left accelerationism, which aims to navigate through technology and abstraction to a post-capitalist society. My analysis will focus, in both cases, on three points of tension: the subject of acceleration,[12] the temporal model of accelerationism, and finally the resulting politics. While not disregarding the difference in political orientation, my suggestion is that accelerationism converges on a politics of will, as expression of the desire to accelerate, and various fictions, which are then supposed to motivate this will to accelerate. The problem

with this politics lies in its aesthetic manipulation of reality to create, or to try to create, its desired effects, especially in forging a bridge between our fallen present and the desired future. This transformation of politics and the world into an aesthetic matter neglects the ways in which artistic practice engages with its material, and offers a politics that is driven by an irrational celebration of powerful images.

### Cthulhu Capitalism

It sometimes appears that right accelerationism is a camp of one, the British philosopher Nick Land who worked at the University of Warwick in the 1990s and early 2000s with his colleagues in the Cybernetic Culture Research Unit (CCRU) before becoming a journalist in Shanghai.[13] Land's ideas have been disseminated widely and he has become the figure of 'renegade academia'.[14] In the 1990s, Land argued that: 'Machinic revolution must therefore go in the opposite direction to socialistic regulation; pressing towards ever more uninhibited marketization of the processes that are tearing down the social field.'[15] While aiming to push capitalism to 'meltdown', such a position implies this meltdown would result in a purified capitalism unleashed beyond any limit. More recently, Land has turned to an explicitly reactionary position as one of the leading thinkers of the 'dark enlightenment'.[16] Now, the meltdown of capitalism into a pure state is linked to the resurgence of hierarchy, often racial in form, opposing those who embrace the anti-humanist powers of capitalism to those who refuse or are unable to 'accelerate'. The right-wing libertarian philosophies of Friedrich Hayek and Ayn Rand are articulated with a technological fascism.[17]

Right-wing or reactionary accelerationism has a straightforward answer to what is the subject of accelerationism: capitalism. Shearing Marx's celebration of bourgeois dynamism from any revolutionary dialectic, this current places capitalism as the accelerator par excellence, through hymning the 'productive forces'. The role of the human subject in this configuration is as an accelerator of these forces or, more radically, that of one who submerges and dissipates into the fluxes and flows of global capitalism. In such a resolutely anti-humanist worldview, however, it is difficult to see how the subject can exercise their will over these supra-human forces. Instead, the call is for a will to extinction.[18] Of course, the problem then remains of how this call is to be made.

The right accelerationists call for the abandonment of the 'meat' of the body, but this demand comes from the 'meat' of the body. We can see this in the obsession with the figure of Nick Land. He becomes the embodiment of the 'dark' forces of acceleration, a cypher for the unleashed material forces, and so we have a cult of non-personality. Of course, in its reactionary forms, right accelerationism restores the subject in the figure of the neo-feudal 'lord' of technology—those entrepreneurs and technological innovators called to rule over the 'peasantry' of those who do no accelerate.

Srnicek and Williams have criticized Land's vision, from within left accelerationism, as the embrace of 'brain-dead onrush': a vision of speed, not acceleration, that merely replicates capitalist dynamism.[19] The difficulty for this criticism is that Land and the CCRU do not have a simple model of time as teleology. Instead, time for them is recursive and looping, a 'templex', which accounts for the fascination for time travel narratives, from *Terminator* to *Looper*.[20] Acceleration is realized in the future, but these forms loop back to our present. While this presents a model of time as composed of loops, these loops are all related to the moment of realized 'absolute deterritorialization' located in the future. This is the science-fiction military base of 'Cyberia', 'the base of true revolution, hidden from terrestrial immuno-politics in the future'.[21] So, there is a disavowed teleology, in the sense that the loops are always oriented to a future. This vision of time as multiple loops structured through a science-fiction future ruptures any attempt to model time through a vision of emancipation and replicates the looping circuits of capitalist accumulation and consumption.

Of course, as accelerationism of the right, we should expect nothing less. That said, however, we should pay more attention to the right/reactionary elements of this disruption of time, certainly since whole swathes of twentieth-century thought have located a 'good' durational or disruptive time against a 'bad' linear or homogenous time.[22] The notion of a time richer and superior to the banal time of teleology can offer a critique of the linear notion of progress and capitalist development, but only on the condition of mapping and rationally articulating this 'alternative' form and its relation to the time of value accumulation. Otherwise, this notion of flux can serve to disable our capacity to grasp the complexity of capitalist time and can even celebrate that capitalist time as a superior 'chaotic' form of time. In this second case, a metaphysics

of temporal flux that serves to disable and disenable any scope for future-directed action of a collective and emancipatory type.

The political conclusion might be obvious: this is a politics that welcomes and celebrates capitalism, playing off its false capitalist promise of equality and levelling ('Freedom, Equality, Property and Bentham', as Marx put it[23]) against any left-wing claims to freedom and emancipation. We can add that the reactionary tenor of this politics is already implicit in the celebration of the will to join with capitalism, which separates out subjects and allows stratification. There are those subjects who recognize the power of capitalism and join with it and those who are 'left behind' or who should be 'abandoned'. This later takes a racist, or hyper-racist, form in reactionary accelerationisms,[24] but was already implied in the stratification and selection of 'accelerating' subjects. I also want to add, and return to, the fact that this can sharpen the metaphysical and politics stakes of a counter thought. This is not an argument for debate with these currents, which replicate and repeat many past reactionary tropes and movements, but rather for a recognition of how the door is opened to reaction through these 'complexifications' and 'fractures' of time that have been rendered aesthetically.

### Instruments of Darkness

Left-wing accelerationism, instead, aims at a post-capitalist future. The image is not of a 'purified' capitalism per se, but a socialism or communism that will make full use of productive forces developed by capitalism. It is another sci-fi vision, taking references not so much from *Terminator*, but from various 'utopian' forms of sci-fi. The aesthetics draws on the 1960s Soviet experiments in cybernetics and associated imaginaries of communist space travel.[25] It also, as Land did, draws on claims for the 'inventiveness' of British post-rave dance music, now in the forms of dubstep and grime.[26] These political and aesthetic experiments are seen as prefiguring a technological future of 'red plenty' in the form of full automation and universal basic income. My focus here is on the articulations by Srnicek and Williams in '#Accelerate: Manifesto for an Accelerationist Politics' and in their later book *Inventing the Future*. I do not have space to explore all the differences between the 'Manifesto' and *Inventing the Future*. Briefly, the later book is more carefully expressed than the polemical verve of the 'Manifesto' and even rejects the use of the term accelerationism,

although not its tenets.[27] What I do want to identify is common problems that operate across both right and left articulations of accelerationism.

The problem of the subject for left articulations of accelerationism can be read in at least two ways. In terms of human subjects, we have the problem of who is doing the accelerating and who is being accelerated. Left accelerationists have a vision which is explicitly top-down; of the introduction of the notion of accelerationism which will then grip the masses. Their view of accelerationism is an administrative and aesthetic one, with organized images of accelerationism deployed to seize hegemony, and is strangely not that at home with politics, as the negotiation of representation and action. While there is more attempt to flesh out the subject in *Inventing the Future*, the subject remains divided between those struggling for future hegemony, the accelerationists, and those to be 'reached', the 'acceleratable'.

The other sense of subject is the technology or abstractions to be accelerated. The tendency of accelerationism, while arguing that technology must be re-purposed and re-used, is to be vague about how this might take place and what technological forms might best be subject to acceleration. This is evident in the lack of discussion of particular examples of technologies to be accelerated and, when examples are used, their problematic nature is not discussed. In the 'Manifesto' the major example of political accelerationism is Project Cybersyn, the project to cybernetically manage the Chilean economy, under socialist president Salvador Allende, initiated by the British cybernetician Stafford Beer.[28] In fact, the evidence suggests that the system did not really function that well and, in the end, was mainly used for communication, especially during the build-up of the right-wing coup which would bring the experiment and the Allende government to a violent end.[29] A later discussion of algorithmic finance by Srnicek and Williams is also similarly vague how these 'cunning automata' might be reworked to post-capitalist ends.[30] My suggestion is that technology, like humans, might be a more recalcitrant subject for acceleration than the accelerationists admit. The Italian operaist Raniero Panzieri had pointed out, in 1957, that *'[t]he relations of production are within the productive forces*, and these have been "moulded" by capital'.[31] What this means is that there are no neutral 'forces of production', forms of technology and production, that can be taken over and used to different ends.

Certainly, accelerationism admits the necessity to rework technology to new ends but, as I have suggested, doesn't seem to consider this 'moulding' of technology by capitalism in detail and how we might respond to this problem.

In temporal terms, the problem, especially in the 'Manifesto', is the lack of temporal specificity of when accelerationism takes place. The moment of accelerationism slides between something that needs to be engaged in as the condition of struggle, acceleration as the marker of struggle, and acceleration as the sign of a true revolutionary process. In brief, do we accelerate into the revolution, accelerate as part of the revolutionary process, or accelerate after the revolution? While such a brief statement is liable to these kinds of variations, and the answer could be all three, I would say the lack of specificity leaves the moment of acceleration a floating one. In this case, acceleration can be invoked at various points and in various ways, especially when detached from speed, to become the imprimatur of a 'true' or correct line or process. This is especially the case when the major target of these texts is the left and the failures of the left. The temporal index of acceleration is used to settle a debate with left tendencies and so this temporality is also left detached from critical engagement with capitalist forms of time.

This links to my concerns with the politics of left accelerationism. The focus on the left as target leaves the analysis ungrounded, as capitalism and the right recede into material to be used for accelerative processes. It seems that if we get the correct line in that dwindling constituency that is the left everything will unfold from there. Certainly, *Inventing the Future* tries to remedy this fault with a more detailed conjunctural analysis, but the major target remains the left. The constant in both texts, in different ways, is an invocation of ideas and the delivery of ideas, via hegemonic struggles, as central to the battle over the future. Again, I think this is not per se wrong, but the analysis seems to me often to leave hegemony as empty of content, reduced to a struggle of ideas or of power that is undertaken by different groups of intellectuals. The discussion is also light on previous uses of hegemony as a concept and practice and the various faults and failures of these past experiments. Aesthetics plays a less evident role in left accelerationism compared to right acceleration. The stress on images of inventing the future and problems of motivation does, however, leave the concrete analysis of the concrete situation, as

Lenin would have said, sacrificed to the desire for aesthetic success in 'inventing the future'.

### Vectors of Will

The common horizon of both accelerationisms lies in the notion of will, the conception of reality as a site of fictions to be manipulated, and an obsession with settling accounts with the left. These modes of thought are obviously not restricted to accelerationism and, at such a broad level, run through many currents of theory and politics to varying degrees and in different forms. This is accelerationism as will and representation. Obviously, this would seem a reference to Schopenhauer or to Nietzschean conceptions of the will. The rejoinder is that these forms of will are inhuman forms of flux and flow with no place for human 'direction'. Still, while claiming a materialist and inhuman will such philosophical forms leave open a place for the philosopher who knows how to subsume into this will, who can give up rational control and apprehension of the world for immersion in 'blind' materiality. This is clearest in Nietzschean invocations of the *Übermensch* and superior beings who are able to embrace and traverse the nihilism of the present. Accelerationism reveals this play between a materialism that treats the world as a flux of random matter and an 'idealism' that supposes a will that can manipulate or join with this flux. The random world of colliding material atoms requires an infusion of human will that in the process will become one with this chaotic world.

In right or reactionary accelerationism, materiality is the deterritorialized flows of capitalism to which we must submit and to which we can only contribute by pushing them further and faster. This admits the role of human will as a kind of 'vanishing mediator' to this absolute acceleration. In the more reactionary versions, this vision of flux is overlaid with toxic class, racial, gendered, and sexualized fantasies of those subjects who can impose this immersion on others. This inhabits the 'aristocratic' Nietzschean politics that rejects movements of equality and social justice as unnecessary 'brakes' on the achievement of a new 'superior' human, at one with the will as eternal recurrence. If Nietzsche might be said to be the primary reference for the right version of accelerationism, we could suggest Georges Sorel, or a decaffeinated Sorel, for the left version. Sorel, influential on Gramsci, developed an equivocal politics of will as mode of

division and struggle. For Sorel, revolution required myths to galvanize the will to overturn 'bourgeois' society. In left accelerationism this is not a will of violent separation, but a will vectored through platforms and think tanks, a will that is 'for' the left but which produces analysis as a matter of competing force and power. If the right have been successful it is due to their force and will and if we are to be successful we must match them.

In terms of representation, it is hyperstition that is the key category for both forms of accelerationism. Hyperstition describes the ways in which fiction structures or produces reality. A common example is H.P. Lovecraft's 'Cthulhu Mythos', a fictional construct of alien beings who once ruled the earth and will again, which has become 'real' through its reproduction as a mythology.[32] This kind of representation is what gives 'weight' to these intellectual or cultural interventions. On the right, the fictions tend to be nihilistic deconstructions of selfhood, hence the appeal of Cthulhu, and nihilistic celebrations of the sublime power of capitalism, hence, again, the appeal of Cthulhu. On the left the fictions have been more 'real', a tendency to appeal to past utopian moments of accelerationism, notably Project Cybersyn, that did not 'work' but contain potential to reactivate a new techno-politics. Again, we could say this is an invocation of a kind of myth. Across both, an appeal to sci-fi and electronic dance music provides an aesthetic core of hyperstitional forms of acceleration. While we should obviously be sensitive to the power of fictions that structure the real, especially evident in the various financial instruments that stalk the world, fiction here risks dissolving reality into competing claims in which representation is, again, a matter of power and authority.

Finally, while critiques of the left are certainly necessary, a slippage occurs in the fact that the left may have powerful political ideas but it certainly does not have much political power. While certainly left accelerationism tries to bridge this gap, it can also overestimate the power of the left even at the level of ideas and leave the right untouched. For right accelerationism it is obvious to target the left, which is dismissed as a moralistic constraint on the raw power of capitalism unleashed. This is a trope that dates back to Land's 1990s work and that of the CCRU, which, as I have already quoted, suggests 'Machinic revolution must therefore go in the opposite direction to socialistic regulation'. It now, in Land's recent work, connects to the racist inflection of the new

reactionaries (NRx) that this restraint also includes a refusal to consider forms of 'natural' hierarchy (i.e. racism). In terms of inflation, the definition of the left as a planetary cabal, what Mencius Moldbug (aka Curtis Yarvin) calls the 'Cathedral',[33] in charge of regimes that obviously, by any sensible measure, are not left wing, serves as ideological justification for the 'rebel' or 'guerrilla' stance of NRx and reactionary accelerationism. This also accounts for how the right accelerationists adopt (and pervert) certain left political tropes and forms of organization. While they make use of technology (memes, political trolling, etc.) the irony is these techniques often remain 'folk political', in terms of bottom-up insurgencies.[34]

In the case of left accelerationism, matters have shifted considerably, at least in the case of Srnicek and Williams' work, from a striking critique of the left as 'folk politics' in the *Manifesto* to a more moderated critique in *Inventing the Future*, where 'folk politics' comes to mean something like Gramscian common sense (why that category isn't used is an interesting question).[35] Folk politics remains an error, and something to be reformed, however. It also remains the province of the left. While this can be said to be obvious for a therapeutic intervention aimed at the left, if folk politics is a more general name for the condition of all politics why this restriction? Also, there doesn't seem to be much of an epistemological and political account about the position from which folk politics is identified and critiqued, or of a dialectical articulation of the possibilities in 'folk politics', if we were to accept this category. While recently folk politics has been considerably loosened or expanded, and hegemonic struggle has stepped to the fore as the counter-strategy, the concept of politics still remains to me in the mode of power politics, of competing fictions. Hegemony, itself a loose concept, leaves vague what is specific to accelerationism, except demands that cannot be met. This, finally, is a neo-Kantian conception of politics, by which I mean it tries to develop a condition of how we should do politics and impose it on reality. This involves a split between an ideal condition and a recalcitrant reality, which have to be brought together by those who are 'enlightened', rather than developing a thinking of struggle and politics out of current struggles.

### Conclusion: Arts of Acceleration
I want to draw some conclusions for the left out of these three points of critique I have posed: subject, temporality, and politics.

In terms of subject, the left has had the traditional answer of the proletariat. The class with nothing to lose but their chains, the class which is the source of labour that capitalism exploits, and so forms the universal class opposed to capitalism. Certainly, we can say, which has always been the case, the proletariat appears as a *problem*. The collapse or decline of 'traditional' institutional and political forms of worker resistance (states, unions, parties) seems to leave a vacuum into which not only accelerationism steps. Current left analysis seems to oscillate between the identification of a vanguard group of workers closest to the (Kantian) idea of the proletariat (cognitariat, surplus population, precariat, etc.) and a dispersion of the concept to include, nearly, everyone (99%, multitude). I think the purification of the proletariat as subject out of the empirical working class is part of the problem.[36] We are lacking, or forgetting, the need for class analysis that can grasp the overlapping and displacement of these strategies (think of the category of 'the retired' for example). While I am suggesting this is a task, I still think this is a central task to displace a politics of will that engages in a forcing not attentive to these realities.

Second, temporality. Here the left has a temporality of progress. While I myself have no doubt been equivocal on this, and still have much sympathy for Walter Benjamin's critique, this critique does not simply disable a notion of progress or, if you prefer, teleology. After all, even the dead will not be safe if the enemy wins. While *Inventing the Future* is staked on progress, this remains with utopian fiction as 'the embodiment of the hyperstitions of progress',[37] which is to say in the register of willed fictions, even if these produce 'real' effects. Against this fictionalization of progress, which risks reducing it to mere option, and against the pluralization and dispersion of time into a churn of loops or micro-times, we might be better if we return to Brecht's demand that we start with the bad new. This involves a task of sorting, identifying, and strengthening those points of resistance in time that promise or develop towards a socialist or communist future. The imagination of the future is not enough, we also need to imagine the bridge to that future out of our present.

In line with what I have said, this is a politics that is geared to contesting the right, reactionary currents, and capitalism. No doubt this politics, which attempts a material grounding in our conjuncture, is also going to involve contests amongst the left, but I see also the need to *target* the right. It sees politics not as

a matter of will, but as a matter of necessity, working with the various dispersed and fractured struggles of the moment. This would be to abandon the neo-Kantian politics of the idea and demand for a politics of class struggle engaged with contemporary forces. In this I am saying nothing original and something that many here would say they have already said or would agree with. That is good. I do think, however, that if accelerationism has no future, fine. If it is to be abandoned by its adherents, fine. This does not mean, however, that certain of its habits of thought do not remain and in so far as I consider them pernicious need to be critiqued. After all, accelerationism did not fall from the sky(net), but it fell on fertile ground already prepared in many intellectual and political currents and out of certain continuities, especially from thinking in the 1980s and 1990s.

To end, I want to clarify my criticism of accelerationism as an aesthetics. My suggestion is that while it poses as a political strategy, accelerationism takes an aesthetic form.[38] This includes an aestheticization of capitalism, which is recreated in the image of a 'great accelerator', whether that be welcomed as monstrous inhuman horror or subject to future modification for transition to a post-capitalist future. It also includes an aestheticized politics that aims at the use of irrational myths to galvanize and motivate action, as well as an authoritarian vision of reality and humans as manipulable material to be accelerated. This is not to reject art or aesthetics, or the role of the aesthetic within politics. Instead, it is the ways in which art and aesthetic practice engage with 'material' that might rupture these aestheticized fantasies that tend to depart from the material or leave it as chaotic 'stuff'. We might even talk of art *against* accelerationism, rather than supposing some smooth translation between them. This is not to suggest art can save us, but rather that a better grasp of the problems that accelerationism raises requires artistic and political 'thinking'. That is why this is one more, or one more last, effort to make a critique. Not in the hope or regret that this will finish things, but as a means to start again.

# Notes

1   Hartmut Rosa, *Social Acceleration: A New Theory of Modernity* (New York: Columbia University Press, 2015).

2   Gilles Deleuze and Félix Guattari, *Anti-Oedipus: Capitalism and Schizophrenia*, trans. Robert Hurley et al. (Minnesota: University of Minnesota Press, 1983), p. 240.

3   For a collection of the main texts see Robin Mackay and Armen Avanessian, eds., *#Accelerate: The Accelerationist Reader* (Falmouth: Urbanomic, 2014).

4   See the *e-flux* 46 (2013) 'Accelerationist Aesthetics', www.e-flux.com/journal/46/.

5   Benjamin Noys, *Malign Velocities: Accelerationism & Capitalism* (Winchester: Zero Books, 2014).

6   Ruth Saxelby, '10 Radical Ideas that Inspired Holly Herndon's *Platform*', *Fader* 21 May 2015, www.thefader.com/2015/05/21/radical-ideas-that-inspired-holly-herndon-platform.

7   Steven Shaviro, *No Speed Limit* (Minnesota: University of Minnesota Press, 2015).

8   Mark Fisher, 'Break it Down: Mark Fisher on DJ Rashad's Double Cup', Electronic Beats (2013), www.electronicbeats.net/mark-fisher-on-dj-rashads-double-cup/.

9   Nick Srnicek and Alex Williams, '#Accelerate: Manifesto for an Accelerationist Politics' (2013), in *#Accelerate: The Accelerationist Reader*, ed. Robin Mackay and Armen Avanessian (Falmouth: Urbanomic, 2014), pp. 347–362, http://criticallegalthinking.com/2013/05/14/accelerate-manifesto-for-an-accelerationist-politics/, p. 351 (02.2).

10  Nick Srnicek and Alex Williams, *Inventing the Future: Postcapitalism and a World Without Work* (London: Verso, 2015).

11  Patricia Reed, 'Seven Prescriptions for Accelerationism', in *#Accelerate: The Accelerationist Reader*, ed. Robin Mackay and Armen Avanessian (Falmouth: Urbanomic, 2014), pp. 521–536, p. 523.

12  For a more sympathetic discussion of this problem for accelerationism, see Simon O'Sullivan, 'The Missing Subject of Accelerationism', *Mute* (12 September 2014), www.metamute.org/editorial/articles/missing-subject-accelerationism

13  Robin Mackay and Ray Brassier, 'Editor's Introduction', in *Fanged Noumena*, ed. Nick Land (Falmouth: Urbanomic, 2011), pp. 1–54.

14  Simon Reynolds, 'Renegade Academia: The Cybernetic Culture Research Unit', Energy Flash Blog, 3 November 2009, http://energyflashbysimonreynolds.blogspot.co.uk/2009/11/renegade-academia-cybernetic-culture.html

15  Land, *Fanged Noumena*, p. 340.

16  Jamie Bartlett, 'Meet The Dark Enlightenment: Sophisticated Neo-Fascism That's Spreading Fast on the Net', *The Telegraph*, 20 January 2014, http://blogs.telegraph.co.uk/technology/jamiebartlett/100012093/meet-the-dark-enlightenment-sophisticated-neo-fascism-thats-spreading-fast-on-the-net/

17  Harrison Fluss and Landon Frim, 'Behemoth and Leviathan: The Fascist Bestiary of the Alt-Right', *Salvage*, 21 December 2017: http://salvage.zone/in-print/behemoth-and-leviathan-the-fascist-bestiary-of-the-alt-right/

18  This would be evident from Land's first and only monograph *Thirst for Annihilation* (London and New York: Routledge, 1992), which embraces Schopenhauer's vision of will as flux.

19  Srnicek and Williams, '#Accelerate', p. 351 (02.2).

20  Nick Land, *Templexity* (S.l.: Urbanatomy Electronic, 2014).

21  Land, *Fanged Noumena*, p. 292.

22  Peter Osborne, 'Marx and the Philosophy of Time', *Radical Philosophy* 147 (2008), pp. 15–22, p. 17.

23  Karl Marx, *Capital vol. 1*, Marxists Internet Archive, Ch. 6, www.marxists.org/archive/marx/works/download/pdf/Capital-Volume-I.pdf

24  Nick Land, 'Dark Enlightenment', www.thedarkenlightenment.com/the-dark-enlightenment-by-nick-land/.

25  Francis Spufford, *Red Plenty* (London: Faber & Faber, 2010).

26  Alex Williams. 'Back to the Future? Technopolitics and the Legacy of the CCRU'. 'The Death of Rave' event, Berlin, 1 February 2013, www.electronicbeats.net/en/radio/eb-listening/the-death-of-rave-panel-discussions-from-ctm-13/.

27  Srnicek and Williams, *Inventing the Future*, p. 189, note 55.

28  Srnicek and Williams, '#Accelerate', p. 357 (03.10). See also Srnicek and Williams, *Inventing the Future*, pp. 149–151.

29  Eden Medina, *Cybernetic Revolutionaries: Technology and Politics in Allende's Chile* (Cambridge, MA: MIT Press, 2011).

30  Nick Srnicek and Alex Williams, 'On Cunning Automata: Financial Acceleration at the Limits of the Dromological', *Collapse* VIII (2014), pp. 463–506.

31  Raniero Panzieri, 'Surplus Value and Planning: Notes on the Reading of *Capital*', in *The Labour Process and Class Strategies* (London: Conference of Socialist Economists, 1976), pp. 4–25, p. 12 (italics in original), https://libcom.org/files/The_Labour_Process_&_Class_Strategies.pdf.

32  CCRU, 'Origins of the Cthulhu Club', in *CCRU: Writings 1997–2003* (S.l.: Time Spiral Press, 2015, e-book).

33  Mencius Moldbug, 'OL9: How to Uninstall a Cathedral', *Unqualified Reservations*, 12 June 2008, https://unqualified-reservations.blogspot.co.uk/2008/06/ol9-how-to-uninstall-cathedral.html.

34  See Mike Davis, 'A Week in the Death of Alfred Olongo', *Los Angeles Review of Books*, 6 October 2016, https://lareviewofbooks.org/article/week-death-alfred-olongo/

35  Srnicek and Williams, *Inventing the Future*, pp. 5–24.

36  See '"The Proletariat is Missing": Representations of the Proletariat in Cinema'. Interview with Ramin Alaei of *Culture Today* Magazine (Iran), www.academia.edu/28620075/The_Proletariat_is_Missing_Representations_of_the_Proletariat_in_Cinema_Interview_with_Ramin_Alaei_of_Culture_Today_Magazine_Iran_.

37  Srnicek and Williams, *Inventing the Future*, pp. 71–75.

38  On the critique of the 'aestheticization of politics' see Walter Benjamin, 'The Work of Art in the Age of Mechanical Reproduction', in *Illuminations*, ed. and intro. Hannah Arendt, trans. Harry Zohn (New York: Schocken Books, 1968), pp. 217–251, p. 242, and Philippe Lacoue-Labarthe, *Heidegger, Art and Politics: The Fiction of the Political* (Chichester: Wiley-Blackwell, 1990).

# Accounting for Xeno
# (How) Can Speculative Knowledge Productions Actually Produce New Knowledges?

Lietje Bauwens

'Perhaps it is high time for a xeno-architecture (of knowing) to match' is the second last sentence from Armen Avanessian's preface to Markus Miessen's publication *Crossbenching*.[1] Intrigued by the neologism 'xeno-architecture' and curious about its progressive potential for spatial practice, Wouter De Raeve, Alice Haddad and myself approached Miessen and Avanessian to collaborate on further developing the 'xeno'—risk, uncertainty, and the unknown—and investigate how it could be thought of in relation to architecture.

The research of the 'Perhaps It Is High Time for a Xeno-Architecture to Match' project (hereafter referred to as 'Perhaps It Is High Time') was twofold; it consisted of a series of estafette conversations with philosophers, a poet, experts in the field of human rights, and designers that took place both live and via Skype between February and April 2017 (which are now compiled in a publication[2]) and, secondly, a performative event in the Kaaitheater in Brussels on 18 April 2017. By intertwining theory and praxis and proposing the 'xeno' as a (curatorial) methodology for various cultural productions, our collaborative inquiry slowly evolved into a research laboratory and 'xeno-test case' in and of itself. Based on the idea that a genuine 'new' future can only be constructed when one's rational knowledge apparatus becomes open to indeterminacies and contingencies, 'blind spots' were intentionally injected into the thinking processes. The different interpretations and applications of these 'blind spots' and of 'othering' and 'alienation' proved that, whilst these may be interesting concepts, one must consider the relationship between their usage and consequences. Is it possible to move away from a stagnant 'what is' towards an open 'what could be', while still being held accountable for 'what actually happens'?

### Conceptual Stagnation of the New

To better grasp this methodological question, which is at the core of this essay, it seems necessary to return to the roots of our project, our frustrations with the architectural realm and our subsequent interest in the ambitious prefix 'xeno'. 'Perhaps It Is High Time' was the result of a dissatisfaction with current practices in the public, and thus political sphere. The city of Brussels, our hometown and starting point of the xeno-architecture project, is instructive in this regard. It embodies a long tradition of social engagement, of which the resistance to urban developments of the sixties and

seventies is emblematic. In response to the dramatic mutilation of entire neighbourhoods in the name of modernization and profit—a phenomenon known as Brusselization—citizens, architects, artists, cultural workers, academics, and the like called for the right to make decisions about their city and for a politics that emphasizes particularities. Small-scale, local and especially *bottom-up* projects became more and more popular—a city garden to halt climate change or a communal playground to overcome segregation. Even if such practices used to have engaged and subversive functions, at present their radical nature has been neutralized. Key ideals such as participation, direct human contact, and local action have been integrated within the neoliberal logic against which they were aimed in defiance.

These merely local and physical approaches are incapable of dealing with the complex and planetary challenges the world faces today. Politics of austerity and exclusion, protection of privacy, climate change, and so on; how does one begin to envisage solutions when it is impossible to even truly fathom the problems? The size and structure of these issues, dazzling in scale, are often offshoots of human engineering—technology, capitalism, big data— that have begun to move as independent agents in their own right. If Facebook convinces you who to vote for in the next election, if Google tells you what treatment to seek when you feel sick, and fridges, mobile phones, and public transport cards are in constant interconnection, tracking and directing daily movements, we should be asking ourselves who, or what, is truly governing reality?

Beyond merely seeking new forms of designing, structuring, and occupying space that might better deal with abstract structures on a global scale—beyond the tangible and physical—'Perhaps It Is High Time' should be perceived of as an exercise in stretching current humanistic understandings of rationality and knowledge. With his preface, Armen Avanessian provoked Miessen to reconsider his 'Critical', and, according to Avanessian, therefore deconstructive, 'Spatial Practice'[3] in the light of the prefix 'xeno'.

The focus on 'xeno' emerged out of a conceptual stagnation and fundamental miscommunication between on the one side a Critical attitude, with a capital C, being an end-in-itself, and on the other side a more and more complex, insecure, and contingent (digital) world. As Patricia Reed emphasizes in the second estafette-conversation of 'Perhaps It Is High Time':

To me the problem is that we have, on the one hand, a proliferation of contingencies in the techno-sphere and, on the other, a conceptual stagnation that actually limits the impact of what that novelty could signal and how it can be instrumentalized.[4]

In their '#Accelerate Manifesto',[5] Nick Srnicek and Alex Williams state that even though we might consider ourselves capable of designing 'the new', our conception of novelty is still limited by the strict frameworks of capitalism. If the highest values of our society are innovation, novelty, and creativity; then how can this attitude only result in more of the same? Instead of retreating from technological transformations, Srnicek and Williams propose to 'accelerate' them.

By emphasizing the existence and manipulation of global, complex, and non-physical structures, these accelerationist ideas are strongly linked to what has been coined the 'speculative turn'. It is difficult to trace the exact beginning of the speculative movement, but the 2007 conference at Goldsmith University of London hosting Ray Brassier, Quentin Meillassoux, Graham Harman, and Ian Hamilton Grant marks an important moment in this regard. Whereas the four philosophers hold very different viewpoints, they agreed that a break is needed with the correlationist conception that takes the human being as the centre of all meaning. Even that which we cannot see or have knowledge of is *real*. As such, rationalist speculation—one that, as is captured in the prefix 'xeno', includes risk, uncertainty and the unknown—becomes the *only* way to talk about a world that can never be completely understood.

This becomes increasingly pressing in the world of today. In order to think through the implications of big data and personal privacy, one must to learn through the contingency and risk of the algorithm—to think *as* an algorithm. A solution for climate change needs to be as abstract, pluri-local, multi-systemic and trans-generational as the problem it addresses.[6] Thus, in order to formulate effective progressive political strategies, it is necessary to reach for what is (as yet) unknown and strive ambitiously towards 'what could be' instead of settling for answers that are within reach and under control.

Rather than the accelerationist's call to 'speed up', the collective Laboria Cuboniks proposes the notion of an alienating 'xeno' in their *Xenofeminist Manifesto*. The manifesto does not

reject the (as yet) unknown—a key element within the xenophobic debate—but rather proposes to fully engage with it and foster it further. 'The construction of freedom', the collective states, 'involves not less but more alienation'.[7] By emphasizing the xeno, a whole spectrum of possibilities opens up, and as such the alienating forces of society become not something to fear but something we can use and build upon.

As speculative designer Benjamin Bratton underlines, it would be a missed opportunity to search for architectural solutions for only those problems we already know exist, just as it would be a missed opportunity, for example, to only construct an artificial intelligence that aimed for human, i.e. recognizable, qualities. Behind this limited and thus limiting perspective lies a world full of possibilities: 'The things that are of interest to me in the field of AI philosophically have less to do with how to teach the machine to think as we think, but rather in how they might demonstrate a wider range of embodied intelligence we could understand. That way we could see our own position in a much wider context and it would teach us a little about what 'thinking' actually is.'[8] By starting from a point of view that is not purely human, speculative design can help to learn from unknown and still unconceived technologies in order to expand the image of humanity, our way of thinking and our political agency.

### Alienation as Method

The prefix 'xeno' is not a static image of 'the unknown' but stands for the incorporation, by *praxis,* of 'othering' and 'alienation'; by accepting that which exists outside of human perception as 'real', it becomes possible to inject the imaginary into our rational knowledge apparatus. Philosopher Reza Negarestani rejects propositions that would abandon the humanistic, rational project—as post-, non- and trans-humanistic tendencies do—and proposes instead an 'inhumanism'.[9] Not denial, but a dedication to humanism and rationality as being a continuous (re)construction and update of what it means to be human. By 'playing the game of giving and asking for reason', humans are not only able to map out the space of reason, but also negotiate its boundaries by incorporating new 'xeno-spaces' or 'blind spots' that push it beyond its limits in the search for new ground.

Not only are we already surrounded by existing blind spots, there is also an opportunity to broaden our cognitive horizon by

consciously creating more, and instrumentalizing, 'unknown unknowns', as Luciana Parisi states in the second estafette conversation: 'We do not think of transcendental or metaphysical indeterminacy—the blind spot—as some kind of limit to human knowledge, but instead we look at how it precisely demarcates the point of incomputability that is, or rather should be, part of our construction of imaginaries, theories, and aesthetic practices.'[10] The indeterminate unknown is a fertile zone, without which it is impossible for new propositions, theories and artistic projects to arise.

Theory-fiction is the simulating engine of philosophy, according to Reza Negarestani who wrote *Cyclonopedia* (2008), a philosophic horror-science fiction. Speculative knowledge productions are always both a reflective and a performative act that investigates and embraces the (as yet) unknown. In line with these convictions, it comes as no surprise that many thinkers are interested in (science) fiction as a way to leave the beaten track of the academic context and language. It is important for many that their means of expression surpass that which is expressed; to not only write *about* speculation but let the text itself be a speculative exercise. Where the 'inwardly' academic form of critical discourse suits particular kinds of knowledge and content, the speculative turn proposes a constructive thinking that expands the imagination with fictional and ambitious proposals. To remain faithful to the content of their point of departure, many speculative philosophers feel the need to embrace experimental forms of knowledge production as a fundamental part of their theoretical research.

Meillassoux, for example, was closely involved in thinking with musician Florian Hecker about the latter's composition *Speculative Solutions*. In the transcript of a conversation between the philosopher and the musician, Meillassoux argues that one can only approach the contingent nature of the world, which he calls 'hyperchaos', by creating a 'toolbox' in which constant change could manifest itself. Instead of making a music piece that is 'merely a sonification of the idea [of hyperchaos]',[11] Hecker proposes to let a dialogue spring from his experimental composition, the cd-box, and the accompanying booklet with excerpts from the work of Meillassoux. He continuously lets these three elements intersect and refer to one another. What hyperchaos offers, perhaps, is the image of a speculative artwork

that is not a representation of contingency and unpredictability, but the enactment of a situation in which the contingency of *laws* themselves might make themselves known.

A few years ago, philosopher Armen Avanessian and artist Andreas Töpfer published *Speculative Drawings*.[12] The drawings that make up the book attempt neither to be representation nor illustration of its theory, but to precede it and they are used as a setting for imagining new ways of reading and thinking. The central question is how to *think with* art instead of *reflecting on* it. Together with filmmaker Christopher Roth, Avanessian further developed this approach in his project DISCREET, presented during the 9th Berlin Biennale–'*The Present in* Drag'–in 2016. Instead of displaying an aesthetic interpretation of the future, Avanessian set up an 'Intelligence Agency for the People' at the Akademie der Künste. Over the course of three weeks, data analysts, theorists, and hackers gathered to propose new codes and strategies for speculatively dealing with data: a collective, performative production of knowledge instead of a transfer of ideas.

### Xeno Test Case

Within this mind-set, 'Perhaps It Is High Time' used a 'xeno-methodology' in order to deal with an unknown concept and its (yet) unknown meaning. By means of not only thinking *about* 'xeno' but also testing it, the inquiry brought critical questions about the limitations of its productivity to the fore.

Whereas the ambitious manifesto format of the *#Accelerate* and *Xenofeminist* manifestos were in line with the decisive content of the texts, Miessen and Avanessian decided to instead organize a series of estafette conversations; intentionally injecting contingency into the thinking process by inviting thinkers and practitioners to continue each other's lines of thought. The different points, the transfer of the baton, of the texts, to one another, via e-mail and Skype became a temporal and spatial event in which each conversation functioned as a building ground for the next one. The selection of speakers may have been conventional, and the format of the conversations left room for the participants to put their expertise on the table without being brought into completely alienating positions, but this xeno-structure made it possible to give an, albeit indefinite, meaning to xeno-architecture and the idea of what an 'inhuman architecture'

could be. By inviting experts from juridical, technological, and political realms to approach their research through a 'xeno-lens' and simultaneously knitting their individual discourses into an architecture of knowledge, the series of conversations managed to stretch the neologism from within, probing what it entails not only rhetorically but also as a means of practice; dealing with the instrumentalization and governance that are necessarily involved in the geopolitics of architecture, the emancipatory potential in offshore structures, and the possibility of transnational citizenship.

The performative event in the Kaaitheater was located at the other end of what I call the methodological xeno-spectrum. Instead of giving a talk or lecture about 'xeno-architecture' Miessen and Avanessian used the xeno as a curatorial methodology, aiming to amplify an understanding of the xeno through an audio, visual, olfactory, and relational experience by giving carte blanche to different artists in what Avanessian calls 'an attempt to abductively produce something new'.[13] How can one think of a non-physical architecture by not merely speaking about it, but by 'feeling', 'smelling', and 'experiencing' it? The modus operandi leading to the event showed that in building this chain of contingency, while its outcome was unpredictable, the notion of responsibility also became unstable. The diverse artistic interventions, lacking a collective anchor to hold on to, ultimately flattened into overall confusion.

The event 'failed'. But can we even use terms such as success or failure, given the speculative aims of the event? How can we account for this failure within an experiment that explicitly seeks to destabilize the conditions for its own legibility? By ceding all control, based on the desire for a complete 'othering', radical contingency was injected into the Kaaitheater to create a setting 'in which we are not in charge, in a way forcing the other to do what he or she cannot do'.[14] Based on this wish, Avanessian and Miessen positioned themselves as performance-curators instead of philosopher and architect—thereby completely othering themselves from their fields of expertise. In the middle of an unstructured gathering of accelerated videos, sense-dancers, and a participatory performance, the confusion foremost displayed how 'alienation' became an 'end in itself' and thereby resulted in an isolated blind spot, instead of a relational one. The disorienting outcome raised a pressing question: can you still speak of knowledge production when knowledge leaves the

stage, and the artistic intervention surpasses the theory it aims to develop further?

While its main purpose was to go beyond the presentation of knowledge, and to contrarily produce a theory *live*, the overload of chaos, speed and 'xeno' within the performative event did not surpass a one-to-one representation (read: aestheticization) of 'hyperchaos' instead of expressing its structural existence, as Meillassoux underlines. In line with an adequate interpretation of 'contingency', the new or unknown is not by definition a complete degeneration of what is familiar. Contingency, the continuous possibility of complete and incomprehensible change, effectively lies in the fact that we cannot predict how the world will look tomorrow. Thus, we cannot even predict whether it will be any different from the world of today. Forced disorder is just another form of order. Overemphasizing chaotic and accelerating characteristics, as in the speculative 'xeno-architecture' event at the Kaaitheater, doesn't do justice to the incoherent nature of speculation in which continuity should also be recognized as an indispensable option.

**The Productive Blind Spot**
The unlimited size of the blind spot in the performance and its disorienting outcome raised important critical questions; when is the creation of uncertainty productive, and what can be the definition of productivity in a speculative context? When are we dealing with an incomprehensibility that (in the long term) stretches the ability of reason, and when with an incomprehensibility that has lost touch with its function?

From a 'xeno point of view', one could argue it is impossible to immediately state whether something has failed or not and that this will only show itself in and from the future; what seems to confuse us at the moment, is exactly what the potentiality to widen our rational capability entails. But is this not too easy? Does such an attitude not exclude itself in every situation from any form of criticism?

The blind spot marks a relational actuality between points. In *Contagious Architecture*, Luciana Parisi states:

> The turnaround point is the spatiotemporality of the relation itself, which overlaps the point of arrival and the point of departure but does not fuse them together. For this

reason, this relational actuality remains a blind spot: an invisible but lived spatiotemporal actuality.[15]

The estafette-series created such an interval, a 'break from the continuity of experience of two positions'[16] between the different participants and 'their' conversations, *within* an authored structure. I argue that the estafette concept 'worked' in creating a 'toolbox' in which the xeno could manifest itself, whereas on the stage of the Kaaitheater the xeno became an end-in-itself. Alienation is necessary to move away from 'what is' towards 'what could be', but in itself it can never become totalizing: one can only alienate oneself 'from something' or 'from oneself'—without such a relation, alienation can not be constituted.[17]

As above, the 'xeno,' and therefore Armen Avanessian's intervention in Markus Miessen's Critical Spatial Practice, originated from a dissatisfaction with capital C Critique; critique (lowercase) is necessary to think about new thoughts, but should not be an end in itself. A similar danger lurks in fetishizing speculation when, as Negarestani warns, imagination is not located within the ever-changing boundaries of reason but is left unattended outside. If 'what could be' becomes nonsense when its ties to 'what is' are broken, then how should one find a balance between 'too safe' and 'too much?' How big can the letter X of xeno grow before it loses its productive power? Is it possible to redefine 'productivity' in terms that are non-immediately measurable, without dismissing the concept entirely? The most interesting outcome of the xeno-architecture project may have been the realization that despite, or perhaps because of, the difficulty of the relationship between speculation and xeno and their quantifiable productivity, there is a need to design speculative parameters that can test what forms of speculative art can function as a synthetic medium to enlarge not only the space of knowledge but also that of action.

The biggest challenge for knowledge production and cultivation of a new speculative rationality perhaps lies less in the performative incomprehensibility of what is academically comprehensible, but in trying out alienating settings and manipulations that explore experimental ways of learning in real contingency. Not by (aesthetically) representing 'the unknown', 'chaos', or 'acceleration' from a comfortable and familiar point of view, but by structuring the conditions for randomness without shackling it to a predefined image. 'The difficulty', states

Meillassoux in conversation with Hecker, 'is to break with this lawful randomness in a way that is other than random and show that controlled narratives can still be constructed in a world without substance'.[18]

Parts of this text are based on the preface to *Perhaps It Is High Time for a Xeno-Architecture to Match* publication (Berlin: Sternberg Press, 2018), which I wrote together with Wouter De Raeve and Alice Haddad in June 2017.

I would like to thank Wouter De Raeve and Henry Andersen for their thoughts and support in developing this text.

# Notes

1   Markus Miessen, *Crossbenching: Toward Participation as Critical Spatial Practice* (Berlin: Sternberg Press, 2016).

2   *Perhaps It Is High Time for a Xeno-Architecture to Match*, ed. Armen Avanessian, Lietje Bauwens, Wouter De Raeve, Markus Miessen, and Alice Haddad (Berlin: Sternberg Press, 2018).

3   The full title of Markus Miessen's publication is *Crossbenching: Towards Participation as Critical Spatial Practice*. The concept of Critical Spatial Practice is present throughout all Miessen's work. In a series of publications (*Critical Spatial Practice*, Berlin: Sternberg Press, 2011–ongoing), for example, he and Nikolaus Hirsch invite protagonists from the field of architecture, art, philosophy, and literature to reflect on the single question of what, today, can be understood as a critical modality of spatial practice.

4   Patricia Reed, in 'Conversation 2', in *Perhaps It Is High Time for a Xeno-Architecture to Match*.

5   Nick Srnicek and Alex Williams, '#Accelerate: Manifesto for an Accelerationist Politics', in *#Accelerate: The Accelerationist Reader*, ed. Robin Mackay and Armen Avanessian (Falmouth: Urbanomic, 2014), p. 358.

6   Patricia Reed, 'Uncertainty, Hypothesis, Interface', in *_AH Journal* 00 ('Scientific Romance'), ed. Beatriz Ortega Botas, 2017. _AH Journal Online

7   Laboria Cuboniks, 'Xenofeminism: A Politics for Alienation' (2015), www.laboriacuboniks.net/qx8bq.txt, last accessed on 06-03-2018.

8   'Benjamin Bratton on Artificial Intelligence, Language and 'The New Normal', Interview with Benjamin Bratton by James Taylor-Foster, 9 February 2017, www.archdaily. com/799871/benjamin-bratton-on-artificial-intelligence-language-and-the-new-normal-strelka-moscow.

9   Reza Negarestani, The Labor of the Inhuman, Part 1: Human & Part 2: Inhuman', *E-flux journal* #52 (February 2014).

10  Luciana Parisi, in Conversation 2,' in *Perhaps It Is High Time...* See note 2.

11  *Speculative Solution: Quentin Meillassoux and Florian Hecker Talk Hyperchaos,* www.urbanomic.com/wp-content/uploads/2015/06/Urbanomic_Document_UFD001.pdf

12  Armen Avanessian and Andreas Töpfer, *Speculative Drawings* (Berlin: Sternberg Press, 2014).

13  Armen Avanessian in 'Conversation 1', in *Perhaps It Is High Time for a Xeno-Architecture to Match.*

14  Ibid.

15  Luciana Parisi, *Contagious Architecture, Computation, Aesthetics and Space* (Cambridge, MA: MIT Press, 2013), p. 120.

16  Ibid., p. 119.

17  Patricia Reed, 'Xenophily and Computational Denaturalization', *E-flux, Artificial Labour*, 18 September 2017.

18  *Speculative Solution: Quentin Meillassoux and Florian Hecker Talk Hyperchaos*, www.urbanomic.com/wp-content/uploads/2015/06/Urbanomic_Document_UFD001.pdf

# Part 2

# Instituting the New

# The Museum vs. the Supermarket
## An Interview with Boris Groys

Thijs Lijster

**Introduction**

Is the new still the first and final criterion for evaluating art? In the 1980s and 1990s theorists of the postmodern argued that this final criterion now too failed us. In his essay 'The Sublime and the Avant-garde' (1984) Jean-François Lyotard scorned 'the cheap thrill, the profitable pathos, that accompanies an innovation' (p. 106), Fredric Jameson in his seminal essay 'Postmodernism and Consumer Society' (1983) argued that 'the writers and artists of the present day will no longer be able to invent new styles and worlds' (p. 7), and American art critic Rosalind Krauss published a book titled *The Originality of the Avant-garde and Other Modernist Myths* (1986). The fall of the Berlin Wall in 1989 forced artists worldwide to rethink the legacy of modernism and modernity. In his essay 'Comrades of Time' (2009) Boris Groys wrote about this transition:

> The present as such was mostly seen in the context of modernity as something negative, as something that should be overcome in the name of the future ... Today, we are stuck in the present as it reproduces itself without leading to any future. ... One can say that we now live in a time of indecision, of delay—a boring time.

This boredom characterizes contemporary art, in Groys' view. The contemporary artist for him is like Sisyphus, who in the same repetitive and senseless act has to keep rolling the boulder up the mountain. The modernist artist was facing the glorious horizon of the future, but the contemporary artist swims in a sea of contemplation and confusion. For Groys this is not necessarily a bad thing, but it does raise questions on the nature and function of 'artistic innovation' today.

These were questions that he already dealt with in his book *Über das Neue* (On the New), which was published 26 years ago in 1992, in the context of the aforementioned debates in art and theory.[1] According to Groys, something peculiar was happening with regard to the new: on the one hand, and in line with the theorists mentioned above, no one 'believed' in the new any longer; but on the other hand, everyone still expected to see, hear, or read something new, upon entering the museum, going to concerts or theatre plays, or when reading novels, poems, philosophical books, and so on. To Groys, this meant that we had to start looking for a new understanding of the new.

In order to do that, Groys first stripped the new from its—mostly modernist—connotations with concepts such as utopia, historical progress, creativity, and authenticity. Referring back to Nietzsche, he defines innovation instead as the revaluation of values:

> Innovation does not consist in the emergence of something previously hidden, but in the fact that the value of something always already seen and known is re-valued. The revaluation of values is the general form of innovation: here the true or the refined that is regarded as valuable is devalorized, while that which was formerly considered profane, alien, primitive, or vulgar, and therefore valueless, is valorized (p. 10).

The exemplary work of art, to which Groys would return again and again throughout his oeuvre, is Marcel Duchamp's *Fountain* (1917). What Duchamp did, after all, is not inventing something that wasn't there before, but placing something from the domain of the profane in the domain of the sacred. In retrospect, argues Groys, this was what art and artists have always done. Duchamp, by stripping the act of artistic transformation down to almost nothing, shows us what innovation comes down to: cultural revaluation.

For Groys this meant that the answer to the question of innovation was to be found in a specific place: the collection or archive. To collect something, whether it concerns books in the library, immortal souls in church, or works of art in the museum, means to grant it importance, that is, to sanctify this something. Hence, *Über das Neue* can be considered as the starting point of Groys' reflections on the function and status of the museum in our contemporary society, which he later developed in books such as *Logik der Sammlung* (The Logic of the Collection) (1997) and *Topologie der Kunst* (A Topology of Art) (2003). As the subtitle of *Logik der Sammlung* makes clear—*Am Ende des musealen Zeitalter*, 'at the end of the museum age'—Groys was already well aware of the waning influence and importance of the traditional museum, in the face of not only societal developments such as the suspicion towards a supposedly elitist culture and the increasing power of private collectors, but also of artistic movements, which in several waves of so called 'institutional critique' tried to break

out of or emancipate themselves from the museum. Still, as Groys emphasizes again in the interview below, without the museum, there can be no innovation.

Groys distinguishes the new from modernist 'myths' of historical progress and utopia, but also from contemporary myths such as creativity and the 'Other'. With regard to the latter, he has always been critical of the idea that the art world should be a 'reflection' of society. In *Art Power* (2008), for instance, he writes:

> When art relinquishes its autonomous ability to artificially produce its own differences, it also loses the ability to subject society, as it is, to a radical critique. All that remains for art is to illustrate a critique that society has already leveled at or manufactured for itself. To demand that art be practiced in the name of existing social differences is actually to demand the affirmation of the existing structure of society in the guise of social critique (p. 113).

However, this does not mean that art is apolitical for Groys. On the contrary, as he argues below, the revaluation of values that is the general form of innovation, i.e. to value something that was not valued before, or to devalue something that was valued, is the political act *per se*. Scenes from everyday life, the dream, primitive rituals, household equipment, advertisement, and popular culture—all these things were considered too base or banal for art, but were included in the cultural realm by innovative artists, in much the same way as voices that are not heard in the political realm strive to be heard, and as entities that were not represented in politics and law gained rights.[2]

Born in East Berlin in 1947, Groys began his academic career in Leningrad and Moscow, where he was also active in the unofficial art scene. In 1981 he moved to West Germany where he later obtained his PhD at the University of Münster. Today he is Global Distinguished Professor of Russian and Slavic Studies at New York University, and travels around the globe as a lecturer and curator at art institutes, biennials, conferences, etc. His experiences with both sides of the Iron Curtain proved to be crucial for his thinking, which is always thought-provoking, sometimes puzzling, and now and then also leads to controversial or even questionable statements. He has a way of thinking a

certain statement through to its most extreme and seemingly bizarre consequences, such as in *Gesamtkunstwerk Stalin* (1988) in which he argues that Stalin completed the utopian project of Russian avant-garde artists like Malevich or Mayakovski, and even understood it better than they themselves did; or in *Das kommunistische Postskriptum* (2006), where he argued that the Soviet Union was the realization of the linguistic turn in the political realm.

Another aspect of his work and style that makes him both a fascinating and provocative thinker is his apparent nihilism. In this interview as well as in any of his other writings, he resolutely refuses to be nostalgic or moralistic. He registers the historical developments of and differences between the modern and the postmodern, between the East and the West, or between the museum and the supermarket, but he nowhere speaks of decline. Rather than passing value judgments, Groys seems to be more interested in analyzing what has actually changed, and how this change allows or forces us to reframe our concepts and practices.

On the occasion of the 25th anniversary of *Über das Neue*, which, as it happens, is also the 100th anniversary of Marcel Duchamp's *Fountain*, I asked Groys to reflect on the legacy of this book, on the contemporary meaning of notions such as creativity, originality, and novelty, and on the future of the new.

### I *Über das Neue*, 25 Years Ago

**Thijs Lijster:** Could you tell something about the time in which the book was written? What was the situation in the art world, and why did you think it was important to write a book on the category of the new back then?

**Boris Groys:** That was the time of postmodern discourses: everywhere everybody was speaking about the impossibility of the new. That was a core belief of the postmodern mind frame. At the same time, it was quite clear to me—I was teaching at the university and I was also, as a curator, participating in artistic activities—that the factual criteria of the new were still valid. For example, imagine someone who has to write a doctoral thesis, saying: I don't say anything new, because we live in postmodern times and the new is impossible, so let me

only repeat what was said before. It would not be possible for him to make his doctorate. So, to make the doctorate, he would have to prove that he said something new. It was the same in the case of selections of artworks at an exhibition, especially contemporary overviews of the state of the art world. Here again, the first question was still: is the art work a new phenomenon, did this artist do something new or not?

So, there was a kind of duplicity in culture that I experienced at that point: on a theoretical level everybody said that the new was impossible, but in cultural practice this requirement of the new was still valid. The goal of the book *Über das Neue* was to try to reconstruct and to describe the hidden, implicit presuppositions of this requirement. So: what does it mean to require something new after the new became impossible? What is the context in which the new is still possible? My book was an attempt to reconstruct the theoretical, and in a certain way also pragmatic presuppositions of the new, against the background of this cultural duplicity.

**TL:** In order to do that, you rid the concept of the new from all kinds of ideological connotations, like 'utopia' and 'progress'. You start out by giving a series of negative definitions of the new: 'The New is not just the Other', 'The New is not utopian', 'The New is not a product of human freedom', and so on. Could one say you tried to 'rescue' the category of the new, by detaching it from all these other categories?

**BG:** I wouldn't say I tried to rescue it, and I wouldn't say I tried to negate all the other concepts. I merely responded to the situation I just described. I saw that all these connections, between the new and progress, utopia, and so on, became obsolete if we would take the postmodern discourse seriously. All the while, the new hadn't become obsolete; it remained operative in our culture. So, it's not like I tried to do something – to disengage the new from all these associations. It is what happened in culture, that was the situation. I was not the author of this situation; I just tried to phenomenologically describe it.

**TL:** The new was, as you said, separated from utopia and progress, and with that also from its temporal dimension. You write: 'The new stands in opposition to the future as much as to the past' [2014, p. 41]. Innovation, in your view, is what happens when an object is transferred from everyday life into cultural tradition. Still, is it possible to detach the new from its temporal dimension? After all, isn't the new what happens after the old?

**BG:** Again, I didn't detach it; it was detached *de facto*. So I asked myself: What is the function of the new in this context? It became clear to me that the new, in the context of art, is related to what is already in our archives. Our culture is structured in the following way: we have the archives, and the world outside of the archives. The archives exist in the here and now, and the world outside of the archives also exists now; it is not the world of the future or the past. Both worlds—that of the archives and the outside world—are contemporary to each other and to our own experience.

But what is their relation? My idea was that it is in the intersection between these two worlds that the new emerges. If I write a doctorate and I want to show that the doctorate is new I do not compare what I said to all possible opinions in the world I'm living in, because it can happen that some of these opinions actually are part of my world. I begin to compare this text, my own text, with the archives, with what is already accepted as valid in a certain discipline. So, I take some opinions or knowledge—my own opinions and those of my friends—from outside of the archives, compare them to what is already in the archives and precisely if some of these opinions are not in the archives I present them as new. The artist does the same. That is something already described very well by Baudelaire, in his famous essay on 'The Painter of Modern Life'. Baudelaire speaks about an artist who looks at the classical ideal of beauty and at the same time at what happens around him, and then what he tries to do is to combine them. The same can be said about the avant-garde. The avant-garde never ever indicated any future. If we look at the avant-garde writings, their programmes and manifestoes, they all tell you the same:

we have the museums, filled with ancient Apollos and so on, and outside of the museums and around us we have tanks, trains, airplanes, explosions, and killings, industrial machines, and mathematics and geometry. Some kind of new order. These things are not precisely the things of the future; they are already around.

**TL:** All they did was implement them into the cultural realm?

**BG:** Precisely. That's it, and only that. The avant-garde never went one inch into the future. The avant-garde always only wanted to transport and transpose certain experiences that the people in their contemporary life had into the museum space, into the space of the cultural archives. And the power of the avant-garde was precisely its ability to cross this border and to bring the lived experience into the cultural space. It was not concerned with some idle projection of the future, or some senseless utopia, but with the lived experience of everyday life in an industrial civilization. It is the same with Marcel Duchamp, Andy Warhol, and so on. Duchamp doesn't invent anything. He takes a urinal and places it in the museum. Now imagine that you bring to the museum another urinal, and say: this is a different one, because it has a different form. No museum would take it, because they would say: it is irrelevant, because it is not new enough. What does that mean, not new enough? It means that it might be different in form but does not engage in the difference between art and life, between the cultural and the profane realm, between the archives and everyday existence. So, I would say that the notion of the new, and the effect of the new, is something that has its place on the border of the cultural archive and contemporary life.

**TL:** If the new is detached from the aforementioned categories like utopia, progress and human freedom, doesn't that also imply a depoliticization of the new? In *Über das Neue*, also in *Logik der Sammlung*, you point to the many failed liaisons between artistic and political avant-gardes. However, if the idea of innovation is detached

from the idea of a better world, what is then still the value of the new?

**BG:** First of all, I consider my own theory of the new as a total politicization of the new. The decision to take something from everyday life or everyday experience and to put it into the archive is an eminently political decision. In a certain way it is the *actual* political decision. It's what Kierkegaard said with regard to Jesus Christ: believing he was not just a normal man but the son of God is simply a decision. To ascribe value to something that up till then had no value, to put it in a valuable context, is the *Urform* of political decision-making. Actual politics functions according to the same pattern. For example: up to a certain point in history the workers had no value in the system of representation. It takes a political decision to change this value, after which they are represented.

In the Second Surrealist Manifesto, Breton asks: What is an authentic surrealist artwork? And he answers: to go into the crowd with a revolver and randomly shooting into it. So, you take this action, a terrorist deed, and put it into another context, the context of art. In the same way, Marinetti speaks of the metallization of the human body, the wonderful effect of exploding African villages, and so on. If you look at those examples, you see immediately that what I describe is eminently political. Utopias are not by nature political, they are literary fictions. Whether they have any political value has to be decided politically. In other words: utopias are not a source of politics, but an object of politics. I have to make the decision, and this decision cannot be delegated to any theory or any utopian vision. That means that the value of my political decision cannot be deduced from utopia itself.

**TL:** The politics of the new, then, is that in the same way that people who were not politically represented get a vote and get representation, something that was outside of the cultural realm gets inserted.

**BG:** Yes. And with regard to politics, not only people, but maybe even lions or plants. A new ecological consciousness

has emerged that believes that certain animals or plants should also be represented in our culture, which means they should be protected. The question what should be represented is the crucial question of our society, because our society knows only two modes of relating to things and people: to let them perish, or to protect them. That is the basic political decision. If you decide to include something into the system of representation, this means that you are interested in how this thing—object, human being, animal or whatever—will be translated into the future. The museum, the archive in general, is a futurist institution, because it keeps things for the future. Futurism was never about the future, innovation is not about the future, but it relates to the future in so far as it gives us a promise of protection and preservation.

TL: So, what is new now will be included in the collection and preserved for the future.

BG: Yes, precisely. Being included, it will not be discarded. That is the promise on which our culture is based. This basis is so fundamental that it is often neglected. For example, Nietzsche said: my writings will only be understood after three hundred years. It meant that he firmly believed that mankind, without actually understanding his writings, would be reproducing them, putting them in libraries, distributing them, for three hundred years. If you want to speak about utopia, this is a true utopia. There is an almost automatic and unconscious reliance on the institutions of protection in our culture. People writing books, producing artworks, have an instinctive trust in the possibility that these works will survive. This faith is precisely what gives the basic energy to the effort to make something new, so that it will be safeguarded, protected, translated into the future. And that is precisely what I was and still am interested in.

## II The New, Then and Now

TL: What, in your view, is the main difference between the situation in the art world 25 years ago and now?

**BG:** The main differences have to do with the emergence of the Internet, as an electronic archive. These differences manifest themselves in the two following ways. First, if you think of the traditional role of the writer, philosopher, and artist, it was precisely to mediate between the archive and everyday life, that is, to provide artistic (or theoretical) expression and representation of everyday life. But the Internet gives to everybody the immediate possibility to present oneself on the global stage—everybody makes selfies, videos, writes blogs, and so on. We no longer have a mass culture of consumers—the situation that was described by Adorno—but a situation of mass cultural production, where everybody is an artist, everybody is a writer, and a philosopher. We no longer need mediators, so we no longer need writers, philosophers, or artists.

The second difference, however, is that the Internet still does not produce the stability, security, and protection that the traditional archives had. We often think this is an institutional question, or a technological one, but in fact it is an economic one. Internet platforms are privately driven, so they have to make profit. And that means that on the Internet there is no place for the museum, or an archive in any form. I'm quite sceptical about whether this will change. Basically, today, if you want to have an archive on the Internet, it should be based on already existing archives. Only institutions such as the MoMA and Tate can establish something like an Internet archive, partially also because they are able to pay for this. In the EU, if you want to establish an Internet archive, you get a guarantee of protection of maximum 30 years. So, it will cost a lot of money, and there is still a lot of insecurity.

What does it mean if you take these two points together? It means that in the contemporary global framework, you have total representation, but from a future perspective it is all garbage. What is interesting is that the Silicon Valley people know this very well; they all create secret museums, libraries, documentation centres, etc. but these are not traditional archives in the sense I describe in my book, since they are not publicly supported and accessible to the public. There have been many attempts to create electronic archives, but *de facto*

none of these attempts were really successful, precisely because of the general structure of the Internet and its relations of property.

It is the classical Marxist situation of collective use and private property. That analysis, if there is any place to use it, very much applies here. Everybody uses these Internet platforms, but they belong to only a few companies. There is a tension between the interests of the users and the interests of the companies, but this tension is hidden and not thematized, because people believe that the Internet is a means of communication. If we would start to think the Internet as a means of archiving, then this tension would be obvious. It is possible, however, that people would give up the archive in general, that people will be only interested in communication and no longer in archiving. That would mean indeed that they would not be interested in the future, and then the role of the archives would be decreasing. To some extent, we already are in this situation: the museums are poor; they cannot compete with private collections. Private collections are based partially on the current situation in the art world but being private they are based very much on the collector's taste, which cannot be collectivized. These private collections do not of course constitute the framework for protection that I was describing. The same can be said about libraries, and so on. We more and more experience them as too expensive, taking up too much space.

It seems to me that today we are in a period of transition. One the one hand, the structures I described in my book—in academia, in museum, in the art world—still exist and function in the same way. Parallel to that we have Instagram, virtual reality, viral videos, and so on. I don't say we have to make a choice; I only want to say that there is a factor of uncertainty and a lack of clarity about their relationship, and I think that is a factor that emerged only after the book was written.

**TL:** You say that people are no longer interested in the archival function, but at the same time there is a lot of anxiety about the preservation of tradition, in the shape of 'cultural heritage' and so forth. In *Über das Neue* you wrote:

'[T]he new ceases to represent a danger and becomes a positive demand only after the identity of tradition has been preserved' [2014, p. 21]. Might one say that the contemporary anxiety emerges from a lack of historical orientation? In other words: since we cannot make sense of the present, or determine our direction for the future, we do not know what is historically meaningful and what is meaningless. And what would this mean for the category of the new?

**BG:** Indeed, we can no longer rely on the tradition. And again, I think this is related to digital media: we are confronted with everything at the same time, and everyone has globalized themselves. At the same time, we're not sure what the archive still means under this new condition. But as long as there are archives, it makes no difference for the category of the new. There would only be a difference if the archives would dissolve completely. If that happens, then we no longer have the new, but then we also no longer have philosophy, literature, or art. Probably we'll still have politics, but I'm not sure about it. All these phenomena relate to the archives, so if the archives dissolve, then all the other things dissolve as well.

**TL:** Is that a real threat?

**BG:** Maybe it is a threat, maybe a relief. I think a lot of people would see it as liberation. It is difficult to say. I think it is a mixture between threat and liberation, in the same way that every utopia is also a dystopia. But I think the fact is that many people welcome this development; that the feeling of liberation prevails, the feeling of being liberated from the archive, but also from literature, art, and philosophy.

In a sense it would be another step in the history of secularization. European culture has a complex relation to its religious heritage. You still have the names of the saints, ideals of sovereignty and creativity, and an institutional long-term memory, which all together show that it is really a secularized version of a feudal or religious order. In one of my early texts, written at the same time as *Über das*

*Neue*, I wrote that I would not be surprised if after a new revolution, curators would be hanged from lampposts in the same way the French aristocracy was, because they incorporate the same feudal order. It is possible that we go through a new wave of liberation, which started in the 1960s, found its medium in the Internet, and now rids itself of the final traces of the feudal order.

**TL:** And would this also mean the end of the new?

**BG:** Yes. The problem is that the new itself, in European culture, has of course its origin in the New Testament. So, what is the new? The New Testament is new in relation to the Old Testament. If you don't have the Old Testament, you can't have a New Testament. That's just logic. Now, if we have an anti-testamentarian movement, as we have now, almost already full-fledged, then it is all over. There is no old, no new, there's no culture. And I tell you: people experience that as liberation. I see that a young generation is very happy about it. And I'm not against it.

**TL:** In your book you discuss the issue of representation, and also the struggle of minorities or socially oppressed groups that want to be represented in the collection or archive. This seems to be a highly topical issue (not only with regard to the museum, but for instance also with regard to popular culture: Hollywood that is considered to be too masculine, too white, etc.). However, you are quite sceptical of the way this debate is usually framed. You write: 'Even if an artist or theoretician utilizes things and signs of the social class from which she comes, she has always already detached herself from this class and acquired a capacity for observing it from without' [2014, p. 169]. But isn't it also the question from which direction the innovation is supposed to come? In other words: whether it is from the perspective of the collection that something appears as new (as you argued in your book), or that something from the outside demands access to the collection? In the latter case, you might say that claims to just representation or, in Honneth's terms, cultural recognition, are in fact highly important.

**BG:** They are relevant. But first of all: if there is a pressure from the outside, a struggle to enter the collection, this struggle is almost always successful. Why is that? It is always successful because, as I try to show, it corresponds to a certain kind of inner logic of the collection itself: it wants to expand. When collections are confronted with something they overlooked they are eager to absorb it.

However, as I tried to discuss in *Über das Neue*, the question of minority representation involves two problems. In my view, this whole issue has an American background. When I went to America some years ago, it was an interesting discovery for me that I had to declare my 'race' in many forms. I suddenly belonged to the cultural majority, because I am a white male. There are 1,5 million Russians living in New York City alone, many don't speak English, but they are supposed to belong to the majority culture of the US. So first of all, the problem is: what counts as a minority and what is the majority? These categories are always problematic.

The second problem is that individual artists, writers, or philosophers never really represent their culture of origin. Could we say that Baudelaire is typical French, that Huysmans is? Or who is typical German or Dutch? After all, these artists represent only themselves. The idea that they represent a bigger group is, I would say, a very American idea.

**TL:** But even if you say that the individual artist doesn't represent a group, you still might say that the museum represents a certain Western white male culture, rather than other cultures, which are present geographically speaking but aren't represented in the museum's collection.

**BG:** I agree with that. We have a complicated structure of protest and domestication. To become a famous French poet, you first have to hate everything French, to break with the tradition. Like Rimbaud who said: I want to become black, I hate France, or Breton who said: when I see a French flag I vomit, and so on. If you are really and typically French, your work will never be in a French museum, and you will never be a French poet of genius,

because you will be average French. You will have to break all the rules, hate France—committing some crimes is always helpful; think of Genet—and only then you get the status of being a great French artist.

The problem with the contemporary struggles is that people want to have access to the collection, but without putting into question themselves and their own tradition. You are not obliged or expected to make this detour, not obliged to become other to yourself, which is, actually, the meaning of the word 'other'. As French philosophy crossed the Atlantic it changed in many ways, but the crucial change was in the word 'other'. In the French tradition, the 'other' is either God, or the subconscious, but in any case it is something living in you that is not you, that can possess you, destroy you, take over. You are struggling against it, put it under control or otherwise it controls you. It is an old story, and eventually led to Bataille, Foucault, and Derrida, for whom the other is writing: it is not you who write, but something in you and through you. But then, after this French philosophy crossed the Atlantic Ocean, the 'other' became simply: the other guy. People think they are already the other, because they are the other guy. This secularization or banalization of otherness is actually what constitutes the major part of contemporary discourse.

I don't say it's a wrong development, because secularization is at the core of our modern consciousness. I just wanted to point out that, in relation to the concept of the new, something changed. My relation to my identity changed. Instead of trying to destroy my identity, becoming other to myself and in this way gain access to the cultural tradition (as was always the case), now I simply reassert my identity and raise a claim to be accepted to the cultural archives, without any kind of suffering or inner struggle.

**TL:** Today, even more than when you wrote the book, innovation seems to be applauded throughout society, especially with regard to economic production. Think of Richard Florida's praise of the creative class and the creative city. Everyone has to be creative, think outside the

box, every product has to be innovative, and so on. How do you regard this imperative of creativity in the sphere of economic production?

**BG:** I think creativity is nonsense, total nonsense. The notion of creativity is a Christian notion *per se*, it is a residue of religion. I think that, if you are not a Catholic, and all these people probably are, you cannot believe in creativity. Mankind cannot be creative. It's the worst form of religious naivety. The only form of human productivity is combining, putting things together. The Internet was modelled after an elementary Turing machine, and that was actually a full description of what a human mind can do. After all it is just copy and paste. We cannot do anything ontologically new; that is the principle of human activity. So, creativity is divine privilege.

**TL:** You argue in your book that it is impossible to distinguish authentic from inauthentic newness. But don't you think that newness/novelty means something different, or is used in a different way, in different spheres? For instance, the new iPhone that one needs to have every couple of years; is it the same kind of newness as an innovation in the art world?

**BG:** A new iPhone is not an innovation. It is repetition. The structural condition of innovation is the archive. We have two models in our civilization: the supermarket, and the museum. What is the difference? One model, the museum, allows for innovation, because it keeps all the old productions, and so you can compare the old with the new. If I introduce a new product in the supermarket, it is simply part of the offer. You don't see what is not offered. Assyrian Gods, for instance, are not offered in the supermarket. What is not produced here and now is removed from the supermarket, and so we can't see it. And because you can't see it, you can't compare it, and because you can't compare it, you are in the same situation as you were before. Maybe you can remember what was in the supermarket two months ago, if you have a good memory, but not for very much longer. So, if you

are not in the archive but in the real world, there is no real change, because every moment is like the other moment. As long as you don't think teleologically—so if you don't think there is an origin, and don't believe there is an end—you cannot differentiate between one moment and another, since you cannot determine their distance from the beginning or the end. If you believe in the second coming of Christ, you can calculate the distance of a particular moment from the first and the second coming, but if there is no such promise, whatever it is, then it is like if you're running on a treadmill: you are running, but you remain in the same place.

When I came to America, there was the Obama campaign, with the posters 'Change', and 'Yes we can'. I always told my students: changing is the only thing we can. There is change today and change tomorrow. The only real change would be a change from change to no change—that is utopia.

**TL:** But social institutions can change. Replacing the feudal order with a democratic system is an actual change, isn't it?

**BG:** Yes, that was a historical change. But after that, and if there is no longer a hierarchy, then you don't have any change. The problem of our social institutions today is rather that they change all the time. You can never find the same person in the same place. I don't think democracy has anything to do with it. What happened is that ever since the industrial revolution, there is constant technological development, and we as humans tried to accommodate to changing situations. Every day, all our effort is concentrated on how to survive this day under different conditions. I cannot send e-mails because my mail program is obsolete; I can't install a new program, because my computer is obsolete; I cannot buy a new one, because I don't have Internet connection, etc. I spend day after day just trying to accommodate to these changes. Today we are witnessing the disappearance of the division of labour: you have to do everything yourself on the Internet, become your own doctor, taxi driver, and so on. What our civilization is about is basically the sheer material survival of mankind.

The protection of human beings is very closely related to the protection of artworks. Actually, the museum was installed at the same time and by the same people who thought of human rights. Human rights are actually the rights of the artwork: there is this body that has to be protected, and so you cannot use it, you cannot mistreat it, and so on. All you can do is look at it and speak about it. And that is precisely what is established in the museum: you look at art, you speak about it, but you cannot use it. Human rights are basically art rights.

Now, it seems to me that human beings are more and more left to themselves. We feel like Mowgli, or Tarzan, so that we have to see for ourselves what is dangerous, how we can improve our chances, and so on. Children are raised this way, with a very cautious and frightened attitude. If I remember my own young years, I was absolutely not frightened, but today my own students are scared to death. They have the feeling that if they lose, they'll simply perish; it is sheer fear for survival. They no longer believe in the social conditions for survival. It is an interesting period in human history. But there's no place to think of innovation, only of survival.

### III Innovation and Acceleration

**TL:** A more recent plea for societal innovation and progress has been accelerationism, as explained in Nick Srnicek and Alex Williams' much-discussed *#Accelerate Manifesto* from 2013. They argue that capitalism has become a source of stasis rather than of innovation. Rather than working against the accelerating powers of capitalism—as in the different slow-movements, or romanticizing localism and authenticity—we should speed up even further, so as to let capitalism crash against its own limits and go beyond it. How do you consider this proposal, or how in general would you describe the relationship between acceleration and innovation?

**BG:** There is no acceleration, there is just more pressure. Moreover, you are not the subject of this movement. The problem of accelerationism is the belief that you can appropriate this movement and steer it. That is impossible.

Even our friend Deleuze didn't believe that. He believed we can enjoy acceleration, but he didn't believe that we could control it, or appropriate it.

**TL:** In their recent book *Inventing the Future: Postcapitalism and a World Without Work* [2015], Srnicek and Williams further argue that left politics has abandoned the idea of progress and modernization, leaving them in the hands of neoliberalism, while retreating in a localized and romanticized 'folk politics', as they call it. In their view, the left should reclaim the future, and the category of the new is the instrument to do so. They write: 'If the supplanting of capitalism is impossible from the standpoint of one or even many defensive stances, it is because any form of prospective politics must set out to construct the new' [p. 75]. How would you respond to this?

**BG:** I think that the moment we are experiencing now creates illusions of this type in the minds of young people. They believe that they are something like living start-ups. It's a new neoliberal illusion. Our whole development will lead to stagnation. First of all, the globe itself is a symbol of stagnation: it circulates, while progress is linear. Today we speak not about universalism, but about globalization. But globalization is circulation and that means that we have already reached the point of stagnation. The stagnation is not obvious to most people, because there is still a middle class, with its traditional institutions: the universities, the museums, and so on. But as soon as these collapse, the middle class will also collapse. I sometimes tell my students that every day they spend at the university makes them poorer, because the people who have money, from Madonna to Bill Gates, never went to school. So, we will come to a very traditional situation of poor and rich, and this will produce the return of left ideas. Because, as long as you think that you can individually cross the bridge between poor and rich, as long as there is still a bridge to cross, you will always be neoliberal. You can think what you want, but you will try to do so. But if the gap is too wide, like in the 1920s and 1930s, like in Fritz Lang's *Metropolis*, then the only answer will be left ideas.

**TL:** What will these left ideas produce, then? A new middle class?

**BG:** We will see, we don't know that. I am like Marx: never predict what that revolution will produce. He was always against French utopianism. But I think it will produce a new Soviet Union. Not in precisely the same way, but to the extent that the Soviet Union was basically the administration of stagnation. In the contemporary competitive world, it was difficult to keep it. But if the whole world becomes stagnating, then the question of world revolution can come again, the question of international socialism can come again, the question of world administration and world state can come again, all the Hegelian/Marxist/Kojevian line will come again. Right now, it is suppressed by this running to nowhere. The feeling of that may be exciting, but it is a certain period of time, and it will not last very long.

**TL:** So if I understand you correctly you say that the left doesn't need new ideas, because these ideas are already there.

**BG:** Yes. In many ways we are back in the nineteenth century, and that is the rhythm of the European culture: the seventeenth century was reactionary, the eighteenth century was progressive, the nineteenth reactionary, the twentieth century progressive, etc. If you look at the reaction of the nineteenth century to the French Revolution, first of all, everybody believed that the Republican democratic regime collapsed because they could not succeed structurally, and secondly everybody believed the revolutionaries were morally evil because they killed children and young women under the guillotine. Both this moralization and the disbelief in the capacity of survival were general throughout the nineteenth century, but at the end everybody was democratic. Now you know how history works, there's nothing new: now the Soviet Union is totalitarian, terrible repression, women and children killed, and it was impossible, it could not survive. But in 70 or 80 years it will be completely reversed. So, we should simply relax and wait, for in time we will be disappointed

by neoliberal illusions and utopias, look at reality of life, which is miserable, and then look at the models, not of the better life, but of how to organize miserable life.

**TL:** Like in the saying of Brecht, that communism isn't the equal distribution of wealth, but of poverty.

**BG:** Of course. And it is as bad as any other social system, but it has at least one advantage, that I understood when I went to the West. You really didn't have *Angst*, this prominent insecurity, and this sheer fear of not surviving the next day. On this very basic level people felt themselves totally secure and protected. And I believe this desire for stability, protection, and security will emerge again.

Today you see it on the right. Why is that? The West believes it has won the Cold War against socialism and communism. But who exactly are the winners? It is neoliberalism and religiously coloured nationalism. Now they are fighting each other. But they will try to find a compromise, because they have a common feature, and that is competition. Neoliberalism believes in the competition of everybody against everybody, and the other in the competition of one ethnic group against the other. Both hate universalism, and both hate the ideas of solidarity and cooperation. They honestly believe that what is best should be defined by competition, and if you don't arrange a harsh competition you won't know what is the best or who is capable of winning. The problem is that, as I believe, man isn't capable of anything at all. The problem of nationalism and neoliberalism, then, is still the illusion of humanism, that humans can be creative, competitive, determine their own lives, can be responsible for themselves, and so on. They believe there is this kind of potential in human beings to deal with and manage any burden, going through any difficulty and making it: the American Dream. But it's all a huge lie, and the challenge is to see it as a huge lie that was only invented to terrorize people. To say to them: why are you poor, you have to make an effort, you have to struggle, you have to constantly improve and update yourself. Somehow, and at a certain point in time, we have to be relieved from this blackmail.

When I was a child and responsive to these things, I was always fascinated by these Russian posters, saying: let us reach the level of the current day. This presupposed that we are somehow always behind. Stalin, who was a good thinker and much more honest than everybody else, said: when we really understand Marxism and Leninism, we should accept that our situation is always a bit ahead of our ability to reflect on it. So, our thinking is behind our real situation. And that is precisely what connects capitalism and socialism, this belief in the powers that are faster than we can think.

### IV The Future of the New

**TL:** Let's return once more to the concept of the new in relation to the art world. In the Dutch book with essays on your work, Dirk van Bastelaere argues that the concept 'entropy' you use in *Logik der Sammlung* (according to which the collection constantly extends and absorbs that which it is not) should—in line with your own economic jargon—be replaced by the concept 'inflation', which is less neutral. Inflation would then mean that the increase in artistic innovations (and hence the culturalization of profane domains) implies at the same time a decrease in value of these innovations [Van Bastelaere et al. 2013, p. 85]. Do you agree with that diagnosis?

**BG:** If we follow our earlier line of thinking, that is if the whole system of selection and representation collapses, then the new will have no value at all. It only makes sense if you have the archives and institutions—and the critique of institutions is part of it. Without the institutions, the critique of institutions obviously makes no sense. Art that leaves the museum [e.g. street art, land art, performance art, community art, TL] always has to return to the museum in the shape of documentation. So whatever you do outside of the museum, also in contemporary art, has cultural value only if it is afterwards represented in the museum in the form of documentation.

**TL:** In an interview I did with Luc Boltanski [Celikates and Lijster, 2015] he argued, following Isabelle Graw,

that the economic valuation of art works can never persist without the aesthetic valuation by critics, curators, artists, and the like. If the two merge this is also destructive for the economic valuation. Do you agree with this analysis, and should this reassure us that market forces could never take over the art world completely?

**BG:** I think that art becomes more and more like a luxury product, like china or perfume. Everyone can make art, but not everybody makes a living from art. But if you don't make a living from art, it doesn't mean that you're not an artist. If you speak about professional art, you speak about making a living from art. Then it becomes simply a segment of the general market, and it's the same as Armani design and so on. If you look at creative districts in China, you see design, cutlery stores, fashion, art galleries, all together. But then it has nothing to do with general society.

**TL:** Is that so different from seventeenth-century Holland, when art was also a luxury product?

**BG:** The institution of the museum, as you know, was created after the French Revolution. The revolutionaries took the objects of use from the aristocracy and instead of destroying them, they disenfranchised them and exhibited them, but forbade their use. It was a decision in between iconoclasm and iconophilia. What Duchamp later did was a repetition of this gesture—it is the same gesture.

This museum is a public space. Privatization recreates the situation as it was before the French Revolution, but then we can no longer speak of public institutions and we lose historical awareness. So, the problem is not whether Isabelle Graw or someone else finds some painting beautiful, according to a certain aesthetic theory. The question is: is a certain artwork historically representative, so that it can be put in the museum? For a private collector, this question has no relevance, because it is his taste that matters, and not the archival importance. After writing *Über das Neue*, I was invited to Switzerland, where they organize schools for leading European collectors. I told them I considered these collections as installations and not as museums, because

the installation is the assemblage of objects according to a certain taste. At the moment you privatize, you get involved in private passions and relationships that have nothing to do with an archive.

I tend to think that the model I proposed is probably a model for secularized culture that started with the French Revolution and ended with the end of communism. Now this system of culture in general collapses—it still survives of course, this process of collapsing takes very long, and maybe the archives survive in another way. The first libraries were private collections, the first art collections were in the pyramids, and they survived. So maybe they will survive in a certain way, in so far as they survive the current model.

## Notes

1 Groys, *Über das Neue*. References in this text are to the English translation: *On the New*, trans. G.M. Goshgarian (London and New York: Verso, 2014).

2 This brings Groys' theory of artistic innovation close to Jacques Rancière's idea that aesthetics and politics are both characterized by *la partage du sensible*, the redistribution of what can be seen, heard, etc. See Rancière 2010.

## References

— Bastelaere, Dirk van, et al. 2013. *Boris Groys in Context*, ed. Solange de Boer. Amsterdam: Octavo.

— Celikates, Robin, and Thijs Lijster. 2015. 'Criticism, Critique, and Capitalism: Luc Boltanski in Conversation with Robin Celikates and Thijs Lijster'. In *Spaces for Criticism: Shifts in Contemporary Art Discourses*, ed. Thijs Lijster et al. Amsterdam: Valiz.

— Groys, Boris. 1988. *Gesamtkunstwerk Stalin*. Münich: Carl Hanser.
—. 1992. *Über das Neue: Versuch einer Kulturökonomie*. Münich: Carl Hanser; *On the New*, transl. G.M. Goshgarian. London and New York: Verso, 2014.
—. 1997. *Logik der Sammlung: Am Ende des musealen Zeitalters*. Münich: Carl Hanser.
—. 2003. *Topologie der Kunst*. Münich: Carl Hanser.
—. 2006. *Das kommunistische Postskriptum*. Frankfurt am Main: Suhrkamp.
—. 2008. *Art Power*. Cambridge, MA, and London: MIT Press.
—. 2009. 'Comrades of Time', *E-flux* #11, retrieved on 4 December 2017, www.e-flux.com/journal/11/61345/comrades-of-time/.

— Jameson, Fredric. 1998. *The Cultural Turn: Selected Writings on the Postmodern 1983-1998*. London and New York: Verso.

— Lyotard, Jean-François. 1991. *The Inhuman: Reflections on Time*, transl. Geoffrey Bennington and Rachel Bowlby. Stanford: Stanford University Press.

— Rancière, Jacques. 2010. *Dissensus: On Politics and Aesthetics*, transl. Steven Corcoran. London and New York: Continuum.

— Srnicek, Nick, and Alex Williams. 2015. *Inventing the Future: Postcapitalism and a World Without Work*. London and New York: Verso.

# Outside the White Cube
## A *Gedanken-experiment*

Akiem Helmling

In 1961, in his last public lecture at the symposium 'Where Do We Go from Here' at the Philadelphia Museum College of Art, Marcel Duchamp said:

> In conclusion, I hope that this mediocrity, conditioned by too many factors foreign to art *per se*, will this time bring a revolution on the ascetic level, of which the general public will not even be aware and which only a few initiates will develop on the fringe of a world blinded by economic fireworks. The great artist of tomorrow will go underground.

At the time of Duchamp's lecture, he himself had no longer been a member of the underground for many years. And now, almost sixty years later, we may undoubtedly conclude that Marcel Duchamp was one of the most important artists of the twentieth century. Perhaps even because of this elevated status Duchamp is also a symbol for the greatest change in art in the past hundred years: the advent of the White Cube, and the subsequent apparently total liberation of the artwork. This is a process with major and far-reaching social, aesthetic, and also economic consequences—both within and outside art—and forms the basis of our current concept of art. It is a turning point in the history of modern art.

Over the past hundred years we have seen how the artwork was first freed from all the constraints of the painted canvas in a gilded frame and then we've had to learn to accept that an artwork can take any form or shape imaginable, including material or immaterial. An artwork can be anything and anything can be an artwork. In order to accomplish this, it was necessary to elevate to the status of art the very works of which it was doubtful whether they could be art at all. Or, to put it differently: to change non-art into art. This was very much facilitated by the White Cube, the exhibition space that isolated artefacts from their surroundings, thereby bestowing upon them the aura of an artwork.

Duchamp's readymades are the best-known examples of this, because for the first time apparently ordinary non-art objects were suddenly transformed into artworks. This is also why the White Cube became the basis of a fundamentally renewed concept of art. Duchamp called it the transition from the retinal (the visible, the perceivable) to the mental. In the lecture quoted above, Duchamp claims that this process—the aesthetic revolution—has by now become reality, as it is even demanded of the public

at large. By using the words 'this time', Duchamp places an ascetic revolution within the context of the situation created by the aesthetic revolution. The one leading to the other.

Just like a hundred years ago, when the wider audience and most artists (perhaps even Duchamp himself) were not yet capable of fully comprehending the consequences and meaning of an *aesthetic* revolution, we may now again wonder whether we are capable of comprehending the possible meaning of an *ascetic* one.

At the time, it took roughly fifty years to realize the aesthetic revolution (the idea of the ready-made stems from 1915[1] but wasn't fully accepted as art until around 1960). Now, almost sixty years have passed since Duchamp predicted the next revolution. So, perhaps this is an interesting moment to ask ourselves what the deeper meaning of an ascetic revolution might be. And it may also be interesting to not only explore exactly what Duchamp was implying with his statement, but especially to look for the potential openings hidden within. We could attempt to regard it as not just a simple critique of the market, as just a call to artists to care less about the market and work even more from an independent, autonomous position. To see it not as a seemingly innocent statement, but as a sign of something much bigger. Perhaps even bigger than Duchamp himself may have imagined. Something that logically connects to the aesthetic revolution that we know, the liberation of the artwork. But then what is that something?

### Prelude to a Broken Arm

It now seems hard to imagine that the Board of the Society of Independent Artists reacted so shocked to Duchamp's entry of the readymade in 1917—an overturned urinal bearing the title *Fountain*. The official statement by which the work was refused for the exhibition at the time was: 'The Fountain may be a very useful object in its place, but its place is not an art exhibition and it is, by no definition, a work of art.' The status the work now has, a hundred years on, may be regarded as proof of the actual feasibility of what is humanly unimaginable. Perhaps not only within art, but in general, also because the 1917 judgement was made by fellow experts of *the* platform for avant-garde art. It is interesting that despite the work's unique position in recent art history there is also debate about its material genesis. For one thing, a

letter from 1917 has turned up in which Duchamp writes to his sister Suzanna that the work *Fountain*, signed by a female artist friend, had been presented to him as a gift. ('One of my female friends who had adopted the pseudonym Richard Mutt sent me a porcelain urinal as a sculpture; since there was nothing indecent about it, there was no reason to reject it.') Experts have since discovered that this unknown artist was most likely the Baroness Elsa von Freytag-Loringhoven, a well-known figure in the New York avant-garde art scene, who was influenced by Duchamp. But there is also a different story, in which the artist Joseph Stella and art collector Walter Arensberg claim to have been with Duchamp when he bought the urinal from J.L. Mott Iron Works at 118 Fifth Avenue. According to them, Duchamp then took it to his studio at 33 West 67th Street, turned it on its back and signed it 'R. Mutt 1917'. The only established fact in the matter seems to be that the term ready-made was already in use by the end of the nineteenth century for industrially produced objects in order to distinguish them from handmade products. That is why it is important to distinguish between the two different conceptual meanings of 'ready-made' and 'readymade'. The former defines the technical material nature of an object, in which the term indicates that an object was produced by machines instead of by hand (ready-made versus made-to-order). And the latter defines a conceptual artistic approach as Duchamp applied in his work. Duchamp has also referred to his readymade as a 'manifest'.

While the question of the technical-material authorship of *Fountain* may perhaps never be completely solved and we can therefore not say with absolute certainty that the object 'Fountain' was really found, moved, and signed by Duchamp himself, it would also be too simplistic to immediately conclude that Duchamp would therefore no longer be the author of the work. Within this context it is important to be aware of the fact that Duchamp had already been working on the idea of readymades for years. For example, in 1915 he had already declared a snow shovel a readymade by labelling it *Prelude to a Broken Arm*. And, finally, the fact that Duchamp had entered the work under a pseudonym does not seem to provide any insight into the material authorship of the work either. It is important to note that Duchamp only presented his readymade *en public* and under his own name many years later. The fact that at that time most of the original readymades had long since been lost and that Duchamp

had replicas of the original ready-made urinal (in the techni-cal-material sense of the word) made by craftsmen, may also be regarded as a sign of Duchamp's ambivalent attitude towards the artwork as such. The fact that the readymades we see today in a museum context are, with one exception,[2] not 'ready-mades' but 'readymades-made-to-order', lends the work another layer of mate-rial complexity that usually goes unnoticed by the public.

In another aspect as well, the materiality of *Fountain* is sig-nificantly different from that of most other works of art. As the Society of Independent Artists deemed the work unacceptable, it was never truly exhibited. The reason why, in spite of this, the work seems so familiar to many people certainly has to do with the fact that there are in total 15 replicas that Duchamp ordered between 1950 and 1964—33 years after he submitted the original version. These replicas are now on display in museums all over the world as the *Fountain*. Probably these replicas would not even ex-ist if not for the fact that Alfred Stieglitz took a photograph of the original object at the 291 Art Gallery, in 1917. In this photograph we see the work in front of the painting *Warriors* by Marsden Hartley, with the entry label also visible. The photograph became known later because it was published in the second issue of the art and Dada magazine *The Blind Man*. It is the only documentation of the work before it vanished for years without a trace. Of course, it is tempting to speculate about what would have become of the work if it had been exhibited, but its rejection does not appear to be the main reason for its eventual success. But then what makes the work so important? And especially: how is it possible that an artwork without the work itself, an image that only exists in docu-mentation, becomes so important in the end?

The main pitfall is perhaps to regard the work as an *objet trouvé*. This is a term once coined by Pablo Picasso but it is also frequently used in the context of Duchamp's work, especially with regard to *Fountain*. In the original material sense of the word the term is in fact incorrect when applied to the replicas that are now on display in museums all over the world. These are not artefacts produced by machines, but handcrafted ob-jects—replicas commissioned by Duchamp and produced spe-cifically for museum collections. An even bigger danger is that the term *objet trouvé* evokes the wrong suggestion: that *Foun-tain* was just something found by Duchamp that gained signif-icance only by presenting it within the context of a museum.

This object-motivated argument is contradictory to Duchamp's thinking, as it emphasizes the retinal, the visible, and not the mental. Based on Duchamp's thinking and the fact that he also called his readymades 'manifests', *Fountain* should primarily be regarded as a *concept declaré*. 'Readymade' is then used to describe a particular artistic *process*, not in the technical-material sense of the word.

Starting from the question whether it was at all possible to make works that are non-art, Duchamp was also always looking for 'a work without art', which may perhaps also be interpreted as 'art without a work'. This would be in line with Duchamp's opinion that art is a process of doing, not of making. To him art works were primarily important because collectors could buy them so that artists would have an income and be able to make art.

### The New

It is not surprising that Boris Groys in his 1992 book *Über das Neue: Versuch einer Kulturökonomie* (*On the New*) refers to Duchamp's readymades—and particularly to *Fountain*—when introducing his concept of 'the new'. Groys describes 'the new' as a moment of valorization change: a situation when something that had not been regarded as relevant (valuable) until then, suddenly acquires a cultural and therefore an economic value. This valorization is often counter-balanced by something else losing its value to us. From this perspective, the work *Fountain* was not created when Duchamp decided to submit a urinal for an exhibition in 1917. Nor in 1950, when the art dealer Sidney Janis asked Duchamp to declare a urinal—which Janis had bought himself for an exhibition in his New York gallery—to be art by signing it. It was created at the very moment when the first people, like Sidney Janis, suddenly realized that a urinal on its back could be more than a urinal on its back, shortly before a wider group of experts also saw cultural value in putting a urinal on its back, signing it, and calling it *Fountain*. It was long before replicas of *Fountain* would be exhibited all over the world. It was the moment when it changed from non-art into art, without actually existing. 'The new' is a change of perspective, exclusively founded on a mental process. 'The new' understood as a reframing of cultural values, not of objects.

'The new' was produced through a purely communicative process generated by a photograph that was published in a magazine a few years before. An image that on the one hand wasn't a

classical 'installation shot' as we know it today, but on the other hand had exactly the same effect. Because the beholder is eliminated from the image it gives the impression of a contemplative art experience, giving us the feeling of participating in the presentation without actually being there. The photograph displaces the work from its spatial location to a medial dimension. This is also why, as Brian O'Doherty explains in his 1976 book *Inside the White Cube*, the installation shot can be regarded as a cultural icon of the twentieth century. The century in which the traditional notion of Ernst Gombrich that one always had to have seen a work in reality in order to experience it, slowly but surely lost its meaning by the advent of new media and virtualization of society.

While this development could be seen as a threat to the aura of art, it can also be understood as a logical development of art as a discipline defined by continuous change. Or, as Adorno states in his *Aesthetic Theory*: 'It is self-evident that nothing concerning art is self-evident anymore, not its inner life, not its relation to the world, not even its right to exist.'[3] Or: the only constant in art is this not being self-evident of all its elements: production, perception, meaning; the artist, the work, the beholder. In art everything can change.

Convinced that in art everything must change, curator, director, and driving force behind the then recently opened Museum Abteiberg in Mönchengladbach, Johannes Cladders, wrote the essay 'Das Antimuseum: Gedanken zur Kunstplege' (The Anti-Museum: Thoughts on Art Presentation), in 1968. This text was part of a 'Kassettenkatalog' published on the occasion of the exhibition 'Beleg: Kunstwerke der zweiten Hälfte des 20. Jahrhunderts aus dem Besitz der Stadt Mönchengladbach' (Evidence: Artworks from the Second Half of the Twentieth Century from the Collection of the City of Mönchengladbach). Cladders wanted to introduce a broader perspective for the presentation of art by regarding the institution of the 'museum' first and foremost as a spiritual home. This idea is especially reflected in the museum's new building because of the human-scale dimensions in which the art is displayed. Commissioned by Johannes Cladders and designed by Hans Hollein, the new museum opened in 1982. Not only did Cladders see the museum as an architectural, contemplative space, he felt it was important to approach an exhibition as an experimental meeting place as well. By publishing three-dimensional boxes (the aforementioned 'Kassettenkataloge') instead of

traditional catalogues he made these elements full-fledged parts of the exhibition instead of just being purely supplemental. In a sense, by doing so he also opened up the institutional space by not limiting it exclusively to the space inside the museum walls.

In his essay 'Anti-Museum...', Cladders was driven by his wish to overcome the museum as an aloof and cold institution and he saw a chance to achieve this through Dada and Duchamp's work especially. He builds on this and tries to translate these thoughts to the institutional sector. Cladders doesn't use the term 'anti' here as a rejection of what is, but much more as a kind of contrast to it. Just as Duchamp's art—which Cladders also calls Anti-Art—has nonetheless remained art, Cladders believed that it was the Anti-Museum's fate to still remain a museum. The Anti-Museum is therefore not so much a revolutionary programme, but rather a broadening of the possibilities of what is already there. He noted that this possible broadening and shifting is typically something that has always taken place in art. This is why the history of art is always also the history of different concepts and models of art. Palaeolithic art, the art of the Renaissance, of antiquity, and of the Gothic Age are just as different from each other as that of the Romantic era from the art of today. In this respect he agreed with Adorno that if you include the future in this, it cannot be taken for granted that art and its concomitant institutes will even still exist then. These two aspects, art and presentation (for which Cladders used the word 'Kunstpflege') always coexist, with the museum occupying centre stage. From the sixteenth-century *Wunderkammer* via the Historical Museum of the nineteenth century to the White Cube of today.

The Anti-Museum builds on an essay by Willem Sandberg—director of the Stedelijk Museum Amsterdam from 1945 to 1964—that was published ten years before in the series 'kwadraatbladen' of Steendrukkerij De Jong. In this highly controversial essay bearing the title 'Nu: Midden in de XXe eeuw: De kunst en het leven' (Now: In the Middle of the XXth Century: Art and Life) Sandberg outlined a conceptual framework in which the museum was not seen as a purely contemplative space, but primarily as a social space, a space of life. Thereto, Sandberg distinguished between two groups of art practices. On the one side the group that builds on what is already there with the aim of making life more beautiful and more pleasant. On the other side the group that, by contrast,

tries to make that which does not yet exist. It is in this second group, according to Sandberg, that the work is created in which the new reveals itself to us:

> the first group calms us
> the public admires their work immediately
> the critics are raving about it
> and forget it
> the others shock our feelings
> they grip our interest, they stimulate
> or simply repel us
> and future generations will appreciate them
> using terms like 'grand' and beautiful

Sandberg concludes his argument for a different vision on art by stating that '...that place of today, where the future is at home, has no property, otherwise it will soon be a museum again.'

In short: the very moment that artefacts become part of a museum collection they are no longer synonymous with the new, but merely evidence of something that at one time was new. They are witnesses of a different age. This is also a big dilemma for the museum/White Cube: on the one hand they need to point out the new, on the other hand the new is already no longer new at the time that it is actually on display, because this makes it part of the system. It is like Russell's paradox.

### The Ethics of Aesthetics

The dominance of the White Cube as a conceptual framework in contemporary art is emphasized by the extensive infrastructure that has developed around it. There are professions such as curator, media such as contemporary art magazines, and events such as biennials and art fairs. Meanwhile, though, there seems to be some kind of emancipatory process going on: the mutual emancipation of art and the White Cube.

Whereas the White Cube was once needed to elevate art as such and the White Cube without art was unimaginable, today both aspects no longer seem to be the case. Nowadays the White Cube's primary significance is no longer cultural but much more commercial. In the twentieth century the White Cube still played an important role in exploring the question 'What is art?' but that same space now appears to function primarily as a way

of distinguishing between artworks as commodities. Just like artefacts once needed the White Cube to be elevated to art and be accepted as such, now art uses the White Cube mainly to increase its value. This makes the question of whether something is art or not a moot point and it changes cultural necessity into economic interest. At the same time, the White Cube also no longer really needs art to legitimize itself. The emancipated White Cube is increasingly a shop catering to the market: art, design, fashion. It is fully incorporated within the capitalist system that we have opted for ourselves. This means that this emancipation is not so much a deliberate choice but rather the result of a situation that is primarily determined by thinking in terms of profit.

In his 2015 book *Die Kunst und das gute Leben: Über die Ethik der Ästhetik* (Art and the Good Life: On the Ethics of Aesthetics) Hanno Rautenberg observes these developments and in this new economic position of the White Cube and concomitant infrastructure he discerns a paradigm shift in art. Whereas the artists of the twentieth century fought for their autonomy, at the beginning of the twenty-first century it looks as if there is a relapse to the situation in which the artist is an 'executive agent', someone who makes work in commission. Also a situation in which huge exhibitions such as documenta—the 'conscience of art', that once started from the questions 'What is art?' and 'Why art at all?'—commission works from artists that fit the concept of the exhibition. If the beginning of the twentieth century was defined by the advent of the readymades, now, at the beginning of the twenty-first century, it looks like we are back again at the 'made-to-orders': delivery on demand. Unlike the readymades, they originate within an existing system rather than outside of it.

In an article in the Dutch weekly magazine *De Groene Amsterdammer* of 9 September 2015, Rudi Fuchs, artistic director of Documenta 7 (1982) and as such responsible for the historical work *7000 Eichen* (*7000 Oaks*) by Joseph Beuys, straightforwardly explained that he too had preconceived ideas about the content of 'his' Documenta at the time. He envisioned a large Beuys fountain or basin, a sort of spectacular water display that would serve as a symbol for Beuys' notion of energy and also function as a striking, accessible, and spectacular crowd puller. Two days after presenting his idea for a fountain to Beuys, the artist returned his call and simply said: 'A fountain is nice... but I wish to plant 7000 oaks.' Fuchs responded with empathy, spontaneously dropped his own

idea and accepted that of Beuys. Beuys, also known at the time for his formula art=capital, then told Fuchs: 'Our real capital is not money, but the agility of human thinking.' In other words: *'Es kommt alles auf den Wärmecharakter im Denken an.'*

Now, in 2018, we may conclude that this *Wärmecharakter im Denken*—Fuchs' empathy for Beuys' idea—not only left us with a spectacular work in which public perception changed from enormous irritation to an enthusiastic embrace, but meanwhile scientists too have discovered the work as a unique treasure trove. Never before in the history of our planet were so many trees planted at various locations in a city at one specific moment. Almost forty years later, this enables scientists such as Prof. Dr. Thorsten Gaertig to study the degree of density or closure of the soil in relation to a healthy growth of the trees.

The interesting thing about Beuys' work *7000 Eichen:* Stadtverwaldung statt Stadtverwaltung (7000 Oaks: City Forestation Instead of City Administration) is that there is both a form and a counter-form of it. There is the form it has now: 7000 oaks, all with a basalt stone partly embedded in the soil next to them, in and around the town of Kassel. As these stones were placed at the same time the trees were planted and had to be stored somewhere in the meantime, there was a temporary counter-form as a wedge-shaped pile of 7000 basalt stones on Friedrichsplatz. A temporary storage, a temporary monument, a presence that underlined the urgency of the project. By choosing oaks, which can live up to 1500 years, Beuys wanted to put the human scale into perspective while at the same time realizing the unimaginable. This aspect was underlined by placing the stones next to the trees. This means that the present form can again be seen as the counter-form for a later stage, when the trees eventually disappear. To then be regarded as yet another counterform for the completion of the work: the moment that the stones have also disintegrated into individual molecules.

Beuys took a very pragmatic attitude to his pile of basalt stones: he too liked to see it disappear sooner rather than later. This is why he asked the town residents to help him plant the trees as quickly as possible and thus make the pile of stones disappear. *7000 Oaks* therefore perhaps says just as much about the disappearance of this counter-form as it does about the form, the trees, that is now still there. And if you wish to take it even further, in the end this work is perhaps not even about its materiality, the stones

or the trees, but purely about the mental awareness of looking at art and life in a different way.

Although neither Beuys nor Duchamp ever used the word 'Anti' with regard to their art practice it is often associated with their work by art historians. Outside the field of art, the less subtle term 'charlatan' is also frequently used. In Beuys' case people mainly saw an unacceptable contradiction between his commercial success and the anthropological concept of art he advocated: *Der erweiterter Kunstbegriff* (The expanded notion of art) and the *Soziale Plastik* (Social sculpture) that resulted from it. It was a conceptual framework in which Beuys saw mankind as a work of art, a kind of continuous global performance that was defined by those taking part in it, or, in his words, was sculpturally formed by them.

In this line of thinking mankind can not only be regarded as a social *corpus*, but also as an aesthetic sculpture that is being defined by the behaviour of all individuals. This opens up the perspective of mankind as a work of art, or even more concise: the notion of mankind as an artwork and being-human as art. As this artwork is formed by us, it follows that we take up the position of an artist. Just as a sculptor shapes a sculpture from a piece of clay, we shape the artwork called mankind together, wherein human creativity is the key to doing this in a relevant and conceptually interesting manner. The fact that works by Beuys were at one point among the most expensive in the world doesn't take anything away from this concept. Especially at the pinnacle of his career Beuys increasingly focused on pure social sculpture, leaving the material, the White Cube, and commerce behind and using his income from the White Cube infrastructure towards the realization of projects outside of it.

Thanks to the great number of recordings that have since become available via the Internet we have a pretty good insight into Beuys' thinking. Whereas Duchamp used language primarily with a dense playfulness (for example in the work *L.H.O.O.Q* from 1919), for Beuys the dialogue about the work has always been an important element in all of his art. Unlike other artists, Beuys never feared that the unambiguousness of words would threaten the imaginative nature of art or could make an artwork look simplistic. Perhaps we will one day become convinced that these recordings are closer to the essence of Beuys' work than the material forms currently in museum collections all over the world.

As, for instance, the work *Wille Gefühl Form* from 1980, which is in the collection of the Boijmans Van Beuningen Museum in Rotterdam. The interesting thing about this work is that Boijmans is also in possession of the video recordings of the public debate during which this work came to be. The work consists of a large chalk drawing on a blackboard in which Beuys illustrates his energy-anthroposophical notion of sculpture. When Beuys can no longer clearly formulate what he is trying to express, he goes to the blackboard in order to say it in a drawing. Language and image, artwork and discourse thus merge fluently.

Interestingly, although Beuys could sometimes be hard to follow due to his specific use of language, there is great coherence in all of his public debates and speeches. Instead of seeing him as the 'felt-and-fat' artist, from a different perspective one could justifiably see him as an artist of the word. As with Duchamp, in Beuys' work it is especially the concepts he created rather than the works themselves that take centre stage and have led to innovations in art. Building on Beuys' thinking, the creation of a concept should not be seen as just a neologism but also as an artistic, sculptural process. Apart from this, the choice to create an imaginary 'course of work'—a sequence of works—instead of a course of life seems just as logical as his conviction to see us humans not so much as productive but rather as creative beings. And from that follows his notion: 'Jeder Mensch ist ein Künstler'. A call that was often mistakenly understood to mean a possibility, but according to Beuys being an artist is not a choice. It is an inescapable part of human existence if we see mankind as creative instead of productive.

Via the 'expanded notion of art' it is possible to regard human thinking as a process that goes from rational to sculptural. This allowed Beuys to break through the physical limitations of the White Cube and have this process take place within ourselves, through art. In doing so, he built on the ideas of Nietzsche and his 'Umwertung aller Werte' (Revaluation of all values) and was in line with Erich Fromm by placing 'to be' above 'to have'.

### Outside the White Cube

Within the context of the 1972 São Paulo Biennial, the Czech philosopher and author Vilém Flusser stated that the crisis of art is a crisis of its presentation. Duchamp and Beuys are perhaps the clearest evidence of this. It seems rather logical that a mental

work or an 'expanded notion of art' would take place on a textual rather than a visual level. This of course is at odds with the mechanism of the White Cube model, as with the disappearance of the retinal experience the work would lose most of its legitimization. Meanwhile we have a situation in which institutions all over the world present 'artistic ideas' to the public as 'retinal works', while at the same time excluding much art, especially art that is critical of the idea of 'artworks'.

Perhaps the biggest pitfall for art in the twenty-first century is to not see and not understand the new (in art) because it is shown in an inadequate context and/or format. Just as we instantly regard a pile of annotated pages in a library as a book, we automatically regard anything that is on display in a White Cube as a work of art. This is the tragedy of the White Cube: where once it was needed to make way for a new concept of art, it now starts to be an obstacle for such a new concept. Just like the 'salon' format restrained art in a gilded frame, the White Cube frames art in artworks. And thus, our insight changes: a space that made innovation possible now transforms into a space that blocks innovation. This means that the most progressive trends in art remain invisible to the public at large.

Tehching Hsieh is one example of such a progressive artist. He not only approaches art as an immaterial discipline, but beyond and above that also as a discipline oriented to 'being'. Born in 1950 in Taiwan, he emigrated to the USA when he was 24. Between 1978 and 1986, as an illegal immigrant, he completed five one-year-long performances. One of these was the 1978–1979 *Cage Piece*, in which he locked himself into a wooden cell of 3.5 x 2.7 x 2.4 metres that contained only a washstand, a lamp, a bucket, and a bed, for a whole year. During that year he did not permit himself to talk, read, write, or watch TV, or listen to the radio. The entire process was documented by a public notary who also testified that the artist did not leave the cell. A roommate of his prepared Hsieh's meals and took out the garbage. Once or twice a month the action was open to the public. Looking back, the interesting thing about this action is that it took place before this type of happenings were automatically public events via the Internet and social media. Although no exact record exists of how many people actually visited Hsieh at his cell in his own house we may assume that the *Cage Piece*, just like Duchamp's *Fountain*, became known mainly through its documentation and archiving.

In the years after this Hsieh continued his One Year Performances. In 1980-1981 with *Time Clock Piece*, in which he punched a card in a timeclock every hour and took a photograph of himself. This resulted in more than 8700 photographs (365 days times 24 hours), which the artist later edited into a six-minute film that showed each photograph for 1/25th of a second. During 1981-1982 Hsieh worked on his *Outdoor Piece*: for a whole year he did not enter any buildings or other sheltered spaces, such as trains, boats, or public toilets. This action was followed up by *Rope Piece*, another one year-long performance in which the artist was tied to the female artist Linda Montano with a rope of 2.4 metres. The series was concluded with the work *No Art Piece*, in which the artist eliminated art from his life for an entire year by not making art, not talking about art, not looking at anything related to art, not reading about it or entering any art institutions. This is also the only work in the cycle that remains undocumented.

Tehching Hsieh's reason for making these five works is not that he is into self-castigation or suffering but has to do with his conviction that in human 'being' the relationship with time plays an existential role. This role is so crucial because the interaction between time and being affords the hidden possibility of the new, of the unknown. In order to actually make this process happen, one needs to take the necessary time, which for Hsieh was always one whole year. Hsieh calls this process 'Doing Time'.

While this cycle can also be seen as an illustration of the ascetic revolution announced by Duchamp—'a revolution that will develop on the fringe of a world blinded by economic fireworks'[4]—Hsieh takes this even one step further in his next work. In his *Thirteen Year Plan, 1986-1999* he sets himself the condition to make art during these 13 years but not exhibit it. He concludes this action with the words: 'I kept myself a life. I passed the dec 31.1999', made of cut-out letters glued to a poster. The artist himself has said about this work that its completion was also the starting point for yet another period in which he no longer considered himself an artist.

Hsieh's critical-reflective attitude towards art and its presentation can also be found in the work of Gustav Metzger. Born in 1926—five years after Beuys—Metzger became known for his manifestos on 'Auto-destructive Art', which he started writing in

1959. In these manifestos Metzger called for attention to the transformative potential of destruction. To him, 'being' was primarily defined by 'perishing', for humans as well as for objects.

In the 1970s, Metzger introduced his idea of the 'Years without Art'. It was a proposal in which he called on artists not to produce any art for three years. This action was often wrongly interpreted as an 'art strike'. By using the word 'without', Metzger deliberately placed the artists in a superior position with regard to the market, whereas 'strike' would imply a subordinate position, such as that of an employee. In Metzger's view artists, especially because they are autonomous producers, have the option of imposing a kind of embargo on the market, simply by not delivering what they are asked to deliver. In 'Years without Art' this independence is clearly emphasized.

Although Metzger made no clear statements about whether 'Years without Art' itself could be considered a work, it seamlessly fits in the series of the 'readymades' by Duchamp, the 'Sozialen Plastik' of Beuys and 'Doing Time' of Hsieh. And although these 'works' originated from different conceptual frameworks, they all seem to also be a search for a concept of art that transcends the traditional artwork. Duchamp used the strategy of using machine-produced objects in order to make them interchangeable and therefore redundant. Beuys, by expanding art from an explicit discipline of choice to something implicit in human existence. And Hsieh uses art to come into contact with the unknown. The resulting works: a urinal on its back, a chalk drawing on a blackboard, and a six-minute film, are merely witnesses and thereby transcend the expectation that an artwork be self-referential.

By now we know that at the time of his lecture in Philadelphia, Duchamp had already been working in secret on his last work, *Étant donnés*, for more than fifteen years. The work was shown in the Philadelphia Museum of Art in 1969, according to the artist's wish that it wasn't to be exhibited until after his death. But again, it would be too simplistic to regard the ascetic revolution as only self-referential to his own practice.

Fact is that this statement was made by an artist who has dared to think the impossible by regarding non-art as art. Secretly at first, later also publicly. Because we now also know that Duchamp, in spite of the fact that he manifested his first readymades already in 1915, didn't go public with them until around 1950. This may be related to a lack of self-confidence but it is also

quite possible that in 1915 even Duchamp himself wasn't really aware of what his idea would eventually come to mean. Perhaps the call to regard art as a mental instead of a retinal discipline was not only aimed at a concrete objective goal but was especially an appeal to himself to arrive at something new. The fact that both *Fountain* and *Prelude to a Broken Arm* remain retinal artworks in the traditional form does therefore not contradict his own words but illustrates exactly what his statement aims to achieve: a new perspective for art.

Shortly before he died, Duchamp said about his own work: 'I'm not at all sure that the concept of the readymade isn't the most important single idea to come out of my work.' Is this then perhaps the essence of Duchamp and is his work in the end exactly about the same theme as that of Beuys: an expansion of the concept of art? And isn't Duchamp's work therefore less about the works he actually realized than about the new perspective that he introduced with the readymade?

**Art without a Work—Art as a *Gedankenexperiment***
Etymologically, the word 'ascetism' comes from the Greek word 'askeín' (ἀσκεῖν), which means something like 'practising'. It was originally used mainly in a religious-philosophical context in the sense of practising a pure way of living. Through the years, its meaning was expanded until it was applied to all sorts of things: renouncing drugs for pleasure, renouncing food, sex, make-up and body care, clothing, sleep, protection from heat and cold, a soft place to sleep, possessions, social relations, the satisfaction of personal needs, a personal opinion, any form of communication, freedom of movement. And with Duchamp? Is the ascetics he calls for about art itself (the artwork), the person behind it (the artist), or about the final presentation of the work (the public and the institutions)? But then what would be left? Art without artworks, without artists, and without public? Non-art that is yet to become art?

In a BBC interview with Joan Bakewell of 5 June 1968, four months before his death, Duchamp provided more insight into his ideas concerning the ascetic revolution, using the words 'shock' instead of revolution and 'anart' instead of ascetic. 'Anart', no art at all, Duchamp explained, is a shock (i.e. a revolution) because it looks at art from a different perspective, as something we 'do' instead of 'make'. And because this 'doing', the being, the action

is implicitly linked to being-human, art too is a universal thing that concerns each and everyone, not just artists. The difference between artists and non-artists is therefore not a logical distinction but a purely artificial one, according to Duchamp. The very moment we accept this, a new concept of art arises. A model that breaks with the notion of art as a discipline in which artists make works for the market, and in which humanity is promoted to the status of artists by the action itself. The ascetic revolution. The moment in which art is liberated from the primacy of the artist and the artwork.

### Gedankenexperiment

Although the *Gedankenexperiment* is a concept primarily known in mathematics and philosophy, it also seems to harbour the possibility to arrive at a new concept of art. A concept that builds on art as we know it but at the same time transcends it.

If, for example, we imagine the lives of Beuys and Duchamp as lines between two points, one symbolizing their birth and the other their death, we could arrange all their works and thoughts along these lines. And if we then extend these lines beyond both the beginning and the end point, the possibility of seeing speculative events emerges. On Duchamp's line, for example, we may find that he already saw chess—which he practiced at a high level in his later years—as a readymade as well, comparable to *Fountain*, something that just is. Something the meaning and importance of which are determined by ourselves. And if we were to do the same thing with other lines—those of Beuys, Metzger, Hsieh, and yours too—we may also find that all these lines are not completely straight but start to curve at some point. Like the curvature Einstein discovered in his own thought experiment in the space-time model and which became the basis for his general theory of relativity. A curvature that is caused by a force that itself remains invisible and of which we can only observe the effects. A force that, because it is invisible, could be regarded as ascetic and underground. A force that allows us to experience the new and to do something we can't do. And perhaps even more importantly, thus teaches us to value not-being-able-to-do. To discover that within art there is a force that allows us to make the leap from the ladder we have just ascended. To leave behind the things we know and yield to the unknown. To see and experience things that will remain invisible for those who know everything.

## Notes

1 The website of the MoMA states that
*Bicycle Wheel* from 1913 was the first
readymade, declared by Duchamp.
But until now there is no proper proof
that this object was actually regarded
as a work of art by Duchamp himself.
Objectively, it is also not following the
idea of a readymade because it is a
sculptural combination of two un-
connected objects. As also described
on the website of the MoMA: 'I had
the happy idea to fasten a bicycle
wheel to a kitchen stool and watch it
turn... To see that wheel turning was
very soothing, very comforting ...
I enjoyed looking at it, just as I enjoy
looking at the flames dancing in a
fireplace.'
2 In addition to the original version
of *Fountain*, 16 other versions of
the work are known. All except two
are handmade reproductions of the
original work. For a list of the works:
www.cabinetmagazine.org/issues/27/
duchamp.php.
3 Theodor Adorno, *Aesthetic Theory*,
transl. Robert Hullot-Kentor (London
and New York: Continuum, 1977).
4 See the quote at the beginning of this
essay.

## Bibliography

— Adorno,Theodor W. *Ästhetische
Theorie*. Frankfurt: Suhrkamp Verlag,
1973.
— Beuys, Joseph. 'Zur Aktion. 7000
Eichen.' In *Documenta 7*. Edited by
Saskia Bos, pp. 44–47. Kassel: D+V
Paul Dierichs GmbH & Co, 1982.
— Cladders, Johannes. *Reden und Texte,
1967-1978: Eine Auswahl*.
Mönchengladbach: Städtisches
Museum Abteiberg, 2009.
— Duchamp, Marcel. *Die Schriften 1*.
Zürich: Regenbogen-Verlag, 1981.
— Fuchs, Rudi. 'Bomen en mensen.'
*De Groene Amsterdammer* no. 37, 2015.
— Groys, Boris. *Über das Neue: Versuch
eine Kulturökonomie*. Munich: Carl
Hanser Verlag, 1992.
— Fromm, Erich. *Haben oder Sein:
Die seelichen Grundlagen einer neuen
Gesellschaft*. Munich: Deutscher
Taschenbuch Verlag, 1979.
— Hoffmann, Rolf. *Hommage a Cladders*.
Mönchengladbach: Museumsverein
Mönchengladbach, 1984.
— Menke, Christoph. *Die Kraft der Kunst*.
Berlin: Suhrkamp Verlag, 2013.
— O'Doherty, Brian. *In der weißen Zelle:
Inside the White Cube*. Berlin: Merve
Verlag, 1996.
—. *Atelier und Galerie: Studio and Cube*.
Berlin : Merve Verlag, 2012.
— Rauterberg, Hanno. *Die Kunst und das
gute Leben: Über die Ethik der Ästhetik*.
Berlin: Suhrkamp Verlag, 2015.
— Sandberg, Willem. *Nu: Midden in de
XXe eeuw* (Kwadraatblad). Amsterdam:
Steendrukkerij De Jong, 1959.
— Wittgenstein, Ludwig. *Tractatus logico-
philosophicus: Logische-philosophische
Abhandlung*. Frankfurt: Suhrkamp
Verlag, 1963.

# The Paradox of the New Institution
## On Time and Imagination

Bojana Kunst

## The Paradox of the New Institution

Something perplexing is happening with the precarious work of contemporary artists, which is most noticeable in project-based art institutions. I am thinking of those institutions that are diverging from the historical model of national institutions, that appeared together with the late capitalist economy from the 1990s on, and that mainly support contemporary performance practices and the production of projects. These non-governmental, independent institutions producing and supporting contemporary performance, dance, and visual art projects, are the inheritors of the specific politic and economic situation of the early 1990s and haven´t changed much since then, even if their conditions have, and very much so. Those houses and spaces mostly arose from a particular situation in Europe in the beginning of the 1990s, a situation that was the result of economic growth, the fall of the Berlin wall, the rise of neoliberalism, internationalization and overall economization of production and creative imagination, the rise of the creative and attractive cities, and the discovery of the East (and South) of Europe. The model, which was somehow aimed at supporting international, engaged, and daring practices through international collaboration and co-production, and which gave support to nomadic, highly educated, internationally oriented artists, is nowadays deeply questionable and full of paradoxes. This is because of the changed economic and ideological situation, caused by overall governmental precarization. Isabell Lorey has described the process of governing through continuous precarization, the establishment of certain social links, structures, relations and dynamics in society precisely through the production of a pertinent feeling of fear and insecurity (Lorey 2015). In this sense, the very daily reality of the art institution is also governed by precarity—with the accelerated, regulated, and evaluated process of production, where the only possibility is to self-produce continuously while struggling with politicians, marketing processes, and continuous self-invention. At first sight such institutions appear far from being closed or bound to space in a traditional sense, but rather flexible, continuously on the look-out for young and inventive artists, producing concepts, intervening in the surrounding, and so on. However, such a mode of production should be considered in relation to the fear of insecurity: art institutions are not exceptions from governmental precarization, but so deeply involved in its normalization that in many cases they have become

utter examples of it. The art institutions themselves are deeply embedded in the constant use of vulnerability as a main social capital today: not only that many of them are working with a very poorly paid or voluntary work force (and paradoxically this especially goes for the ones that are the most stable and can use their symbolic value for even greater exploitation), but these 'labourers' also work under vulnerable and unstable conditions that require the constant implication of protective measures. The insecurity is caused by several interrelated factors, strongly influencing the production in the contemporary art institutions. Among these are the persistent threats of being cut off from (government) funding, the always changing bureaucratic regulations, which demand continuous production of quantitatively measurable works, and the shift of the public interest to an individualized notion of the public, to the market and private taste. Paradoxically, all these demands are also related to the need to continuously produce new, ground-breaking, and cutting-edge works of art, the kind of art projects that open up new experiences for the audiences and are open to the future. To protect their own vulnerability, the institutions have to constantly reach out, develop themselves primarily as social places, and give a new and attractive form to human productivity: they have not only to develop but also to stage their own public, exhibit their own audience. Only in this way can they endure the clash of temporalities between continuous need for measurement, evaluation on the one hand and aesthetic invention on the other, which finds its perfect form in the temporal project.

### Temporality of Production

Historically the term 'project' was used in the production of arts in the 1960s, mostly as a description of highly heterogeneous practices that entail collaboration with other authors, the blurring of the boundaries between art and life, and a de-hierarchization of the ways of working. Nowadays, project has another meaning. It can still keep its experimental and heterogenous nature, but at the same time these processes are homogenous in relation to time: a project has to be future-oriented, it has to deliver in the future what is already imagined as the proposal at its beginning. There is a temporal loop between present and the future in the project, which I name 'projective temporality' (Kunst 2015). Projective temporality is one of the reasons why artistic work and creative industries can be analyzed in close

connection with capitalist production processes and why we can at the same time observe a disappearance of a constitutive place for art in society; this disappearance is closely connected with various forms of temporality. Projective temporality influences the acceleration of imaginative and creative work, the furthering of the transformation of the new and it causes an even more radical affective individuation of the subject. The rigid connection between work and the future does not give rise to changes in ways of being and creating but is connected to administrating the contexts of the future and recognizing future values on the artistic market. There is something destructive about projective temporality: it opens up numerous possibilities, but it does not really open up the differences as well. The ultimate horizon of the work is always the completion of the project itself. The future is projected as equivalent or somehow proportionate to the present. It is presented as a continuity of the present: the future which is already foreseen as such in the project itself.

Such temporality influences are also the way institutions are working today: most of the time functioning as logistical and production knots for many simultaneous projects, which have to continuously compete in cleverness, cunning, and tactical strength, but at the same time also nourish the values of collaboration and friendship among cultural agents and the surrounding society to keep the affective side of project as an open future possibility. Interesting is also that exactly this need to develop as daring institutions—i.e. flexible, social, and communicative places where art is not only produced but the whole experience of art (including the work process and the post-effect of the work) is curated, managed, and organized—in many ways also changed the conservative, traditional institutions and opened up their production to different collaborations with freelancing and independent authors. However, that does not mean that there are now more possibilities for the artists to develop continuous and stable work, it rather means there is an even faster circulation of authors, the speeding up of their biographies, with very little chance for continuity and decelerated development of their work. At the same time, new collaborations do not necessarily change how institutions operate. Even if the aesthetic hierarchies could be changed (like, for example, the boundaries between performance and exhibition, between art genres and disciplines), the institutional hierarchies mostly remain the same; they only change their pace

and introduce a different management of working. If opening up the institution only means more production and even more accelerated processes of organizing, logistical cleverness and dramaturgical management, then we have a problem: what changes are only the ways in which, through flexible and precarious modes of working, the hierarchies are re-established in a new way. What is actually new are the temporal modes of working, where also artists are becoming organizers of their own subjectivities and projects, skilled in logistics, organization, projection, but at the same time have to be ready to constantly improvise and take risks. These modes of working are somehow in a very interesting way aesthetically mirrored in many participatory art events, which I understood as a way of giving aesthetic expression to the social form of productivity, making visible this social play of production and practising it inside the institutions themselves. This social productivity is made visible as a measurable and recognizable value, however at the same time, exhibited as the experience of something ungraspable and always flexible, and therefore 'democratic'.

### A Misty Core

All institutions (not only artistic institutions) have a dreamy core, one so fundamental and unavoidable, that it also endangers the very institution it enables. It is essential to consider this core when reflecting on the process of institutionalization, especially in relation to the precarity of human beings. Such a core can be described as a dreamy, foggy, steamy, evaporating matter of imagination that brings people together in the process of institutionalization: imagination is the condition of the institution. The institution arises from the mist and vapours of the social imagination, and only through this unstable matter can the change be approached. Cornelius Castoriadis is well known for relating this question of the new to the imagination, that is to the capacity 'that something other than what exists is bringing itself into being, and bringing itself into being as new or as other' (Castoriadis 1987, p. 185). Any human being can, in principle, re-imagine what another human being has imagined. This imagined world of signification allows us 'to create for ourselves a world—or to present to ourselves something of which, without the imagination, we would know nothing and we could say nothing' (Castoriadis 1987, p. 366, also De Cock 2013). But this radical imagination, which Castoriadis approaches as a rupture of reality, is a perplexing

institutional condition: it is the very condition of the instituting processes and at the same time is part of the core of the institutional violence. Although an institution is actually made up and imagined, this same institution, when instituted, tries to erase more or less violently this irrational, misty, impossible core and build a monument to itself in the form of solid spaces, rules of behaviour and protocols, and archival possessions of the past. In this erasure the very fact of self-creation is erased, this social mist and dream at its core. Or to put it differently, in Castoriadis' words: 'Alienation occurs when society does not recognize in the imaginary of institutions something that is its own product, and when it does not see itself as instituting as well as instituted' (Castoriadis 1987, p. 336).

I would like to connect this line of thought to the notion of precarity, or rather to the precarious conditions of instituting processes. The social imaginary, which I compare here to the mist and dreams, to the clouds of imagination, is in fact utterly precarious. That's why it was compared many times to the inflammatory dreams, or to the phantasmagorias to which, as was the belief at the beginning of modernity (when our current institutions were formed) particularly women and children were sensible. Imagination could harm their bodies and well-being, it could kindle their passions and transform them into hysterics and lunatics. But what if the inflammatory dreams actually make the dreamers sensitive and attentive to others, to someone or something else? This misty substance of imagination can then be related to the very important quality of precarity, to vulnerability. Vulnerability is an intrinsic part of instituting: it is at the core of the imagination of living together, in the creative invention of forms of togetherness, and the imagination of support and care. It is part of the capacity of taking care and enabling the ways in which in our vulnerability we are actually not alone. In this sense the mist springs from the conditions of the vulnerability, and no change or innovation can be thought without this capacity of being sensitive, attentive, and open to the others.

### Becoming Institutionalized

I was very much inspired to think in a different way about this imaginary core of the institution, when hearing a lecture by Athena Athanasiou in Green Park in Athens, in October 2015. She gave her lecture in an old abandoned theatre, which was taken over by

a collective and transformed into the temporary venue of a conference meeting but was also and at the same time a temporary retreat for refugees. The Green Park theatre is located in this city park, where just before the conference in 2015, still hundreds of people were sleeping before moving on to what was then still an open route through the Balkans to the countries of Western Europe. Here, Athena Athanasiou was talking about the paradoxical condition of the institution, the condition that we have to take into the consideration especially at the present moment, which is characterized by both distrust of the institution and institutional failure (both actually coming from all sides of the political spectrum). On the one hand, neoliberalism contains a deep distrust in institutions, especially the ones in the public interest. On the other hand, we are also experiencing a failure of the public (and with them also artistic) institutions and the erasure of their imaginary core as a result of the control of productive and temporal rhythms through which the future is produced (modernity, progressivity, acceleration of production, politics as logistics and perfection of organization, continuous control of the new with the procedures of evaluation, and so on). I still vividly remember Athanasiou's powerful proposition about the paradoxical power of institutions: how they are necessary to sustain human beings and how they can also be violent, and destroy human beings. That's why it is crucial to think about institutions always from a specific temporal perspective: even if they are spatially bound, related to houses, shelters, domains, abodes, constructions and platforms, they should not be approached as facts, as something that is given and complete but rather as the dwelling between *as if* and *not yet*. Athanasiou was actually touching upon the paradoxical temporal structure of institutions, which also defines our action when being involved in the process of institutionalization. As our institutional engagement is only possible as a dwelling between imagination and acting 'as if', time in this sense ceases to be approached as futurity, but more as a very particular rhythm where multiple, several temporalities appear and are maintained together. The institution appears because of the particular temporal constellation of forces. An institution is not a fact, is not an achievement, but a condition enabling the simultaneity of performing the institution and resisting the very process of institutionalization. It is only possible then to defend the process of institutionalization, when also performing it as something that has yet to be constituted. Here the poetic side

enters into the process of institutionalization: this process can only be done when it is at the same time imaginatively and politically working against the very closure of the processes we are in. In that way, said Athanasiou, we have to act in the process of institutionalization as if this process would be possible, but we also have to be always aware of what we lose if we would finally win. Here the poetic side can be described as a temporal deceleration, holding something back, dwelling in the not-yet. Only such an approach opens a crack in time, a temporal amplitude of the new. To act as if it would be possible is also at the core of engagement in general. Not because this would be some kind of individual superpower, a tricky and tactical position of the enlightened institutional worker and critical subjectivity—if we would understand it like that, we could soon end up lonely and exhausted. This conditionality is rather at the core of engagement, which is always already an engagement with others. The temporal quality of the process of the institutionalization belongs to the specific common practice, which is at the same time always incomplete, unforeseeable, rather a 'co-existential history of surprising itself' (Athanasiou 2016). The institutional practice is related to the opening of 'space and time which comes into being precisely through producing its own agents' (Athanasiou 2015) and this is only possible because this practice is already from the start a common practice, protecting the common precariousness of being. Nevertheless, the threat of violence is always there, originating in the erasure of this common pre-condition of every activity.

### Collective Practices of Imagination

Why is it so important to be reminded of this temporal dimension of the process of institutionalization, to think about the conditionality that defines processes of being and working together? How can we relate this observation to the artistic institutions, especially to the ones that are characteristic for the field of performance, choreography and visual arts today, in which so many free-lancing and flexible, nomadic artists are working today? It is not enough to think about institutional change as the opening of new aesthetic choices, because institutional change actually concerns the common, misty core of the institution: is it possible to organize in a poetic way how to work together? A political task for contemporary institutions is to find out how to challenge self-obvious truths about how art and performance should be produced and managed.

They would need to show how these truths depend on the overall economization of culture and human creativity, on 'economystification', as French philosopher Jean-Pierre Dupuy states (Dupuy 2014). In this sense their task is not to offer the choice of different and always new aesthetic products, but actually to challenge the temporal rhythms of working, producing, and making, to challenge the processes of continuous production of futurity through projects, to hold time back for precarious, vulnerable, and caring modes of being, through which change could emerge. This is possible through the collective force of imagination, which is at the core of every process of institutionalization.

The artistic institutions themselves are today in a very peculiar situation, as I already argued: on the one hand they are under a threat to protect themselves as much as possible while on the other they have to endure somehow and sustain their own progressiveness, develop experimentally, and so on. We are living in times when with one swing coming from the populist and nationalistic cultural 'reformations' on the march throughout Europe, such institutions could be erased; and there are currently many places in Europe where this is going on. This is also showing us how problematic the idea of the progressive institution is, on what kind of a shallow foundation this idea is built. Progression is actually one of the ideological falsehoods of neo-liberalism. It can be described here as a hegemonic capture of time, which can find many different embodiments in the forms of production and subjectivity today: professional biography, project, debt, progressive education, management of time, and so on. The progressive institution is controlling the temporal rhythms and is engaged in the violent production of futurity. In this way the precarious forms of imagination, dwelling in the presence, holding back time, amplitude of time, are destroyed and turned into the logistic and managerial operations of flexibility, simultaneity, and multiplicity of time. In this sense the new becomes something else than change, because it is always depending on the existing power relations and on how these relations are defining the coming of the future. That's also why neoliberal imagination in its last instance can only imagine the apocalyptic failure of the future, which re-establishes an even more conservative notion of the presence.

Inside this hegemonic control of time and futurity the artistic institutions are continuously under pressure to produce and give evidence of their 'social and political' value in order to fight

the pressures coming from financial cuts and cultural reforms, thus turning themselves into good and obedient cultural agents. However, the infrastructure they are offering can actually be used and developed further if there is a space for the persistence in the mist, for the fogginess of imagination, and the opening up of new processes. Institutions should today enable a persistent and demanding fight on the field where values are produced and where imagination is not colonized yet. So, they should become something that is in opposition to the transparency and logistical and spinning managerial evidence of success (a crucial institutional criterion of evaluation nowadays). Such awareness about the contradictory process of support and violence inherent to the institution is especially important in a time of immense distrust in institutions, in a time of populism that is deeply intertwined with processes of de-institutionalization, resulting in the destruction of the forms of social support, care, and common infrastructure. Such populist distrust happens simultaneously with the neoliberal processes of de-institutionalizing, even if they often have different goals. Neoliberalism expands globally through extraction and destruction of the existing modes of production in the local surroundings, while populism tries to re-establish the archaic forms of togetherness (based on nationhood, manhood, and religion). However, both processes share the same institutional violence, which transforms the vulnerability and precarity of existing as a condition of being with others to the powerful means of discipline and control, disabling any possible change of forms of living, instituting and organizing, any possibility of the amplitude of temporal rhythms of life.

From this perspective, the artistic institutions should not be defended, when endangered from politics and governments, as monuments to freedom and experiment, but actually invented anew within the utterly changed political and cultural circumstances. Exactly in the moment of danger we need radical proposals. This radical proposal is a power of the collective poetic and inventive action, a persistent working towards impossibility that opens up new forms of imagination and being together.

### A New Rhythm

The poetic capacity of invention has also much to do with a particular rhythm, and rhythm is, at least in theories of poetics, crucial for poetics and poetry, because it is related to the subjectivity

of the language. This would be maybe one way of how to think about the poetic capacity of invention in relationship to the artistic institution; how this dwelling in the not-yet and acting as-if can change the rhythm of artistic work and how we organize ourselves through work, how we organize ourselves inside the precarious foggy environment of imagination. I don't want to propose slowing down or give similar advice, even if this is a much-desired wish of many cultural operators and artists. Something else is at stake here: the need to develop imaginative temporal forms of working that would have the power to resist the flexibility and precarity of contemporary work. In this sense it is necessary to work imaginatively and resist the closure of the institution as a possibility and performing the process of institutionalization in a way that has yet to be constituted.

There should be a radical shift in a temporal dimension of production, fighting the projective temporality, its temporal loop between the present and the future, which structures the future in the relation to the existing power dynamics. Imaginative processes not only challenge the project temporality with a multitude of proposals and works, but also with how modes of work and thinking are enabled, supported, and also sustained. This can only be possible if imagination is understood as a dedication to what has yet to come, which is paradoxically an openness into the present time. This is the openness as if the future is always already there, present in how it is continuously invented, shared, and challenged by the ways of present living. In this sense the temporality of the present is characterized by an amplitude of simultaneous acts, not by the enumeration and acceleration of projects. Such openness into the present time includes something restorative and re-establishing along with something unfinished and incomplete. In this sense the process of institutionalization is not to take care of the past (and freeze it), but neither about pushing it into the future (and, with the continuous production of the new, leave behind ruins), but much more about a difficult process of giving change to the present—visible between the repetition of the past and imagination of the future. Maybe this is exactly what several artistic attempts of institutionalizing, thinking differently, trying different modes of living together are doing today and why there is such a need for bringing back fantasy and imagination when thinking about the institution: this proposal, to try to bathe and take place in this fragile foam, is a poetic proposal. Poetic in the sense that it

tries to make visible the production itself, how something comes into being, to disclose and hold in eternity this not-yet, which is so crucial when thinking about the temporal frame of the institution. New attempts in institutionalization should open up this process of institutionalization as a poetic process, a process that is not only an invention, but a specific production of form, a generation of visibility of production, of bringing something into being. In this way imagination is related to engagement, care, and persistence, which are part of precarious vulnerability. The question is how to practice processes of institutionalization from within this paradoxical knot: here the practice of institutionalization continuously needs imagination and common dedication to the impossible, to actually make something possible. These are the poetic processes, which can be placed very close to performative action, to the engagement with actuality through imaginative, fictional, invented acts of togetherness: actuality is not something that is already lying there, but it is also continuously produced through our engagement with it. At the same time, poetic processes are part of performative actions of engagement; they are namely dealing with the invention of forms and particular inclinations in language and subjectivity, they are disclosing the inventive and imaginative side of being and working together. It is immensely productive for thinking about artistic institutions (but also about institutions in general) to bring these two processes together—performative action (acting as-if) and poetic capacity of invention (imagining of what is not-yet). In this sense the institution could never be understood as an achievement, but it is rather a complex rhythmical loop between acting as-if and imagining of what is not-yet.

# References

— Athanasiou, Athena. 2015. 'Athanasiou, Athena: Counter-institutions, Counter-publics, and the Performative in the Political.' Keynote at the Conference Institutions, Politics, Performance; Athens, Green Park, 24 September. (Based on the notes from the lecture)
— Athanasiou, Athena. 2016. 'Becoming Engaged, Surprising Oneself.' http.//instifdt.bg.ac.rs/wp-content/uploads/2016/04/14-Athena-Athanasiou.pdf
— Castoriadis, Cornelius. 1987. *The Imaginary Institution of Society*. Cambridge, MA: Polity Press.
— De Cock, Christian. 2013. 'From Creativity to Imagination with Cornelius Castoriadis.' www.researchgate.net/...De_Cock/...Castoriadis/.../From-Creativity-to-Imagination.
— Dupuy, Jean-Pierre. 2014. *Economy of the Future: The Crisis of Faith*. Michigan: Michigan State University Press.
— Kunst, Bojana. 2015. *Artist at Work: Proximity of Art and Capitalism*. Winchester: Zero Books.
— Lorey, Isabell. 2015. *State of Insecurity: Government of the Precarious*. London and New York: Verso.

# The Museum, Decoloniality and the End of the Contemporary

Rolando Vázquez

We are experiencing times of open wounds, global injustice, and the depletion of Earth. They are the unequivocal expression of modernity, the Eurocentric and anthropocentric model of civilization. We are facing the question of the (im)possibility of an ethical life. It is a question to which there are no ready-made answers. Can we live an ethical life in a historical order in which our wellbeing, our sense of achievement, the satisfaction of our pleasures and desires are dependent on the consumption of life, of the life of others and the life of Earth, on the exploitation of others and the relentless extraction from and pollution of Earth? How can we live an ethical life when we are made to enjoy the consumption of life?

We are writing from the position of the inhabitants of the consumer society in the Global North. We are at the receiving end of all manners of intersectional privilege in a gendered-colonial order. We know that in the consumer society we are fed and dressed owing to the suffering of others and the depletion of Earth. And we are made to enjoy it. Our sense of success, of a good life has been made dependent on processes of exploitation of others and extraction from Earth. Anthropocentrism and Eurocentrism appear as two axes that imply, on the one hand, a monocultural strand of exploitation and dispossession of other worlds (worldlessness) and on the other an anthropocentric strand wasting away Earth (Earthlessness). Our notions of progress, of development, of civilization cannot be seen separate from the dispossession of others and the depletion of Earth, ecocide. The ethical question, the question for the possibility of an ethical life with Earth is the backdrop of these reflections.

What is the role of the museum as a public space for education and preservation when it is confronted with an awareness of the modern/colonial order, when it is confronted with the ethical question? What can the museum do? Has the museum been engaged with these questions or has it rather been oblivious to and complicit with global injustice and ecocide? Our times demand that we pay attention to what is being asked. It is a call that, despite the lack of answers, is pushing us to dare to move and think differently. What we offer here is not a solution but a path to begin to understand the museum in relation to its modern/colonial historical reality. How is the modern formation of collections, narratives, and publics implicated in coloniality?

This text starts by addressing the museum from a decolonial perspective, so as to indicate the sort of questions that lay ahead in the task of decolonizing the museum. The second and longest part of the text moves on to present some of the major propositions of decolonial thought, as an indication of a framework of reference that can sustain this task. Finally, in way of a conclusion we address the question of the end of the contemporary.

### The Museum and Decolonial Critique

The museum, like the university, has been one of the core institutions of modernity. The museum has been enacting the anthropocentric colonial difference, configuring the normative self, and negating alterity through exclusion and/or exhibition of alterity. It has been instrumental in the affirmation, production, and dissemination of western epistemology, in the formation of ways of knowing and forms of perception that configure normative subjectivities. Its coloniality is enacted in a negation of appropriating, exhibiting, and relegating other people's life-worlds, animals, and the Earth as 'alterity'. The museum draws the alterity against which the normative self becomes human, modern, universal, and absent to the plurality of the world. The self is constituted in the separation from Earth, animals, and other peoples' worlds as being outside the here and now of modernity. His aesthetic experience is an expression of the separation from other worlds of meaning and from embodied realities.

When we ask what the modern/colonial function of the museum has been, we see its movement of affirmation as that which constitutes a cultural archive (Wekker 2016) and is geared towards a normative subject formation. The formation of collections, narratives, and publics are co-implicated processes of configuring normative cultural archives, worldviews, and subject-formations. We need to ask to what extent intersectional forms of oppression and privilege have found a breeding ground in the museum.

The modernity of the museum, as movement of affirmation and normativity refers to the way in which it has been a mechanism for the formation of the normative ideal subject: as citizen (National History Museum), Human (Natural History Museum), white (Ethnographic Museum), as the 'modern' and contemporary self (Art and Contemporary Art Museum). Of course, these functions are intermingled and not exclusive to each type of museum.

They are all about entering civilization, humanity, and becoming modern, about becoming the self at the centre of the now.

If the museum has been so central in the formation of the cultural archive, the world view, and the normative subject, how can it engage in the task of 'humbling modernity'? How can it engage in the task of divesting modernity of its normative positionality? We believe that the humbling of modernity is the condition of possibility for beginning to listen to other worlds of meaning (Vázquez 2012).

How can the museum undo the white western gaze? How can it undo its position of abstraction? How can it reveal its negated modern/colonial positionality? How can the museum critically engage its role in the formation of a monocultural archive and normative publics? How can it come to terms with its geo-historical positionality and reach towards responsibility? How can the museum become aware of how it has been implicated in configuring, guarding, and benefiting from the colonial difference? Can the museum unlearn its own self-made narrative and engage in the task of humbling modernity? Can the museum engage in a decolonial transformation of the cultural archive, of its collections and narratives, of its public formations?

It seems to us that the first step to be taken is to humble its own narratives to recognize the limits of its own episteme so that it can begin listening. It has to recognize how it is implicated in the modern/colonial difference. We see the exhibitions 'The Making of Modern Art' and 'The Way Beyond Art' curated at the Van Abbemuseum (2017–2018) under the notion of demodernizing as engaging in this process.

The second step is for the museum to recognize itself as being implicated in the modern colonial/order, and take responsibility. The notion of being implicated is a tool against 'arrogant ignorance' that comes from black and chicana feminist thought (Anzaldúa 2007; Alexander 2006; Lugones 2010; Wekker 2016). When you are in a position of abstraction, when you are in this nowhere where you hold the power to see while not being seen (Haraway 1988) you cannot take responsibility.

The third step that we see for decolonizing the museum in connection with decolonial aesthesis is to engage with the task of listening across the colonial difference. We are entering a time in which we have to stop focusing on holding the monopoly of enunciation and claiming the radically new, we need to begin listening

to that which has been silenced by coloniality, by our cultural archive, by our narratives and our privilege. We need to ask how can we listen to that which has been made silent, invisible, irrelevant by our own narratives? Decolonial critique is cracking open the presentism/noveltism of modernity to illuminate already existing alternative genealogies and paths into the to-come. We have to learn to become quiet, to quiet the cacophony of our own narratives.

### Decolonial Critique

One of the characteristics of modernity is that it is oblivious to coloniality. While upholding its own self-made narrative it has simultaneously hidden the processes of negation that have enabled it to exist. Decolonial forms of questioning are needed to overcome the enclosure in the epistemic territory of modernity that is built on the denial of coloniality (Vázquez 2011). Our notions of progress, of development, of civilization have been sustained on exploitation, dispossession of others, and on the depletion of Earth, on ecocide. Thinking our historical reality as a modern/colonial order is fundamental for understanding our times. In this second part of the essay we will present some of the key propositions that sustain the decolonial critique of the modern/colonial order.

### 1492 Birth of Modernity

Unlike the most common approach, which sees modernity as stemming from the enlightenment, the industrial revolution, the French revolution, and the reformation, decolonial thought understands modernity as starting in 1492. For us the timespan of modernity comes from the beginning of the colonial enterprise. To clarify this proposition, we recall the famous quote from Enrique Dussel:

> According to my central thesis, 1492 is the date of the 'birth' of modernity ... [M]odernity as such was 'born' when Europe was in a position to pose itself against another, when, in other words, Europe could constitute itself as a unified ego exploring, conquering, colonizing an alterity that gave back its image of itself. This other, in other words, was not 'dis-covered' as such, but concealed (Dussel 1993, p. 66).

Before 1492, before the colonial enterprise, Europe could not think of itself as the centre of the entire world. This Eurocentrism is easy to visualize in the 'world map' that inhabits the imagination of most of us, a 'world map' in which Europe stands at the centre. In it you have a very clear example of the epistemic power of colonialism. Why is Europe sitting at the centre of the 'world map' in our modern/colonial imagination?

The Euro-centred world map serves us as a metaphor to show that without colonialism Europe could neither represent itself as the centre of geography nor as the 'now' of history. Colonialism enables Europe to claim for itself the central position of enunciation. Colonialism enables the universal validity claim that sustains 'Eurocentrism'. Europe begins claiming the central position of enunciation across the world, presenting itself as the reference point in both space and time.

Apart from revealing the colonial underpinnings of the epistemic privilege of Europe, the quote from Dussel also shows that the conditions for Europe's self-understanding is that of positing itself 'against an other', of 'colonizing an alterity that gave back its image of itself'. Europe cannot understand itself without the negation of the other. This has happened through a process of double negation, constituted by two co-implicated movements. The first movement is the colonial enactment of negation of the other by enslaving, exterminating, exploiting, dispossessing, extracting... The second and simultaneous movement of the double negation is that of the denial and erasure of the first. The negation of coloniality is achieved by the dominion of modernity over representation with its narrative of salvation, of civilization, of progress, of development, and so on, and through the discrimination of the other by relegating her to the past or to the outside of history, under categories such as 'barbarism', 'underdevelopment', 'poverty', and so on. For example, in the narratives of progress and development, we erase the fact that the plantation system was essential for the formation of the Atlantic economy and the emergence of a global capitalism centred in the West. We negate the 'other' materially through oppression, exploitation, and extraction but we also erase that process from our representation of world-historical reality.

Let us clarify that the proposition of placing the start of modernity in 1492 is not a naïve interpretation of modernity. It is not as if we are not aware of the narratives of modernity

as multiple, contested, never achieved, and so on. But for us, all those representations of modernity belong to intra-European perspectives. When you see modernity from the outside of the dominant west, other questions emerge. Modernity appears then as the Western project of civilization and as a driving principle for the historical constitution of the modern/colonial order.

## The Eurocentrism of Modernity

The second proposition is about the Eurocentric character of the project of modernity. Eurocentrism is a form of arrogant ignorance, because it assumes itself as universal and assumes that there is no outside its own logic, so that there is no epistemic outside and no genealogical outside its epistemic territory. When non-Western-centred peoples show that they have other knowledges, other philosophies, other forms of life, they are often seen as holding romanticist positions. We are told that everyone has been touched by modernity and that there is no such thing as an 'outside modernity'. For decolonial thought, however, there is an 'outside' of modernity; this is not to claim that there are worlds in a state of purity that remain untouched by modernity, but rather that there are genealogies and trajectories of life and thought that do not come and cannot be traced back to the claimed Greco Latin heritage of the Enlightenment and the Renaissance.

Especially since the last part of the twentieth century up until today, critique has been praised for its self-reflexivity, for being critical of one's self-understanding. We think that this movement of thought is completely insufficient to address the problems of the modern/colonial world and that it is actually complicit with enforcing the epistemic self-enclosure of modernity. The moment this Eurocentric-West begins listening to the other that it has negated, to the alterity that gives it the image of itself, is the moment when the West will begin to understand its location in the broader historical reality of the modern/colonial order. Locating the West requires the overcoming of the double negation that has enabled its claim to the abstract position of universality, of being in the present of history and at the centre of geography. It is through an act of listening to 'the other', of understanding itself through the voice of 'others', that the West can overcome the ignorance of Eurocentrism and recognize itself

The Museum, Decoloniality and the End
of the Contemporary
183

through a more truthful positionality. This we believe is one of the key tasks that needs to be addressed by cultural institutions such as the museum.

Let me clarify here that when we speak of 'Europe' we do not mean to say that Europe as a geographical place is not diverse. The dominant project of modernity has also suppressed diversity inside European geography. For instance, Silvia Federici (Federici 2014) has shown how women with knowledge and authority were persecuted throughout the inquisition in Europe. The project of modernity is a dominant project also inside Europe that will establish a dominant order over other knowledges, languages, forms of relating to Earth, and so on. We have the big task of listening to the 'others of Europe' and engaging the question of decolonizing Europe.

## No Modernity without Coloniality

The third proposition, coming from Aníbal Quijano (Quijano 2010), is that there is no modernity without coloniality. The history of progress and civilization cannot be disconnected from the history of enslavement, plantation, extraction, and so on. Modernity/ coloniality is written as a binomial separated by a slash to signify that its terms are co-constitutive and that they are enjoined by the colonial difference. However, it is very important to recognize that each term of the binomial designates a distinct movement towards the real. The movement of modernity is clearly distinct from the movement of coloniality. 'Modernity' is about the control of presence, the control of world historical reality: what appears as world is what modernity is controlling, ranging from its institutions to its forms of subjectivity and from its sciences and arts to its everyday practices. Modernity's movement as the control of presence has two important coexisting moments: appropriation and representation. Modernity has been materially about the appropriation of land, the massive appropriation of what it will name 'America', possibly the largest appropriation of land in history, that will be followed by massive colonial appropriations in Africa, Asia and Oceania. The appropriation of land has to be understood in connection to the appropriation of Earth through extractive practices and the appropriation of life of humans and non-humans.

Together with this moment of appropriation there is a moment of representation. Modernity controls materially through

the force of appropriation that will be accompanied by the control of representation, that is the control of knowledge, epistemologies, narratives, and the control of appearance. Modernity will control presence through tangible forms of appropriation, like the plantation for the extraction of human life and Earth's life, while at one and the same time it will represent it as civilization, progress, and development. Appropriation and representation work hand in hand. The combination of appropriation and representation enables modernity to hold the monopoly over worlding the world. Modernity's world as artifice results from the forceful projection of its mode of representation, often dressed as salvation utopias, enabled by the appropriation of life and the negation of other worlds of meaning. Without coloniality there is no modernity as world's artifice, there are no simulacra.

When we ask the question of modernity we see how power is operating tangibly, instituting itself as world-historical reality. This has been the focus of critical social sciences and humanities in the West. But when we ask the question of coloniality, we ask the question of what has been lost. What is being lost? What is being de-futured? What is being stopped from becoming world? While 'modernity' is that which controls the presence and enacts the dominant way of worlding the world, 'coloniality' expresses the absenting of the other. Whereas modernity controls the world presencing, coloniality is the movement of absencing. It speaks of all sorts of processes of denigration, exploitation, extraction, racialization, dispossession, and the double erasure through their occlusion. To ask the question of coloniality is very different from asking the question of modernity.

Allow us a small parenthesis to clarify the importance of thinking about modernity/coloniality in conjunction. Geologists who have been busy finding markers to establish the onset of the Anthropocene, of human-driven geological transformations, have made a striking discovery that confirms the inseparability of modernity and coloniality. Geologists have found an important reduction in atmospheric $CO_2$ concentration between 1570 and 1620 registered in the Antarctic ice-core, what they call the Orbis Spike (Lewis 2015). This reduction in $CO_2$ is linked to the mass death of three quarters of the population of the Americas and Africa and corresponds to the unfolding of colonialism (Biello 2015). We have now the geological confirmation that the onset of modernity and the dominion of the Western

project of civilization corresponds to the genocidal erasure of other worlds. The Euro-centred and anthropo-centred project of civilization is inseparable from coloniality. To be sure, the mass death of the early colonial period is not only explained through the mass appropriation of land, enslavement, and mass killings—the biota exchange and the resulting epidemics that followed also played a role. The work on the so-called 'Columbian Exchange' shows that European domination was also based on pathogens (Carney 2015). That pathogenic non-human agents played a role in the destruction of colonized worlds stresses the importance of thinking coloniality as inseparable from the onset of modernity. Historically, the experience of mass death and colonial domination are inseparable. Now, thanks to the work of geologists, we have the geological markers that confirm the entwinement of colonialism and genocide. We know that the unfolding of the modern/colonial order meant genocide and that the thesis of Dussel, for whom 1492 coincides with the start of modernity is inseparable from coloniality, as the destruction of other worlds. The mass death of the colonized through domination and contagion is inseparable from the foundation of the modern/colonial order, and modernity's claim to 'universal' domination. Coloniality must be part of the on-going conversations on the Anthropocene.

## Decoloniality as Delinking

The fourth proposition holds that decoloniality is an orientation and a practice that doesn't want to be included in modernity. We don't want to be modern, because for us modernity is the Western project of civilization that is coeval to and inseparable from coloniality. Decolonial thought does not fight for the recognition of being modern, neither for the recognition of contemporaneity. We don't want to be modern, we want to overcome modernity, to overcome the modern/colonial order. The movement of decoloniality is what Walter Mignolo calls a movement of delinking (Mignolo 2011). We are not fighting for recognition. We are not struggling for denied histories to be recognized as part of the global history of modernity nor do we want to claim that we are also modern. We do not want to discredit those struggles for recognition, we think they are valid strategies for many local histories, but our strategy, inspired by the radical autonomy of maroon and first nations struggles, is

that of not seeking to become modern. Decolonial delinking and the rejection of modernity as the horizon of expectations is not to be confused with a backward or traditional perspective, it is rather a strong stand for autonomy and dignity, and a radical departure of the historical horizon of Eurocentrism and the dominant West.

Decoloniality, as the overcoming of the modern/colonial order, is not just oppositional resistance, it is driven by the struggle for re-existence (Albán Achinte 2009), for dignity and justice. If we look at social movements across the global South (including the South in the North, such as diaspora communities or first nations in Europe, North America, and Oceania) in their different struggles for land, against feminicide, against ecocide, against violence, the common denominator is that they are demanding and fighting for dignity.

Decoloniality is about enabling other worlds to become world. What modernity has done is to suppress the possibility of other worlds to become world (worldlessness). Decoloniality means to reclaim the possibility of naming and inhabiting the world; it is to be able to embody and experience those other worlds. Decoloniality has to do with the question of the vernacular and of verbality; not with having or taking; not with the object but with the verb, with being others and being able to make worlds, recovering the autonomy of naming and worlding our worlds.

## Modernity as Separation

Once we have distinguished the movement of modernity and coloniality, we will now address how they become conjugated as modernity/coloniality and come to constitute the colonial difference. More broadly, we will see how modernity attains its affirmation as the 'self' of world-historical reality through major processes of production and separation from alterity. The processes of separation reveal the mediation between the controlling of presence and the absencing of alterity. We suggest ordering the processes of separation in three major axes that are mutually implicated: a) Eurocentrism, b) anthropocentrism and c) contemporaneity.

a) Eurocentrism, as mentioned before, is the axis of separation from other worlds. It establishes the dominance of the mono-culture of the West and expresses the modern/colonial order as worldlessness. It affirms whiteness and patriarchy through racialization

The Museum, Decoloniality and the End
of the Contemporary
187

and the imposition of the modern/colonial gender system. Through its operation the 'other' is racialized, animalized, impoverished, de-sexualized or hyper-sexualized, the other is made sub-human and the male/white/western self becomes the norm of the human. Eurocentrism, the monoculture of the West, rules over the relations to others, leading us towards 'wordlessness', to the loss of worlds. It means the imposition of a single world and the loss of the diversity of worlds.

b) Anthropocentrism is the axis of separation from Earth. It establishes the superiority of the 'human' (as an expression of Eurocentrism, of 'reason', civilization, culture) over Earth life (including animals, rivers, mountains, forests, etc). It expresses the modern/colonial order as 'Earthlessness'. The axis of anthropocentrism, with its concurrent manifestation in science, 'reason', humanity, culture etc. rules over the relation to Earth, and leads us to a condition of 'Earthlesness'.

c) Contemporaneity is the axis of separation from relational temporality. It establishes chronology and the principle of novelty (immanence, futurity, contemporaneity) over relational temporalities, over precedence (Vázquez 2017a; Chavéz and Vázquez 2017). It expresses the modern/colonial order as amnesic, as oblivion. Through the axis of contemporaneity, the 'now' attains its definition through temporal discrimination. The 'now' as a property of the self is defined through seeing the other as traditional, as passé, as backward, as a belated copy. Contemporaneity, the notions of novelty, futurity, nowness, rules over our experience in time and leads us into the oblivion of empty presence, confining us to the surface of present that is reduced to presence. It establishes the empty present and the concurrent affirmation of the world as artifice as the confinement of experience. Experience becomes akin to superficiality and emptiness.

These three axes of separation become embodied in the subject that experiences life as separated from others in his individuality, as separated from Earth in his 'humanity' and as being uprooted from his communal precedence. The subject experiences life in the confinement of his individual identity. The self is confined in the artifice and superficiality of representation. The 'modern subject', the model of the 'human', lives a confined life of individuality, consumption and artifice, lives in

conditions of separation from others, from Earth and from his communal precedence.

The axes of separation offer us a different understanding of modernity, one that is inaccessible from its own epistemic enclosure. Modernity appears as 'worldlessness', as 'Earthlessness' and as 'oblivion'. The radical impoverishment of experience is the consequence of the loss of our relation to other worlds, to Earth and to precedence.

### The End of the Contemporary

The decolonial critique of time shows us that the configuration of the modern/colonial order corresponds to the establishment of a world-historical reality that is mediated by a particular relation to time. The modern/colonial politics of time configure the mediation between what is to be considered real, what is to be considered normative, and that which will be produced as alterity or relegated to oblivion. 'Contemporaneity' is a normative field that renders real modern chronology, with its cult of novelty and the sovereignty of empty present. Allow us to use a fragment of the text that summoned the meeting on 'The End of the Contemporary' in Berlin in 2017.

> The contemporary has been a normative position in the arts since the second half of the 20th century. The emergence of the global contemporary towards 1989 opened a critique of Eurocentrism in the field of contemporary art but left the normativity of the contemporary untouched. What remained untouched and at the same time became globalized was the normativity of modern time' (Vázquez 2017b).

The decolonial critique of time shows how the seemingly open-ended and inclusive notion of contemporaneity has been functioning to reinforce the colonial difference by normalizing the modern/ postmodern conception of time as the condition for recognition and legibility. In contrast with the normativity of contemporaneity we suggest listening to the philosophies from 'Abya Yala' (The Americas), we propose to address the question of time beyond the enclosure of modern chronology, by mobilizing the notion of 'precedence'. The notion of precedence is a way to overcome the binary between immanence and transcendence (Vázquez 2017a).

The Museum, Decoloniality and the End
of the Contemporary
189

It is a way to relate to deep temporalities, in which what precedes us is not immanent, not fully contained in the now of the present, but it is both ahead of us and before us. This is the notion of time that exists in many philosophies of Abya Yala (The Americas), and that cannot be articulated through the dominant philosophical framework of the West, precisely because the epistemology of the West is confined to the dichotomy immanence/transcendence.

Decolonial aesthesis (Vázquez and Mignolo 2013) is not about seeking novelty nor contemporaneity; decolonial aesthesis is about disobeying the chronology of modernity (Vázquez 2016). It's coming under the 'sign of the return'; a radical return that is capable of breaking open the modern/colonial order of the present.

This text is a version of the lecture by Rolando Vázquez, 22 September 2017, 'The Museum, Decoloniality and the End of the Contemporary'; 'Collections in Transition: Decolonising, Demodernising and Decentralising?', Museum Confederation L'Internationale, Van Abbe Museum, Eindhoven, the Netherlands. This text will also be published in other formats. I want to thank Laura de Gaetano for helping with the transcription of the lecture.

# References

— Albán Achinte, Adolfo. 2009. 'Artistas Indígenas y Afrocolombianos: Entre las Memorias y las Cosmovisiones: Estéticas de la Re-Existencia.' In *Arte y Estética en la Encrucijada Descolonial*, compiled by Zulma Palermo, pp. 83-112. Buenos Aires: Ediciones del Signo.

— Alexander, M. Jacqui. 2006. *Pedagogies of Crossing: Meditations on Feminism, Sexual Politics, Memory, and the Sacred.* Durham: Duke University Press.

— Anzaldúa, Gloria. 2007. *Borderlands/La Frontera: The New Mestiza*. San Francisco: Aunt Lute Books (third edition).

— Biello, David. 2015. 'Mass Deaths in Americas Start New $CO_2$ Epoch.' *Scientific American* 11 March.

— Carney, Judith A. 2015. 'Columbian Exchange.' *UCLA Previously Published Works*.

— Chavéz, Daniel B., and Rolando Vázquez. 2017. 'Precedence, Trans* and the Decolonial.' *Angelaki, Journal of the Theoretical Humanities* 22, no. 2, pp. 39-45.

— Collins, Patricia Hill. 2000. *Black Feminist Thought: Knowledge, Consciousness and the Politics of Empowerment.* London: Routledge.

— Dussel, Enrique. 1993. 'Eurocentrism and Modernity (Introduction to the Frankfurt Lectures).' *boundary* 2, vol. 20, no. 3, pp. 65-76.

— Federici, Silvia. 2014. *Caliban and the Witch.* Brooklyn: Autonomedia.

— Haraway, Donna. 1988. 'Situated Knowledges: The Science Question in Feminism and the Privilege of Partial Perspective.' *Feminist Studies* 14, no. 3, pp. 575-599.

— Lewis, Simon L. 2015. 'Defining the Anthropocene.' *Nature* 519, pp. 171-180.

— Lockward, Alanna. 2011. 'Manifesto for a Decolonial Aesthetics.' *Transnational Decolonial Institute*, 22 May.

— Lugones, María. 2010. 'Toward a Decolonial Feminism.' *Hypatia* 25, no. 4, pp. 742-759.

— Mignolo, Walter. 2000. *Local Histories/Global Designs, Coloniality, Subaltern Knowledges, and Border Thinking.* Princeton, NJ: Princeton University Press.
–. 2011. 'Epistemic Disobedience and the Decolonial Option: A Manifesto.'

*Transmodernity*, pp. 44-66.

— Quijano, Aníbal. 2010. 'Coloniality and Modernity/Rationality.' In *Globalization and the Decolonial Option*, ed. Walter D. Mignolo and Arturo Escobar, pp. 22-32. New York: Routledge.

— Vázquez, Rolando. 2011. 'Translation as Erasure: Thoughts on Modernity's Epistemic Violence.' *Journal of Historical Sociology* 24, no. 1, pp. 27-44.
–. 2012. 'Towards a Decolonial Critique of Modernity: Buen Vivir, Relationality and the Task of Listening.' In *Capital, Poverty, Development*, ed. Raúl Fornet-Betancourt, pp. 241-252. Aachen: Mainz.
–. 2016. 'Against Oblivion.' In *Say it Loud*, ed. Jeannette Ehlers, pp. 14-16. Copenhagen: Forlaget Nemo.
–. 2017a. 'Precedence, Earth and the Anthropocene: Decolonizing Design.' *Design Philosophy Papers* 15, no. 1, pp. 77-91.
–. 2017b. 'Staging the End of the Contemporary'. Retrieved 25 January 2018, from Archiv Maerz Musik. www.berlinerfestspiele.de/de/aktuell/festivals/maerzmusik/archiv_mm/archiv_mm17/mm17_programm/mm17_programm_gesamt/mm17_veranstaltungsdetail_195861.php
–, and Walter Mignolo. 2013. 'Decolonial Aesthesis: Colonial Wounds/Decolonial Healings.' *Social Text/Periscope*.

— Wekker, Gloria. 2016. *White Innocence: Paradoxes of Colonialism and Race.* Durham and London: Duke University Press.

# Part 3

# No/New Future

# Disentanglement of the Present
# An Interview with Franco 'Bifo' Berardi

Thijs Lijster

> Our postfuturist mood is based on the consciousness that the future is not going to be bright, or at least we doubt that the future means progress.
> Franco Berardi, *After the Future* (2011)

Is it still possible to invent or reinvent the future? Does humankind even have a future? These are some of the questions raised by the recent works of the renowned Italian philosopher Franco 'Bifo' Berardi. Berardi is best known as being one of the intellectuals, along with Paolo Virno and Antonio Negri, emerging from the Italian 'workerist' movement Autonomia Operaia in the 1970s, and one of the founders of the pirate radio station Radio Alice in Bologna. Like Virno and Negri, Berardi takes his cue from the 'Fragment on Machines' in the *Grundrisse* (1857), where Marx explains how the accumulation of knowledge in technology leads to a further exploitation and proletarization of workers. Capitalist production robs workers not only of the surplus value created by their physical labour, but also of their cognitive and communicative skills, which are absorbed by what Marx calls the 'general intellect': '[T]he conditions of the process of social life itself have come under the control of the general intellect and been transformed in accordance with it' (Marx 1857). These lines turned out to be highly predictive of what capitalism would become in the decades after the Second World War, in what is alternately referred to as cognitive, immaterial, or creative capitalism.

While Antonio Negri, together with Michael Hardt, in their famous *Empire/Multitude/Commonwealth* trilogy envisioned this development as an opportunity for cognitive and creative workers to cease the means of production, echoing Marx and Engels' statement that 'capital creates its own gravediggers' (Hardt and Negri 2009, p. 311), Berardi's view is somewhat less optimistic. In *After the Future* (2011) he refers to a deeply felt and generally shared disillusionment with the future within our culture, starting with the punk slogan 'No Future!' in 1977, and spreading ever since. This disillusionment is further elaborated in his next book *Heroes: Mass Murder and Suicide* (2015), a 'horrible' book as Berardi himself labels it, in which he discusses terrorist attacks such as the one by Anders Breivik, increasing suicide rates, and high school shootings as symptoms of what he calls necro-capitalism, a socio-political system that causes ever more stress, suspicion, isolation, anxiety, and eventually death and destruction. He concludes

with the following unsettling advice to the reader: 'Do not take part in the game, do not expect any solution from politics, do not be attached to things, do not hope' (Berardi 2015, p. 137).

Having apparently reached the low-point of hope in *Heroes*, his most recent book *Futurability: The Age of Impotence and the Horizon of Possibility* seems more militant again. Here, he describes the 'general intellect' as 'the field of the next struggle and of the next creation' (Berardi 2017, p. 202), a struggle and creation, moreover, in which the combined forces of the artist and the engineer are of crucial importance.

For the present volume, I went to visit Berardi in Bologna to hear his thoughts about whether there is still a future for innovation and creativity, and indeed for the future itself. It resulted in a conversation, spread over two days, which, like his books, meandered between militant enthusiasm and melancholic despair.

### I Creativity and Capitalism

**Thijs Lijster**: You were part of the Italian workerist movement Autonomia Operaia, a movement that in many ways anticipated the developments of capitalist production from Fordism to post-Fordism, and the way in which language, creativity, affect and emotion play an increasingly important part in it. In your book *Heroes* you describe how workers have been lured into the 'trap' of creativity. Could you elaborate on that and explain why you consider creativity a 'trap'?

**Franco Berardi**: The movement Autonomia was not really a party or organization, but rather a sort of archipelago, consisting of different movements. The group that I was part of in Bologna, that published the magazine A/traverso and founded the radio station Radio Alice, had a special place within Autonomia. We particularly opposed the Leninist workerism of, amongst others, Toni Negri. We called ourselves Autonomia Creativa, because we were stressing the following two points. First, creativity is more and more important in the process of production: communication, information, style, fashion, and so on. Second, the communist strategy up until then was based on the idea of communicating the proletarian truth. We rejected this idea. Rather, the creative movement, and Ra-

dio Alice in particular, was about deconstructing the strict division between broadcaster and receiver. We developed a whole theory about the use of telephones inside the radio station, a kind of forerunner of the Internet revolution. In any case, our emphasis was on shared creativity.

Then, after 1977 and in the beginning of the 1980s, a lot of my friends got jobs at advertisement companies, some even at Berlusconi's company Mediaset. The link between Autonomia Creativa and the new advertisement and media landscape was very strong. In fact, I myself co-founded a magazine titled *Ario*, financed by a Milan advertisement group. They were my friends from the movement, and they told me that we could innovate the language of advertisement, transform it in a progressive sense, and so on. For me, these were beautiful years, even though I did things that had nothing to do with the activist period before. I was creative!

Then, little by little, I came to understand that, first, the word 'creativity' had become totally ambiguous, due to its co-optation by capitalism—think only of Florida's *Rise of the Creative Class*, which was of course only written years later—and, secondly, that the new form of social exploitation through precarity was completely based on the appropriation of the surplus of worker's creativity. Today, of course, this is totally clear. There is a new relation between capital and work, based on the stimulation of competition among individuals, especially in the field of cognitive work, where people have to be singular, creative, and different. Think different! This difference, this creativity, is more and more captured by the capitalist machine, which is transforming innovation into formal innovation, thus reinforcing the substantial persistence of valorization, exploitation, and accumulation in the economic sphere.

So, the Italian autonomists were rebels, but this rebellion has been part of the neoliberal redefinition of the capitalist dynamics. What is the goal of Autonomia, what is the specificity of its political philosophy? That the enemy is not only capital, but also the state. In our view, the main mistake of the Leninists had been that they wanted to turn the capitalist state into a socialist state. We argued that

the state could never be a worker state, that a communist state is an oxymoron, since the state organically emerged from the history of capitalist exploitation. Therefore, if you want to liberate yourself from capitalism, you have to liberate yourself from state control. Autonomia was autonomy from capital, from the state, from the unions. Radio Alice broke the state monopoly on radio broadcasting, since up until that moment you had only RAI1 and RAI2. When we decided to start a new radio station, the communists warned us: you may be saying nice things, but one day someone else may come along, and capitalize the media landscape.

They were right, of course! When Berlusconi became the king of Italy, I said to myself: we have paved the way for this horrible individual! Still, I do not repent, and I would do it again if I had to. The state monopoly was untenable. But now you see the ambiguity, the danger even, in words such as 'creativity' and 'autonomy', and even 'liberalization'. For neoliberalism, liberalization means privatization. Again, Radio Alice is proof of this. We said: liberalization of the media landscape. Then, two years later, Berlusconi comes along and turns liberalization into privatization, the creation of a new kind of monopoly or oligopoly.

TL: So, these concepts have been co-opted. Would the answer be to reject these concepts altogether, or rather to find ways to reclaim them? Can we still use concepts such as creativity or innovation in an alternative, critical way?

FB: I don't think we should reject these words altogether. The point is that they have not only been co-opted, but have even launched the dynamics of capitalist restructuration. This is not unique, though. The entire history of class struggle of the past two hundred years was a constant fight between workers' innovation and capitalist appropriation. After the Russian Revolution, when the workers in Germany and the US started thinking about changing society, capitalism was obliged to transform itself in the direction of massification, the assembly line, and distraction. Capitalist innovation is never the product of the capitalist mind,

but rather an effect of the dynamic or conflict between work and capital. Contemporary technological innovation in the digital age, too, is not the product of capitalist will. It is part of the conflict between capital and in this case cognitive workers.

So yes, our ideals and concepts have been co-opted; we have played into the hands of capitalist exploitation. It's unavoidable: if you produce something useful, capitalism will recuperate[1] it. But we should not be frightened by recuperation. We should trans-innovate. We, the workers, are the trigger, the origin of innovation. The point is: never identify yourself with yourself. After 1977 I came to understand that one should never identify with power, one should never think: we won at last. We will never win. Deleuze says the same in an interview: revolutions always fail. But the interesting thing is not the revolution, but the revolutionary: the group, the movement. You don't have to win; you have to go beyond yourself. That is the true meaning of autonomy.

**TL**: The characterizations of contemporary capitalism are manifold: cognitive capitalism, cultural capitalism, creative capitalism, post-industrialism, post-Fordism, and so on. Two recurring terms in your work are semiocapitalism and necrocapitalism. Could you explain what these terms entail? And how do the prefixes 'semio' (sign) and 'necro' (death) relate to each other in your view?

**FB**: I am not looking for the perfect definition of capitalism, for capitalism is many things at once. I'm not so fond of the term cognitive capitalism, because I would argue that the cognitive dimension is the contribution of the worker; capital itself is not cognitive. What I want to say with the term 'semiocapitalism' is that the specificity of contemporary capitalism exists in the fact that the entire process of production, the process of valorization itself, happens at a semiotic level, the level of the sign. Physical things are still being produced, of course, but what distinguishes contemporary capital from earlier periods is indeed this ability to valorize itself in a semiotic way, in the form of finance. The dimension of finance dominates the entire space of social distribution and production, it is the code of signs (*semia*)

into which the whole of capitalist production is translated. Both from the point of view of work (cognitive, immaterial labour), and from the point of view of capital (financialization of value), the process of production has become a semiotic process.

At the same time, I speak, mainly in *Heroes*, of necrocapitalism. This is because financialization *is* a necrotic process. A peculiar thing is happening: we produce more and more, but the salaries are going down, while the 1% becomes richer and richer. Financial capital is based not only on the exploitation of semiotic nervous energies, but also on the systematic destruction of social resources. Destroying a public school, destroying a hospital, or even the entire health care system as happens here in Italy, means more financial capital.

TL: How?

FB: Think of the European Troika, the IMF, and so forth, with their austerity measures. Austerity is the new form of financial capitalism. Governments have to pay the debts caused by the financial system. How do they pay it? By dismantling public services, lowering public expenses, and then repaying the money to some metaphysical entity. But the effect is not a decrease of debt, on the contrary. After ten years of austerity, the Italian debt has increased enormously. For a simple reason: if we lower the wages of teachers, doctors, and other public servants, or if they become unemployed, they will pay fewer taxes, and the result is that the debt rises. Christian Marazzi [in *The Violence of Financial Capitalism*, TL] says that financial capitalism does no longer work through the extraction of surplus value from labour, but through debt. The worker produces something, but then has to destroy this something in order to pay a debt. Capitalism has become a purely mathematical system, which is exploiting and destroying physical, living reality and society. This is a necrotic process: the entire life is put into the service of and crystallizes into financial capital.

TL: In *After the Future* you discuss how the historical artistic avant-gardes wanted to destroy the relationship between

sign and referent. Semiocapitalism, you argue, has realized this dream (for instance when monetary production was detached from the gold standard), albeit in a perverse way. Could you elaborate on this? And does this also mean that today artists have a different responsibility, maybe even the reverse one of reconnecting sign and referent?

**FB**: In the twentieth century, which was the century of the avant-garde, you indeed see this process of abstraction. What does abstraction mean? If you look at the Latin etymology it literally means 'move away from', but also 'getting free from'. So, the goal of the avant-gardes was towards indeterminism of the sign, the refusal most of all of the determination of representation. And in that regard, it is parallel to Nixon's decision, in 1971, of no longer letting the dollar be determined by the international system of fixed exchange, which basically marked the birth of financial capitalism, and its independence from actual economic production.

How should art respond? There are indeed some theorists, like the Italian philosopher Maurizio Ferraris, who blame abstract art for having opened the door to Berlusconi and financial capitalism, and who wrote a manifesto for a new realism. But I don't think that artists are ever the cause of these kinds of developments, merely the symptom, or a premonition. Futurism, Dadaism and Surrealism were an extraordinary anticipation of all that happened fifty years later.

Still, if I come to the present situation, I do think the history of the avant-garde is over. Basically, the movements in the 1960s and 1970s were conscious and explicit attempts to realize the avant-garde's dreams on a massive scale. Right now, deconstructing the relation between sign and referent is no longer a provocative gesture; this is done, this is advertisement. The new direction, the real possibility, is rather going in the opposite direction. I don't believe that artists have a task, but if they would have a task it would be the reactivation of the body. What body am I talking about? The body of the general intellect: hundred million cognitive workers in the world, the people who are actually reproducing the global machine on a daily basis.

So, we have to reactivate a hundred million bodies, not individually of course, because they are actually one single brain, and therefore also one body. This is my metaphoric way of thinking about the future of art.

TL: If you are talking about the reactivation of the body of the general intellect, do you mean bringing people physically together? Would that be the challenge of art, to break through the contemporary isolation and loneliness you discuss in your book *Heroes*?

FB: Yes, bringing people together, but not just for one night. Create a daily life that enables a continuous socialization. My background is in psychoanalysis, and although I'm not an analyst myself I've spent years of my life with them. The problem is that I have been raised in an age in which the main danger seemed boredom, while right now we live in the age of anxiety. In the 1960s and 1970s, it was all about escaping repression and becoming free. Now the problem is the opposite: we have all the freedom we want, but it's the freedom of being alone and unhappy. The Freudian framework does not work anymore: the problem is not that we are held back, repressing our urges, but rather that we are pushed forward, pushed to express ourselves, to be as expressive as possible. Now I won't say, like [the Italian psychoanalyst, TL] Massimo Recalcati, that we have to re-discover the Father. This is a discourse that seems to me reactionary and empty: putting artificial limits to my actions means nothing, neither from a therapeutic nor from a political point of view. Nevertheless, the paradox of empty freedom in accelerating times is an actual problem for social activation.

## II (No) Future
TL: In *After the Future* you write: 'Notwithstanding the horrors of the century, the utopian imagination never stopped giving new breath to the hope of a progressive future, until the high point of 1968, when the modern promise was supposedly on the brink of fulfilment' (Berardi 2011, 17). You go on to argue that 1977 was a kind of tipping point, a moment when the belief in and hopes for the future gave

way to a dystopian imagination. Could you explain how and why this happened?

**FB**: Obviously, here the concept of the future has to be understood in cultural terms. What is redefined is not the mere succession in time, but our cultural expectation. If I look at my personal experience, I can say that until March 1977 I was a futurist, in the sense that I had trust in the future, and in September 1977, I wasn't anymore. Until March, our movement was growing, but then the police in Bologna killed a student, then some more students were killed in Rome, and the atmosphere changed into one of repression, aggression, and fear. I organized a conference, together with Félix Guattari and others, titled 'Against Repression'. This was a total mistake; we should have called it something like 'Imagining the Future'. But we didn't know the next step.

But 1977 is an important moment in many regards: it was the year the first person was conceived through IVF, it was the year the Apple trademark was deposited, the year of Charta 77 in Prague, and the year Lyotard wrote *The Postmodern Condition*. But it was also the year the Sex Pistols yelled 'No Future!' and the year that Yuri Andropov, head of the KGB, wrote a letter to Brezhnev saying that the USSR was going to collapse if it wouldn't close the gap in information technology with the US. So, socialism was failing, while capitalism didn't seem so promising anymore. Moreover, you see that until the 1970s, the development of technical knowledge and the development of social consciousness had moved in parallel. But after the 1970s, they diverge: the sphere of technology and information keeps accelerating and expanding, but our ability to process this technology and information, and the time wherein to do that, decreases. The effect in the long run is a process of barbarization.

How to explain that at the same moment, young Londoners, Bolognese intellectuals, and many others began to be frightened by the future? I think that in that period we felt and perceived the exhaustion of the futurist promise. In the 1960s this promise was still strong. I've never been pro-Soviet, but I believed in the working class.

Not anymore after 1977, not only because of political experiences that made me realize that the working class is not a unified subject but much more contradictory and complicated, but also because the capitalist machine was going so fast, in technical terms, that we as workers were unable to keep up. Obviously, the Sex Pistols and Radio Alice are only minor phenomena. But if you look at 1977 in general: Louise Brown,[2] the Apple trademark, etcetera, these are all symptoms of technical progress that starts to diverge from social consciousness.

TL: This is a quite specifically European, Western phenomenon, right? If you look at Brazil, India or China, wouldn't you say that there is still this belief of a glorious future that will improve people's lives and so forth? Isn't there still a lot of hopeful projection on the future outside the Western world?

FB: If you mean that the cultural perception or expectation of the future is in good shape, in Brazil, India or China, then you are probably right. But if you look at the lives of individual people, do you think that for young workers Chinese modernization has been a success, an enrichment of their lives? Sure, they have more money, they have a car, but they are also living in hell. The Chinese film maker Jia Zhangke, director of *Still Life* and *Touch of Sin* and in my opinion one of the greatest filmmakers of today, shows us the perception and self-perception of young people in China, who have become much richer than their parents, but in another way much poorer. Just think of the suicides in the Foxconn factories.

I was in Barcelona a few weeks ago, for the presentation of a work by my friend Max de Esteban. He made this installation, *Twenty Red Lights*, in which you hear some influential stock brokers and financial people from New York and the London City talking on the phone. What they are saying is that neoliberal globalization has been the most social and egalitarian project in the history of humankind. Until fifty years ago, the world was divided in billions of very poor people and half a billion very rich people. Now this has changed, hunger and total poverty

have been reduced, thanks to us. But the pictures that are also part of the installation show misery, devastation, war, suicides, and so on. Now, what the brokers are saying is not totally untrue. But in the long run, do you think that the Chinese or Indians will wait 200 years, like the Germans and Americans, to understand that capitalism is bad? No, they understand it already! Not only because of the pollution in Shanghai and Beijing, but also because their lifestyle has changed in such a way that for young men and women it is impossible to imagine a future.

TL: What is your take on the accelerationists who argue that an effective political strategy would be to further speed up capitalism, so as to let it crash against its own borders? You quote from Srnicek and Williams' book *Inventing the Future* (2015) in your book *Futurability*. Do you think it is possible to invent or reinvent the future?

FB: Accelerationism is basically a deployment of Marx' central intuition, in the *Grundrisse*, that capitalism is accelerating the dynamics of productivity thanks to knowledge and technology. This is not all bad, as it forms the condition for the liberation from exploitation, the liberation from work itself even. So, from this point of view I consider myself an accelerationist. As long as we understand acceleration as a historical trend, I agree, but the moment you try to transform this thought into a political strategy, it becomes very problematic, because this political strategy has to be applied to the real, physical bodies of people. And these bodies are unable to deal with this kind of acceleration.

As I write in *Futurability*, I very much appreciate the political intention of Srnicek and Williams, but if they say that we have to reinvent the left, I answer: to reinvent the left is not a political decision. It requires a social and above all a psychological transformation. The problem of accelerationism is its total blindness for the most important thing: human suffering. They have no eye for the psychological, subjective reality of the cognitive worker. Even Jeremy Corbyn, whom I love, could not solve this, for there is no political solution. The real obstacle for social emancipation is

isolation, loneliness, and depression. Depression is linked to acceleration in the following way. Acceleration leads to panic, and panic opens the door to impotence and depression. Panic is the hyper-excitement of the mind, of the organism, that is facing an acceleration of info-neural stimulation. When the organism realizes that there is no way to keep up, it breaks the connection with reality: depression. Acceleration, panic, depression: this is the subjective cycle of our times. And I don't believe in a political solution.

**TL**: If a political programme, namely neoliberalism, has created this social situation in which people are panicked and depressed, why couldn't a different political programme change it, and lead to a different social situation?

**FB**: First of all, I am not sure whether there has been such a political decision. Neoliberalism does not exist as an independent ideology; it is the ideological recording of a techno-social dynamic. At a certain point capitalism was obliged to accelerate the rhythm of the machine, and to expel millions of workers. In the 1970s, the Fiat factories in Italy were confronted with a great refusal of work. At that moment, the capitalists decided to expel workers, to start a flexible hiring system and further stimulate automation and robotization. But this is a technical decision, not a political one. Forty years ago, Fiat had 120,000 workers in Italy, now 6,000. The acceleration of productivity, the total global competition among workers pushing down salaries, this is the real machinery of neoliberalism. There may be a thousand political decisions within neoliberalism, but essentially neoliberalism itself is not a political decision.

**TL**: But don't you then arrive at the same conclusion as Thatcher, that There Is No Alternative?

**FB**: Indeed, I think that there is no alternative. From a philosophical point of view, this statement is very challenging. If we do not change the anthropological disposition towards time, labour, and consumption, there is no alternative. Given these premises, it's unavoidable. The only way

out, if there is a way out, concerns what Foucault calls the *episteme*: the basic disposition of the mind towards reality. This is our challenge, and this is why I think that it's not so much a political problem.

TL: At the end of *After the Future* you include the beautiful 'Manifesto for Post-Futurism', in which one the final sentences is: 'We sing to the infinity of the present and abandon the illusion of a future' (Berardi 2011, p. 166). Here the absence of a future suddenly acquires a far more optimistic ring than it has in the rest of the book. Do you see the loss of future as a blessing or as a curse?

FB: The future is a modern category, or at least it meant something entirely different in the Middle Ages, or in Greek Antiquity. In modernity, the future means expansion. Actually, the imagination of the future is a very American idea. Together with the new world Columbus discovered the future, ushering in the Spanish 'golden age'. The future became a spatial idea of expansion and growth. So, if I say that the future is over, I mean that the age of economic, geographic, and cultural expansion is over. We have reached the limits of our world. California was of course at some point the geographical limit, and precisely the place where expansion and colonization started in a new direction: the colonization of time and imagination in Hollywood and Silicon Valley.

So, at this moment, when the future dissolves, the prevailing reaction is panic, impotence, and depression. After having written about those reactions, I tried to reverse the paradigm, by going back to the Futurist Manifesto—which is itself a wonderful exemplification of the future as expansion and acceleration—and rewrite it into a Post-Futurist Manifesto, in which the future is no longer presented as the condition of hope, but as the cultural and psychological root of malady.

The problem is that we, moderns, have worshipped the future as the only condition for happiness, and in so doing we have invested—in both an economic and psychological sense—the present into the future. This is the central dynamic of capitalism, but also of the Freudian concept

of repression: repression of the present for the sake of the future. If the future disappears, then investment becomes useless, and at that moment we are finally obliged, or allowed, to think in terms of the present.

TL: But couldn't one imagine a future not of expansion but of de-growth, of scaling down?

FB: I believe that we have worked enough in the past 500 years, and what has been accumulated is not just economic value, but technological knowledge. This knowledge is here, not in the future. That is why it is inside the present, in the already existing technological knowledge, that we can find a possibility. We don't need more investments in the future; we need to abandon the propensity towards the future, in order to disentangle the possibilities inscribed in the present.

What does that mean? It means to work less, to liberate time. Again, the contemporary problems of pollution, isolation, and depression cannot be solved by an act of political will, but only by the liberation of social time.

### III Withdrawal

TL: Is this what you mean with 'radical passivity'? In *After the Future* you write: 'Radicalism could abandon the mode of activism and adopt the mode of passivity. A radical passivity would definitely threaten the ethos of relentless productivity that neoliberal politics has imposed' (Berardi 2011, p. 138). Still, I would say that the kinds of things you propose to reach this passive state—universal basic income, drastic reduction of labour time, and so forth—require a political struggle.

FB: Of course, we need a lot of action in order to make passivity possible. But what kind of activism do we need? A cultural and epistemological activism, a revolution of the *episteme*, of our way of facing reality. That does not mean more action, but less. We need to disentangle what is already there, in the present.

I do not see the possibility of a political revolution in the near future. It is out of the picture. Not only because of the disproportion of forces between workers and capital but

also because there is no way to form a party or movement of workers, due to their precarious conditions. This was what I expressed in the Post-Futurist Manifesto. It was one of my most successful works. So many young people came to me saying how important it had been for them. This actually makes me feel melancholical, because it's a symptom of political defeat, of the idea that there is no way out.

I expect instead a withdrawal. So the way out may be: a withdrawal from totality, from the expectation of *Aufhebung*, from economic investment, and, simultaneously, the proliferation of units of self-organization. I don't claim this as a big discovery: during the last forty years, the most interesting experiences were those of withdrawal: *centri sociale* in Italy, artist communities in South America and Northern Europe, and so forth. Even the rise of the Internet, the cyberutopia of the 1980s and 1990s, was basically the promise of withdrawal, into a new dimension that will provide freedom, equality, democracy, and so on. A total mistake, of course, because the Internet went into a different direction, but the intuition that the Internet created a space for withdrawal was not wrong.

The question is, of course: withdrawal, and then what? In *Futurability* I suggest that cultural and psychological withdrawal might be the condition for the creation of an affective and technical platform for the disentanglement of possibilities. What does this mean? That a hundred million cognitive workers in the world have the potency of transforming the direction of technology, from profit to social good. Think of Wikileaks. Wikileaks is interesting not because of the content of the information that is shared; we don't need Wikileaks to tell us that the US Army killed civilians, we already know that. It is interesting because it connects cognitive workers, people like Chelsea Manning and Julian Assange. It is interesting from the point of view of the affective social *dispositif* of solidarity and withdrawal, a common platform to share technology and imagination.

TL: Do you see a role for artists there?

FB: Certainly. In recent years, I was invited many times by artists and cultural organizations. Especially in places

for performance art, dance schools, and the like. At first, I didn't understand why, but it turned out that they knew about my ideas of the reactivation of the body of the general intellect, and they were obviously interested in the body. It's a good starting point. I like artists a lot; they are the most proletarian of all. But this also means they are weak, and lonely. They can say: reactivation, but then what? You also need the engineer. Engineers are also alone; they are two sides of the same coin. That is why it is my dream to create a school for artists and engineers.

Artists, as well as scientists, have the ability to extract from the erotic relations between human beings a new meaning, a meaning that is not already implied in the syntactical succession of signs. Then comes the engineer, someone who can transform conjunctive signs into connective signs, transforming inventions into machines. But then comes the economist, who is subjectively submitting the connective machine, which incorporates the conjunctive innovation, to capital, something that is only useful in the sphere of economic valorization.

These are metaphors, obviously. I have always tried to turn scientific concepts into metaphors. But ten years ago, at the time of Occupy, my theoretical suggestions finally got a social audience. Now, ten years later, I see that my metaphors are nice, but that politically speaking they are not working, because they do not take into account the psychopathological side of it. I've met thousands of artists and engineers, and all liked my story, but in real life people are alone. Loneliness is the real obstacle nowadays.

TL: But in a way this is an organized loneliness, right? In the sense that this isolation of workers from each other, the sense of competition, is also something deliberately organized in the form of precarious work. How to break that? Resist that?

FB: This is the question. I can only repeat it, but not answer it.

TL: Coming back to the theme of this volume: what does this imply for the concept of the new? Does it have a

future, in the artistic sense or maybe also in a different sense, for the engineer?

**FB**: The 'new' is one of the cursed words of the vocabulary. I try to avoid it, but it's almost impossible. This consciousness itself is not new of course; take for instance Harold Rosenberg's book *The Tradition of the New* (1959). The new is a tradition, intertwined with modernity, with the paradigm of expansion and growth. Modernity is the dictatorship of the new, of fashion, of the *modus*. Within this paradigm, innovation actually means: more of the same. So, we need to be liberated from the order of the new, but in order to do that we need a *new* paradigm. We should be able to find a different expression, in order to become free from the obsession with the new.

As I said, we need to disentangle the present. When I see, for instance, that box over there or this glass, my mind is deciphering the flow of sense data, interpreting it into a *Gestalt*. In *The Doors of Perception*, Aldous Huxley describes this very clearly, when he speaks about his experience with taking mescaline. Looking at the wall, he didn't *see* the wall, because his mind was unable to grasp the *Gestalt*. Hallucination is the disentanglement of perception from the existing *Gestalt*, and the possibility of discovering many different things that are actually inscribed in the present, but that we don't see because we see a box or a glass.

So, what we need is a *Gestalt-switch*. In his last book, written just before his death, Félix Guattari speaks of *Chaosmosis*, or chaosmic spasm. In my view, this was the beginning of a new philosophical path that he was unfortunately unable to develop any further. Spasm is the painful effect of an acceleration of the mind in relation to its environment. Acceleration provokes chaos, and the chaos has a spasmodic effect on the human mind. But in the spasm we search desperately for a new rhythm, a new relationship between our own breathing and that of the cosmos. The concept of 'chaosmosis' is about the present chaos and the pain it produces, but also about the possible *osmosis*, in the sense of exchange and respiration, that gets us out of the chaos. I'm writing about this in my next book, titled *Chaos and Poetry. Respiration, Inspiration, Cospiration*.

As a writer, I have mixed feelings: on the one hand I follow the pleasure of the poetic drift, I follow where the words, the concepts, are taking me. But the militant in me is looking at this with contempt: as you are unable to solve the real problem, you escape in the realm of poetry. As a militant, I am guilty, but the solutions to our problems today have to be searched in a sphere that has nothing to do with militancy.

**TL**: This is something you see in many periods in history: in times of political impotence, people turn towards the arts. Is art a form of *Ersatz* politics?

**FB**: Yes, it is *Ersatz*, but at the same time it is a place of experimentation, a survey in a territory that might open up possibilities that we are not seeing at the moment.

## Notes

1   Recuperation, in the sociological sense, is the process by which politically radical ideas and images are twisted, co-opted, absorbed, defused, incorporated, annexed and commodified within media culture and bourgeois society, and thus become interpreted through a neutralized, innocuous or more socially conventional perspective. Source: Wikipedia; https://en.wikipedia.org/wiki/Recuperation_(politics).

2   Louise Joy Brown (born 25 July 1978) is an English woman known for being the first human to have been born after conception by in vitro fertilisation, or IVF, in 1977. Source: Wikipedia: https://en.wikipedia.org/wiki/Louise_Brown.

## References

—   Berardi, Franco. 2011. *After the Future*, edited by Gary Genosko and Nicholas Thoburn. Edinburgh, Oakland, and Baltimore: AK Press.
—. 2015. *Heroes: Mass Murder and Suicide*. London and New York: Verso.
—. 2017. *Futurability: The Age of Impotence and the Horizon of Possibility*. London and New York: Verso.

—   Hardt, Michael, and Antonio Negri. 2009. *Commonwealth*. Cambridge, MA: The Belknap Press of Harvard University Press.

—   Marx, Karl. 1858. *Grundrisse*, retrieved from www.marxists.org/archive/marx/works/1857/grundrisse/ch14.htm, accessed on 13 March 2018.

# The Trash of History

## Thijs Lijster

Because time is a corporate asset now. It belongs to the free market system. The present is harder to find. It is being sucked out of the world to make way for the future of uncontrolled markets and huge investment potential. The future becomes insistent.

Don Delillo, *Cosmopolis* (2003)

The new is the longing for the new, not the new itself: That is what everything new suffers from.

Theodor W. Adorno, *Aesthetic Theory* (1970)

### Prologue: The NEW Forest

*The NEW Forest* is part of Dutch artist and designer Maarten Baas' project *New! Newer! Newest!* It presents the plan to plant a forest of about 120 hectares in the Dutch polder of Flevoland. Viewed from high above, the forest shows a flashy logo saying *New!* This piece of land art, however, will not be completed for another two hundred years, when the trees will be fully grown. Just like in many of his other works, Baas seems to want us to experience time itself, in this case through a projection into the future. When the work is finally finished, we won't be around anymore (and, taking into account the rising sea level, it is even questionable whether the Dutch polder will still be there). Thus, the artwork confronts us with the unstoppable stream of time and the finality of our own lives.

Planting a forest is nothing new in itself; neither is having it grow in a certain shape. *The NEW Forest* is reminiscent of the *Green Cathedral*, the cathedral of poplars planted in 1970 by conceptual artist Marinus Boezem, or, for that matter, of the mysterious Swastika forest planted in the district of Brandenburg in the 1930s (which was only rediscovered and removed in 1992). Unlike these forests, however, where nature is made to adopt a traditional, or even religious shape, Baas chooses to let his forest grow into the particularly contemporary shape of an advertisement logo that, with the seasons, changes colour from green to red to yellow just like the neon ads in a shopping street.

There is a well-known phenomenon related to technological innovation called the 'horseless carriage syndrome': whenever new, revolutionary technology is introduced it is often cloaked in familiar forms either because the designers have not yet come up with anything else, or to let consumers adjust to this technology

through something they are accustomed to. For instance, the first cars were shaped like carriages (without horses), while the first cast iron constructions were made to look like marble pillars or trees. *The NEW Forest* seems to turn this principle around: yes, we want to slow down, we want quiet and *slow* art, but we will only accept it if it is packaged in the familiar and attractive forms of advertising. This is how Baas acknowledges the abiding magnetism of the new for art, and for us as art lovers, perhaps even for our culture in general: we are so fond of it that we are even willing to wait two hundred years.

Then again, we also seem to become increasingly afraid of the new, or tired of it. Emphasizing the novelty of a product may be one way to sell it; another effective way is to underline authenticity, tradition, craftsmanship, etc. ('Like grandma used to make it'). In Western politics, at least, this strategy has proven its value in the last few years, where right-wing and populist parties propagated the return to traditional values, or to some 'golden era' in which the nation was still great. Both of these sentiments—the longing as well as the suspicion for the new—have been part of the fabric of modern experience from the outset. To be modern, as Marshall Berman has stated in his classic study *All That Is Solid Melts into Air* (1982), means to be 'moved at once by a will to change—to transform both themselves and their world—and by a terror of disorientation and disintegration, of life falling apart' (Berman 1988, p. 13).

Today, however, the second half of this formula seems to be gaining the upper hand, at least in the sphere of politics. Indeed, the rise of populism and the far right seems to indicate that for more and more people, change and innovation are not, or no longer, associated with emancipation and liberation, but rather with loss: loss of control, or autonomy, of freedom even. This undoubtedly is a reaction to a mode of governance in capitalist society—ranging from the level of lower management to the level of global bodies such as the IMF—which Luc Boltanski describes as a peculiar mixture of volition and necessity of change:

> [The] elites wanted to be radically innovatory and modernist. The core of their argument ... was as follows: we should want change because it is inevitable. It is therefore necessary to *wish for necessity*. Obviously, change will create victims (those who will not be able to 'keep pace with it' and

who some years later were to be called 'the excluded'), but it would be worse if, 'as leaders', we did not manage change; if we did not *want* it (Boltanski 2011, p. 130).

Change, in short, is presented as something that is at the same time inevitable—it will happen anyway, there is no alternative, so don't fight it!—and as ultimately desirable, for being the 'lesser evil'. The strategy of turning what is essentially a historical state of being into something 'natural' (meaning: inevitable, law-like, something that cannot be altered) has of course always been the cardinal principle of ideology. Ideology basically *is* the transformation or petrification of history into nature, i.e. what Georg Lukács called a 'second nature', or what Walter Benjamin and Theodor W. Adorno called 'natural history' (*Naturgeschichte*). The peculiar move nowadays is, however, that it is precisely *change itself* that is presented as unchangeable. At most, we (that is, the elites) can only 'manage' change, make the best of it, get us through it, even though it will take some sacrifice. No wonder then that today for a lot of people (especially the ones making the sacrifice) change is experienced as a form of subordination: thou shalt change, no matter what the cost, and whether you desire it or not.

### The Myth of Contemporaneity

For at least two centuries artists have been considered to be agents of social change, at least since the French utopian-socialist philosopher Claude Henri de Saint-Simon, in an essay from 1825, named them the *avant-garde* of society (together with scientists and philosophers). Although there have been numerous politically conservative modernists (e.g. Eliot, Pound), still the very fascination or obsession with innovation made artists suspicious in the eyes of the established political class that wanted to maintain the status quo, and thus a natural ally of revolutionary politics. Perhaps no one voiced this relationship as forcefully as the Russian writer and politician Anatoly Lunacharsky in a text titled 'Art and Revolution' (1920): 'If revolution can give art its soul, then art can give revolution its mouthpiece' (quoted in Raunig 2007, p. 12).

Given the fact that today it is capitalism itself that comes closest to the Trotskyist ideal of a 'permanent revolution', does that mean that art is now capitalism's mouthpiece, and that is has thus sold its soul? In that regard it is noteworthy that the predicate of the 'avant-garde', let alone the predicate of the modern, has it-

self fallen out of fashion since the dawn of neoliberalism, and has been replaced by the predicate 'contemporary'. What does it mean to be contemporary, and what is the condition of contemporaneity today? The philosopher Hermann Lübbe, in a beautiful German neologism, speaks of *Gegenwartsschrümpfung*, a 'shrinking of the present' (Lübbe 2000). The present, that is the temporal space in which we are able give meaning to our lives in terms of our past, and from which we can orient ourselves towards the future, is becoming smaller and smaller. Following Lübbe one could argue that the predicate 'contemporary' expresses a *longing*: we wish to be contemporary, or get a grip on 'the contemporary', as soon as the present becomes increasingly transient and ephemeral. The latest trends in fashion, technology, but also politics, philosophy, science, and last but not least, art, are becoming outdated ever more quickly: what was *en vogue* today is *passé* tomorrow. In that regard contemporaneity is a myth.

At the same time, and unlike we did in the nineteenth century, we no longer cherish the belief that this constant innovation and change is heading somewhere. The Kantian dream that had us flying on the wings of science and technology towards 'perpetual peace' has been buried in the course of the twentieth century, under the debris of two horribly destructive world wars. Indeed, as Hartmut Rosa says, we still may believe that our phones and laptops will be increasingly faster and smarter, but this does not necessarily lead to an improvement of our lives, or of the world as a whole (Rosa 2013).[1] Here too the shift from the modern to the contemporary is revealing. The modernists saw a clear break between themselves and the past and considered themselves as the pioneer for a different (and better) future. The modernist is the revolutionary dreamer, the one who will do it all differently, the very tool of history itself. The predicate 'contemporary' on the other hand seems to say nothing more than: belonging to the present, that which appears today, without presupposing a clear understanding of or attitude towards the past or the future.

These two meanings of contemporary—as insatiable desire and as everyday banality—together form the central paradox of our time, which is that the experience of accelerating life goes hand in hand with the experience that nothing *really* changes. We are not yet out of the economic crisis, and the next wave of financial scandals has already begun, while our politicians keep emphasizing that there really are no alternatives for neoliberal

austerity, the demolition of the welfare system, and the privatization of the commons. In museums and in biennales, the experience described by art critic Robert Hughes as the 'shock of the new' has largely given way to the experience of *déjà-vu*. Retro trends even seem to dominate geopolitics as we are entering a new Cold War, complete with nuclear threat and proxy wars. The formula Benjamin once used to characterize fashion now applies to society as a whole: the eternal recurrence of the new.

The myth of the contemporary is therefore first and foremost a symptom of the contemporaneity of myth, if we understand myth as a world view in which the fate of humankind is subject to forces far beyond its control. Mythological thinking, following the line of thought of philosophers such as Benjamin, Horkheimer and Adorno, but also Roland Barthes, is essentially ahistorical, cyclical, and repetitive, like the hellish punishments of Sisyphus and Tantalus. As already mentioned, both Benjamin and Adorno used the concept of 'natural history' as a critical category describing how the contrasting poles of nature and history had dialectically turned into their opposite. Nature traditionally was considered as existing and developing independently of humankind, like the cycles of seasons and tides, while history—at least since Giambattista Vico—was considered as something the course of which lies in human hands. 'Natural history', however, designates the moment in which these concepts turn into their opposites: while we now assume that we can manipulate nature in all its facets, including our own bodies and brains, we have come to regard social relations (i.e. history) as immutable and rigid, in other words as 'nature'. We anxiously anticipate the next economic crisis, war, the very destruction of our planet, as if it is an approaching thunderstorm, something that is beyond our control. Anyone who does propose an alternative is reproached for being 'unrealistic'. But this 'capitalist realism' (Fisher 2009) is mythical thinking par excellence, for it considers history to be already written in the stars, instead of something produced by human beings.

### The Time of Money

This petrification of history into nature is not a mere conceptual misunderstanding or a form of 'false consciousness' but has its roots in the very structure of financial capitalism. 'Time is money' is an old saying, telling us to speed up so as not to let the competition catch up with us. But time is money not only on

a socio-psychological level; money itself brings along with it a temporal logic. The very ontology of money has a certain temporal core, which can explain why commodification, marketization, and financialization lie at the root of the nullification of history's open horizon.

In *The Inhuman* French philosopher Jean-François Lyotard discusses this temporal logic of money, in an essay titled 'Time Today'. The most basic form of exchange, writes Lyotard, exists in the fact that person X gives person Y object A (for example a product or service) at time $t$, if and only if Y gives X object B (in this case money) at time $t'$. What stands out in this formula is that $t'$ (the moment of payment) is ahead in time, but nevertheless forms the precondition for what happens earlier at time $t$. In other words, the moment $t'$ is not something that lies in an open future, something that can be expected or hoped for, but it is that which makes the whole process possible in the first place. Money is therefore time in a very literal way, namely a bridging of the time between two discrete moments, the guarantee that I will be able to recover my investment (for example from work that I put into a product, or a financial investment). As a consequence, future and present collide into one another and nullify each other: the present is determined by a projected future and neutralized as a potential source for actual renewal, while the future is determined by the present, thus no longer open and contingent. As Lyotard writes: 'Money here appears as what it really is, time stocked in view of forestalling what comes about' (Lyotard 1991, p. 66).

In the thirty years that have passed since Lyotard wrote this text, his words have only gained in truth, especially in a world increasingly dominated by debt. Debt—mortgage debts, student loan debts, credit card debts, government debts, etc.—are what keeps financial capitalism going, and thanks to debt even poverty is no longer an excuse for not consuming. By taking on a debt we pretend to take an advance on the future, thus controlling it: why would you wait years to buy a new car/kitchen/television if you can have it right now? But in fact, we ourselves are the ones controlled by this projected future through the medium of debt. Often neither governments nor individual consumers are able to ever pay back all of their debts, but that was never the point. Debt, as Nietzsche already saw, is primarily a source of power, a way of controlling people and having them submit to you (something that became particularly clear during the debt crisis in Greece,

where democracy was completely side-lined by the European troika in order to impose neoliberal reform). The Italian theorist Maurizio Lazzarato elaborately discussed this relationship between debt, time, and power in his book *The Making of the Indebted Man* (2012). There he also writes: 'For debt simply neutralizes time, time as the creation of new possibilities, that is to say, the raw material of all political, or esthetic change' (Lazzarato 2012, p. 49). Lazzarato's mentioning of aesthetic change again brings us to the question what this means for the arts.

In that regard the contemporary art world can once more serve as a model for what unfolds in society as a whole. In the art world the neutralization of time can be very clearly recognized in the notion of the 'project'. If there is one thing that characterizes contemporary art and distinguishes it from previous eras, it is that artists are no longer producing art *works* but rather art *projects*. Several authors have pointed out the fact that the art world is therefore the exemplary form, and in many ways even the forerunner, of project-based labour under the 'new spirit of capitalism' (cf. Boltanski and Chiapello 2005; Gielen 2009; Kunst 2015). It creates a temporary and flexible working relationship, which nevertheless demands the utmost from the individual worker, thus creating the perfect condition for mental and psychological exploitation. One can never do enough for the project, never invest enough time and energy in it; as long as it is not finished the worker has an infinite debt towards the project.

More important in this context, though, is the specific temporal logic that is part of the notion of the project, what Bojana Kunst calls 'projective temporality' (Kunst 2015, p. 157). Indeed, the very etymology of the word as 'something thrown forth' implies a projection into, meaning both an investment in and an anticipation of the future. The project is an investment, but the intended outcome is often already determined in advance, thus neutralizing time itself. The reasons for this can be quite prosaic: to do the project one needs a grant or an investor, and therefore one has to legitimize the project so that it can be judged by others. As said, this is by no means unique of artistic work but characterizes more and more domains of production. The contemporary scientist or scholar is also often a project worker, spending a lot of time finding partners or investors, building alliances and consortia, and of course writing research proposals. What makes the research proposal in itself such a peculiar (and often frustrating)

genre, is that in some way one has to already know (or at least pretend to know) the answer before asking the question. The actual open question, the genuine curiosity, and the uncertain future have no place in this dominant logic of the project. The project thus has the temporal form of debt: by engaging in a project, we become indebted to the future. As Kunst writes:

> The present is thus a debt that we owe to the future: in order to live better we should not live in the present. However, the problem is that the future is never truly imagined anew but remains even more tightly bound to the constellations of power in the present (Kunst 2012).

What we should therefore do by means of resistance or countermovement, Kunst argues, is reclaim the present: 'Only when we are able to simply be "alive" in the present will radical alternatives begin to bloom once again' (Kunst 2012).

In fact, Lyotard already proposed this: as opposed to the temporal logic of the *new*, that is, the eternal recurrence of innovation in service of profit maximization, he developed an aesthetics of the *now*. His essay titled 'The Sublime and the Avant-garde' is an attempt to decode a phrase of Barnett Newman: 'the sublime is now'. According to Lyotard, what matters in an artwork is not *what* is happening (what you see or hear, who is on stage, what it means, and so on.), but *that it happens*, or in other words the happening itself: the painted surface, the gesture, the tone or sound that precedes all cognitive categorization and meaning-making processes. The art of the avant-garde is sublime, Lyotard argues, not because it propels us into the future, but because it confronts us with this incomprehensible *happening*, or rather with the question: *is it happening? (arrive-t-il)?* Newman's work is exemplary in this regard: because it represents nothing, it presents us with the happening of the painting itself, its 'here and now'. In the conclusion of his essay he contrasts the *now* of the avant-garde with the *new* of capitalism:

> [I]nnovating means to behave as though lots of things happened, and to make them happen. Through innovation, the will affirms its hegemony over time. It thus conforms to the metaphysics of capital, which is a technology of time. The innovation 'works'. The question mark of the

> *Is it happening?* stops. With the occurrence, the will is de-
> feated. The avant-gardist task remains that of undoing the
> presumption of the mind with respect to time. The sub-
> lime feeling is the name of this privation (Lyotard 1991,
> p. 107).

Indeed, in many contemporary art practices we see—in the artists
themselves as well as in their audiences—a longing or even nos-
talgia for the present. An exemplary case is Marina Abramović'
performance in the MoMA during a retrospect exhibition of her
work, tellingly titled *The Artist is Present* (2010). During opening
hours, for as long as the exhibition was running (which was about
three months), Abramović sat in silence on a chair in the atri-
um of the museum. Visitors could sit on a chair opposite to her,
and stare into her eyes for as long as they pleased. Many people
burst into tears when finally meeting Abramović' gaze, and in in-
terviews people spoke of an almost mystical experience of being
completely lost in the moment. The success of the performance
and its attraction to a mass audience, without a doubt, has some-
thing to do with the cult of the star being 'present', that is: there
in the building, but probably also with the other meaning of the
word, namely being in the present moment, or in other words the
sublime experience or presence Lyotard was talking about.

And yet, this nostalgia for presence should raise our suspi-
cion, for a number of reasons. First, the 'here and now', despite
its sublimity and evanescence, has proven to be quite marketable,
and thus not so contrary to the temporal logic of capitalism af-
ter all. Presence fits into the very commodification of time and
the 'spectacle-ization' of culture, which entails the marketing of
festivals, exhibitions, and events where you *have to be*. The very
uniqueness and singularity of such events is a by now well-known
advertisement tool, as witness the mushrooming 'once-in-a-
lifetime' experiences one could have on an daily basis. Indeed,
Abramović' retrospective and performance drew a record break-
ing number of visitors to the museum, with people queuing up for
hours and even sleeping in front of the museum before opening
time, as if it was a pop concert. Second, a contemporary reader of
Lyotard's words cannot help but think of the countless self-help
gurus and mindfulness-coaches telling one to 'be in the moment'.
All too often, though, such discourses function as self-improve-
ment therapies, i.e. to help one to better function as employer,

worker, manager, or lover. Thus, they are meant to strengthen our competitive position in the very rat race of which they pretend to liberate us.[2] Finally, singing the praise of the present does not in any way provide a solution to the problem of the petrification of history and the destruction of the future that is the result of the temporal logic of capital. After all, the quasi-mystical experience of 'presence' is an emphatically *individualistic* and rather isolated experience.[3]

It would therefore be unwise to remove the concept of the new all too hastily from the lexicon of critical thinking, by identifying it with the temporal logic of capital, while trading it in for the sublime 'now' of presence. The problem of contemporary culture is not the change or innovation per se, but rather the 'eternal recurrence of the new', that is the empty and automatic progress of history that actually brings nothing new under the sun.

### Now-time

The new, as Boris Groys already argued, is a relational category: 'The new is new in its relation to the old, to tradition' (Groys 2014, p. 6). This is why it can only be recognized and understood against the background of tradition and its cultural archives (literal archives such as museums or libraries, but think also of the canon, university curriculums, and so on). This means that the destruction of the future also has implications for how we relate to history. Since we no longer seem able to project a meaningful future, we also have difficulty determining what is relevant for our past. As a result, we see a tendency to preserve anything, both on an individual and collective level. Like the hard drives of our computers become clogged with digital photos and notes, public space gets cluttered with heritage sites. The musealization of cities has become a serious issue for its inhabitants, while also landscapes, plants and animals, and local customs are declared as 'heritage' (Hartog 2005; Ter Schure 2016). It seems as though we hold on to history all the more desperate as we become less able to write history ourselves.

Rethinking the new therefore requires, first of all, a different attitude towards history. 'Always historicize!', Fredric Jameson famously said—he even called it the only absolute and transhistorical imperative—but the question is of course how to historicize. As Nietzsche already saw clearly, it is not a matter of increasing the burden on our shoulders with mountains of historical heritage—

which would be stifling rather than igniting action—nor should the new be considered in terms of mere accumulation, as the next step in a continuous history of progress. The new, the truly new, allows us to view the tradition in a whole different light.

This is also what Walter Benjamin had in mind with his concept of 'now-time' (*Jetztzeit*), which he developed in his *Arcades Project* and in the theses 'On the Concept of History' (1940). Benjamin was a fierce critic of an evolutionary conception of progress, according to which we could passively see how history would unfold before our eyes, and that moreover assumed that all human suffering in this history of progress should somehow be regarded as a necessary evil. Moreover, Benjamin argued that it is always the victors writing the history of progress, as he vigorously stated in saying that 'there is no document of culture which is not at the same time a document of barbarism' (Benjamin 2003, p. 392).

Benjamin's interest lay with the 'trash' of history, as he formulated it, with the missed opportunities of the *losers* of history. 'Now-time', in his view, was an interruption of the historical continuum, but we should not understand it as a simple dwelling in the present as previously discussed with regard to Lyotard and the mindfulness gurus. On the contrary, now-time is a moment in which an image from a suppressed and unfinished past imposes itself on the present, making a connection with it. Together, past and present form what he calls a 'dialectical image'. This is, of course, an oxymoron: dialectics presuppose motion while an image is static. But images can nevertheless collide with each other, reflect on each other, and evoke new meanings, as in the first photomontages of artists such as Man Ray and John Heartfield. Benjamin gives an example of such a picture by quoting Leonardo da Vinci, who described how the person to first construct a flying machine would grab snow from the mountaintops in the summer and would scatter it over the hot streets. Such an image would be likely to shock Benjamin's contemporaries, most of whom witnessed firsthand how it was mainly bombs scattered from airplanes. The utopian dreams of the past thus collide with the grim reality of the present.

'Now-time' is a 'tiger's leap' into history, meant to blast open the historical continuum. Benjamin was first inspired by the surrealists, who discovered 'the revolutionary energies that appear in the "outmoded"' (Benjamin 1999, p. 210), namely in

outdated architecture, the earliest photographs, old fashion items, and other obsolete artefacts. These phenomena contain revolutionary energy because they express the dreams of a previous generation; now that they have become trash, it is clear that these dreams have not come true. This insight is not meant to make us feel melancholic or nostalgic, but rather calls for action to fulfil these broken promises. As Slavoj Žižek puts it:

> [T]he future one should be faithful to is the future of the past itself, in other words, the emancipatory potential that was not realized due to the failure of the past attempts and that for this reason continues to haunt us (Žižek 2008, p. 394).

This is an important corrective of contemporary attempts to restore utopian thinking and rehabilitate the concept of 'progress', which time and again threaten to fall into the trap of pledging the past as well as the present to the future by developing a blueprint of the latter. Marx, in *The 18th Brumaire*, had ridiculed the historical dressing-up parties of the previous revolutionaries, arguing that the coming revolution 'cannot take its poetry from the past but only from the future' (Marx 1852). But perhaps there is, as Benjamin argued, more revolutionary power hidden in 'the image of enslaved ancestors ... than [in] the ideal of liberated grandchildren' (Benjamin 2003, p. 394). To historicize, in other words, means to face the contingency of history: it could have been otherwise, which means it can be otherwise. Thus, an understanding of history prompts us to a new conception of time, and in turn a different concept of time could change the course of history, making the new possible in the first place.

### Epilogue: The Artist as Rag Picker

Julian Rosefeldt's installation *Manifesto* is an overwhelming collage of thirteen short movies, each starring Cate Blanchett in a different role, proclaiming lines taken from more than fifty artistic manifestoes. Rosefeldt himself characterized his film as a homage, a 'manifesto for manifestoes', yet one cannot help but get the impression that the installation is just as much a eulogy for it, a farewell to the manifesto. After all, not our, but the past century was the century of the manifesto. The oldest artistic manifesto quoted by Rosefeldt is Marinetti's 'Manifesto of Futurism'

from 1909, the most recent one dates from 2004. Throughout the twentieth century the -isms emerged at a rate of knots, each of them ushered in with a manifesto. In spite of all the pessimism about war and destruction there was at least the artist who knew, or pretended to know, the right way.

Art that knows the only right path, the one direction we should be heading – this is an idea that we have given up on, not only in view of the multitude of styles and directions that characterize contemporary art, but also because in retrospect this idea always belonged to a typically Western, and therefore limited conception of art history, and of history in general. In one of the scenes of *Manifesto* we see a tramp roaming an abandoned and derelict industrial site, while the voice-over proclaims these lines of Constant Nieuwenhuys: 'In this period of change, the role of the artist can only be that of the revolutionary.' But can the artist still be revolutionary at a time when everything around us is constantly changing, in a world in which neoliberal capitalism itself seems to sail best in the event of constant crisis and catastrophe, or permanent revolution?

Benjamin writes: 'Catastrophe is progress; progress is catastrophe' (Benjamin 1991, p. 1244, translation TL). This is no mere syntactic inversion. The words mean different things in the two parts of the sentence. Progress, understood in the traditional teleological and social-evolutionist way, indeed turns out to be one single catastrophe. But this also means that true progress can only exist in a catastrophe (from *katastrephein*, to overturn) that brings the blind course of 'natural' progression to a halt. The revolution is not the locomotive of history, as Marx had argued, but rather the grip on the emergency brake that brings the runaway train to a standstill. Today, perhaps even more than ever before, we seem to be in such a runaway train, rushing towards the abyss. An interruption of history, however, cannot be brought about by art, but should itself be an historical event.

Perhaps we should see the tramp in Rosefeldt's film as Benjamin's 'rag picker', that messianic figure who collects the garbage from the streets on the morning of the revolution. Moreover, Rosefeldt seems to identify the artist (and with that himself) with this rag picker, who still sees the value of in the rags that others have carelessly thrown away. In this case, the rags are the artistic manifestoes that in their new constellation are given historical strength again. That was the crucial insight of Benjamin: that his-

torical awareness can only arise in the face of the waste of history.

What, in the end, does it mean to be innovative? Do we need to come up with a new definition of the new? In any case, the truly new means something else than being somehow 'ahead' of one's time, let alone adding yet another gimmick to the trash heap of outmoded novelties. Artists deserving the predicate 'innovative' let the presence collide with tradition, thus offering an alternative understanding of the past as well as opening up a new perspective towards the future. Such works are neither a mere moment in a continuous flow of time, nor a wallowing in the 'here and now' but lift the present from the historical continuum. Only by rewriting history can the truly new come about.

# Notes

1 See also the interview with Rosa in this volume.
2 Mindfulness and meditation techniques are in fact increasingly used in the top managerial layers of international businesses and banks, as well by the US Army to help soldiers overcome their fear of pulling the trigger or deal with PTSS (Bloemink 2015).
3 See also Rosa's critique of 'oases' of resonance in Rosa 2016 as well as in the interview in this volume.

# References

— Benjamin, Walter. 1991. *Abhandlungen: Gesammelte Schriften, Band I-3*, ed. Rolf Tiedemann and Hermann Schweppenhäuser. Frankfurt am Main: Suhrkamp.
—. 1999. *Selected Writings: Volume 2, Part I, 1927-1930*, ed. Michael W. Jennings et al. Cambridge MA: The Belknap Press of Harvard University Press.
—. 2003. *Selected Writings: Volume 4, 1938-1940*, ed. Michael W. Jennings. Cambridge MA: The Belknap Press of Harvard University Press.

— Berman, Marshall. 1988 (1982). *All That is Solid Melts into Air: The Experience of Modernity*. New York: Penguin.

— Bloemink, Sanne. 2015. 'Mindfulness: De nieuwe religie voor ongelovigen.' *De Groene Amsterdammer* 139, no. 32, pp. 28-31.

— Boltanski, Luc. 2011. *On Critique: A Sociology of Emancipation*, trans. Gregory Elliott. Cambridge: Polity.
—, and Eve Chiapello. 2005 (1999). *The New Spirit of Capitalism*, trans. Gregory Elliott. London: Verso.

— Fisher, Mark. 2009. *Capitalist Realism: Is There No Alternative?* London: Zero Books.

— Gielen, Pascal. 2009. *The Murmuring of the Artistic Multitude: Global Art, Memory and Post-Fordism*. Amsterdam: Valiz.

— Groys, Boris. 2014. *On the New*, trans. G.M. Goshgarian. London and New York: Verso.

— Hartog, François. 2005. 'Time and Heritage.' *Museum International* 57, no. 3, pp. 7-18.

— Kunst, Bojana. 2012. 'The Project Horizon: On the Temporality of Making.' *Manifesta Journal* #16, retrieved from: www.manifestajournal. org/issues/regret-and-other-back-pages/project-horizon-temporality-making.
—. 2015. *The Artist at Work: Proximity of Art and Capitalism*. London: Zero Books.

— Lazzarato, Maurizio. 2012. *The Making of the Indebted Man*. Los Angeles: Semiotext(e).

— Lübbe, Hermann. 2000. 'Gegenwartsschrümpfung und zivilisatorische Selbsthistorisierung.' In *Schrumpfungen: Chancen für ein anderes Wachstum*, ed. Frithjof Hager and Werner Schenkel. Berlin and Heidelberg: Springer.

— Lyotard, Jean-François. 1991. *The Inhuman: Reflections on Time*, trans. Geoffrey Bennington and Rachel Bowlby. Stanford: Stanford University Press.

— Marx, Karl. 1852. *The Eighteenth Brumaire of Louis Bonaparte*, retrieved from www.marxists.org on February 2018.

— Raunig, Gerald. 2007. *Art and Revolution: Transversal Activism in the Long Twentieth Century*, trans. Aileen Derieg. Los Angeles: Semiotext(e).

— Rosa, Hartmut. 2013. *Social Acceleration: A New Theory of Modernity*, trans. Jonathan Trejo-Mathys. New York: Columbia University Press.
—. 2016. *Resonanz: Eine Soziologie der Weltbeziehung*. Berlin: Suhrkamp.

— Ter Schure, Leon. 2016. *Bergson and History: Transforming the Modern Regime of Historicity*. Groningen: Rijksuniversiteit.

— Žižek, Slavoj. 2008. *In Defense of Lost Causes*. London: Verso.

# Predicting Innovation
## Artistic Novelty and Digital Forecast

Elena Esposito

Does the new have a future? It certainly has a past. The idea and the evaluation of the new have a history and underwent big transformations, which signal corresponding transformations in the semantics of society and its relationship with time.

First of all, the valorization of the new as a positive, fascinating, and stimulating aspect has a history. Until the modern age, i.e. for many centuries, this was not the case: new meant primarily wrong, disturbing, and irritating. Novelty broke out as an annoyance in a world made of consolidated expectations, it challenged them and forced them to restructure. When you recognize and accept the new, you have to change your references to take account of it, and this is always a laborious and often a controversial process. Old references had been tested, consolidated by tradition, and confirmed by authorities and experience. The new, if it is really new, comes out of nothing and has nothing to confirm it. We have no experience of the new, except that it forces us to revise our experience.

Recognizing something as new also has the annoying consequence that what was there before, which appeared familiar and reliable, suddenly becomes old—not because of some intrinsic characteristic, but simply by contrast with the emerging new. By itself, the 'old' model of the iPhone or of the car is not unsatisfactory and does not look flawed, but with the release of the new version it immediately becomes obsolete, with all related consequences. As Niklas Luhmann argued, looking for the new makes the world age and forces us to constantly seek further innovations.

This is obviously an extremely tiring condition, and it is understandable that for many centuries the new was avoided, and people tried, as far as possible, to neutralize it as a simple mistake or stigmatize it as bad and devious. This, however, is not the notion of new that is familiar to us, the one whose future we want to analyze. Since the seventeenth century, a radical change took place: now we like the new—in fact we only like what is new. Not only is novelty not stigmatized anymore, it is actively looked for and in all areas of society becomes the condition for something to be appreciated. In science, in mass media, in politics, in private life, you first look if a proposal has elements of novelty—and only afterwards you decide if you possibly like it. If there is nothing new, the proposal is often not even considered (unless the rejection of the new is presented as an innovation). In art, as we shall see shortly, this tendency finds its utmost expression.

In modern times forms emerged and quickly became established, such as fashion, that based their credibility precisely on the promise of a continual renewal. Of fashion we only know that it will change. We do not know how and why (fashion is primarily characterized by not having a reason), but we know that next season something else will be fashionable, while what's 'in' will be 'out' and will no longer be followed. Fashion is not liked despite its change, it is liked because it changes. We follow what is 'in' because we know that soon it will be 'out', so it does not bind us to anything other than constant change. What will become 'in' will itself be 'out' and something different will emerge again that will become popular because it is new (or presented as new: think of vintage). This instability does not concern only clothing but spreads in all fields, from philosophical orientation to eating habits, from medical practices to religion—the field which provoked the greatest resistance in the seventeenth and eighteenth centuries when the phenomenon of fashion (itself new) was for the first time analyzed and commented upon. And of course, there are also artistic modes, indeed in that field fashion took peculiar forms, as we shall see.

Fashion is the model of a different kind of stability, which is not based on tradition and constancy but on exploration and transformation. In fashion everything changes, except the fact that fashion changes. Change becomes the only constant reference, the only thing we can count on. This understanding of the new also corresponds to the open future of modern society, with the spread of uncertainty and at the same time the lure of the possibility of actively building our future. In the form of an open future, we actually face a world to come that no one can know because it does not exist yet. The future is not predetermined, decided by some higher entity who already knows the course of things, and can therefore accommodate our projects and our fantasies. In the open future, it is always possible for these projects to be realized, although obviously it is not assured—it does not, however, depend on destiny or a predetermined order of the world, but (also) on what we and others do or don't do today. The future is open but not arbitrary. What will happen tomorrow also depends on us, but we do not know how: if we do nothing or do different things, it will happen otherwise, but our actions can always have unexpected results.

This is the basis of our chronic insecurity but also of the inexhaustible fascination of experimentation, especially in art.

One looks for answers that in turn give rise to other questions. It is the attempt (not just in the avant-gardes) to locate oneself ahead of the present, to anticipate, discover, and test the possibilities that are not yet there and see what happens. The quest for the new is exasperated and purified to the essence of surprise—at the cost of deviance and incomprehensibility. The critical element and the 'counter' connotation of a large part of arts in the modern understanding are linked to the search and extremization of the new, which is by its nature different and deviant. The same reason for which novelty has been refused and stigmatized for many centuries has become the driving principle of artistic production, and also the root of its improbability. Art, which searches for the new, in order to be appreciated must be annoying and disturbing, hence different and 'opposing'.

This normalization of deviance has long been known and is the basis of the social function of modern arts as an instance of irritation and experimentation with the possible—and of its self-stylization as well. But the difficulties of art and its legitimacy arise when the circle closes and deviance becomes routine. If the quest for the new is the normal condition of artistic experimentation, surprise is what is expected, and as such is no longer surprising. The production of novelty becomes boring, deviance is repetitive, and experimentation folds back onto itself. The avant-gardes and the critics of the avant-gardes know this process very well.

If this is the present of the new, what can we say about its future? What is happening (or seems to be emerging) to the parable of the new? Are we witnessing a different idea of new, a new (?) meaning of innovation? If we look at what appears today in many aspects as a true avant-garde (if only because, as much as authentic innovation, it often appears incomprehensible), namely the development of digital procedures and algorithms, one may think this is so. The future of modern society was built of novelties and surprises and was therefore inherently unpredictable. On this were based the uncertainty and the opportunities in the relationship with the future. Today, however, algorithms claim to predict the future. The research area of Predictive Analytics is explicitly devoted to this: mining data to discover the structures of the future. The promises are glittering. The ability to anticipate future trends should help to optimize the use of resources, for example targeting advertisements to the people who are or can be interested

in a certain product or service, finding out problems or possible fraud in advance, preventing illness—but also focusing prevention and crime deterrence on people and groups most at risk.

What happens to the new in digital society, if you can know it in advance? Can there still be something really new, and how can one experience it? How can we know today a future that is not yet there? Algorithms promise to do so because they work performatively and situationally: they do not foresee the future in general, but the future they themselves contribute to shape. By analyzing large quantities of data, structured and largely unstructured (the famous Big Data), algorithms identify patterns (often incomprehensible to human logic) that should show the underlying structures of an individual's behaviour or a situation, and work with them. If the patterns show that a user who has purchased a product is compatible with the purchase of another product (even if you don't know why and on the basis of which connections), you offer this product to him or her, contributing thereby to shape the predicted future. Perhaps the user was not even aware of the existence of that product, and he or she did not feel the need at all: the user bought a Class A dryer and the system offers him of her an adventure trip to Africa. If he or she decides to buy it, the algorithm has changed the conditions of the future and confirms its prediction—if the user does not buy it, the algorithm learns from experience and refines its predictive ability.

In some fields, this ability of algorithms to intervene in the future raises doubts and perplexities. One wonders if and how such a punctual and performative prediction is possible, and what are its costs. There are actually heavy pre-emption problems and risks of depriving the future of its open possibilities. Just think of the 'Minority Report'-like case of an algorithm identifying citizens at risk of committing a crime and intervening before the event happens. If decisions are taken today on security measures about profiled possible criminals, their behaviour is constrained but also the options of the decision maker are limited. If then the crimes turn out to happen somewhere else, one will be watching the wrong people. Instead of looking ahead one will be looking back and the present will be forced to reproduce the image of the future that the algorithm had foreseen. The present future is reduced to the past future. The problem in this case is not just the risk of a wrong prediction, but the reduction of future possibilities for all involved actors.

Here, however, we ask another question: what happens to the new in a world of algorithmic predictions? How can art still experiment with unprecedented possibilities, if the scope of the possible is structured in advance by algorithmic procedures?

What we can observe is that in a world of performative algorithms art itself seems to become more performative, incorporating the reference to the current situation and to the behaviour of the audience. Performance art happens and disappears in a precise point in time and space, including the participants and the present context; interactive art and participatory art rely on the participation of the audience and on its inclusion in the work. In these cases, the effect (the artistic novelty) is produced by what the artist cannot (and now does not want) to control: the actual context and the intervention of the public in the situation structured by the work, which are always different and always unpredictable.

People, their behaviour, and their contexts are an inexhaustible source of diverse data, whose variety seems to become the resource for a different search for novelty—both in the production of works of art and in the curation of exhibition spaces. In visitor-centred exhibitions the rooms, the selection of works, their localization in galleries and museums and in the relationship to one another are becoming more and more structured and somehow pre-conceptualized to produce always different effects. The artistic setting is the preparation of an unpredictable novelty, produced in ever different presents. The future of the new, in a sense, seems to come back to the present, which immediately goes by and cannot be fixed—except in memory and in forecast, where it is not present.

# Contra-Contemporary

## Suhail Malik

Once the priority of the avant-gardes, the future of the new is now a commonplace. Stabilized in art and transposed to design, business, engineering, technoscience, experience-based entertainment, responses to climate change, and so on, the new is a general and ubiquitous feature of contemporary social formation and transformation. Transformation, because the new marks today to be distinct from yesterday; that today is 'futural' rather than traditional. The future is happening now. Everywhere. All the time.

Yet, in an important sense, elaborated below, and as the artistic avant-gardes contested, if the future is to be truly futural, it must be distinct from the past and the present; previously unheralded, the new future will be newer than what is now known or experienced. In this sense, the new future is itself in the future. And if the primary issue of politics is the dispute over that new future and its practical construction—what tomorrow will be, what it should be, and how to attain justice *then* (however justice is otherwise determined)—then the demands, divergences, constraints, and contingencies that comprise politics are accompanied by a reflexive complication in its theorization that sets the scheme of this chapter. Namely, that if the new, utterly distinct from the present and the past, is in the future (it will happen *then*), then a new future for the present is at present a future for the future.

While this complex formulation only rehearses that the new future is indeed in the future, its elaboration leads to the more precise formulation of the problem to be addressed in this chapter: that while the new future can be proclaimed, desired, acted on and acted for, nonetheless, for all its semantic and signifying effects, it is in fact an unknown—precisely because it is in the future. The present future can never *in fact* know or presume the future present.[1] As the dispute over the making of what the new future could be and should be, politics is then also where and how the conditions for the future of the future are set.

Abstract and formal as this definition of politics may be, it serves to generalize the now canonical theorization proposed by Hannah Arendt in the late 1950s. The significance of that generalization will become apparent once Arendt's formulation has been specified and then located in a broader characterization of modernity provided by Reinhart Koselleck. The futurity intrinsic to modernity identified by Koselleck provides the terms for distinguishing it from contemporaneity, which is defined here primarily as a distinct postmodern formation that 'cancels' the

future. Contemporary art is an instructive representative of the modification from modernity to such a postmodernity. The final section of this chapter contrasts contemporaneity with another identification of postmodernity, wherein a specifically modern futurity is not annulled but, rather, exacerbated to the point of being the premise of the present, which is then an intrinsically speculative present. The operational primacy of the future re-orders the received time sequence of past-present-future for the composition of the present, a reordering comprising the speculative time-complex.

The critical point in this rederivation of postmodernity is that the surpassing of modernity does not lead to the cancellation of the future because the future is vitiated, as prevailing critiques propose, but rather that the historical sense of futurity and politics is overwhelmed by a surfeit of futurity. The future of the future is then primarily an issue of whether the present is capable of a new future at all or *too much so*. And that is a politics of postmodernity. But, as will be contested, this is, first, not politics in the Arendtian sense but the new precondition for it; and it is, second, the mandating of a new future subsequent to modernity. Combined, the conclusion is that the future of the new is emphatically operationalized by a postmodernism that inaugurates the future of the future to the detriment of establishing the present; a postmodernism that is contra-contemporary.

### Action

For Arendt, the new is a consequence of action, and action is a uniquely human attribute:

> It is in the nature of beginning that something new is started which cannot be expected from whatever may have happened before. ... The fact that man is capable of action means that the unexpected can be expected from him, that he is able to perform what is infinitely improbable. And this again is possible because each man is unique, so that with each birth something uniquely new comes into the world.[2]

Action gives rise to the unexpected, to what is truly new, because action is unpredictable, and this is in part because of the uniqueness of the individual who acts—an individuality that is itself the consequence of 'the organization of the people as it arises out of

acting and speaking together' in what Arendt calls the 'space of appearances'.[3] It is this uniqueness in the space of appearance and the possibility of the unexpected which brings 'something uniquely new into the world at birth': not the infant per se, but the possibility of the unexpected that the new-born may one day enact. This possibility and unpredictability is occasioned not only at birth but reiterated and renewed with every entry by anybody— *any* body—in the space of appearances. Arendt calls that renewal 'initiative' and for her it defines human being:

> It is initiative from which no human being can refrain and still be human. With word and deed we insert ourselves into the human world, and this insertion is like a second birth, in which we confirm and take upon ourselves the naked fact of our original physical appearance. This insertion ... springs from the beginning which came into the world when we were born and to which we respond by beginning something that is new on our own initiative. To act, in its most general sense, means to take an initiative, to begin..., to set something in motion.[4]

Yet action is also unpredictable because its consequences can only be told retrospectively. That is, the story of the act—what the action is—is apprehended upon its completion—what the action *was*:

> the second outstanding character [of action is] its inherent unpredictability. This ... arises directly out of the story which, as the result of action, begins and establishes itself as soon as the fleeting moment of the deed is past. The trouble is that whatever the character and content of the subsequent story may be ... its full meaning can reveal itself only when it has ended.[5]

The necessary belatedness of the comprehension of action makes it unpredictable—which is to say, without clear meaning at the time it takes place. Together, the unexpectedness and unpredictability of action comprise its freedom, which is the freedom of human beings who act and speak in the space of appearances; political freedom.

Schematic though this outline is, it suffices to identify the relevance of Arendt's theorization of politics—what takes place in

the space of appearances—for a determination of the future of the new. The possibility of the new is guaranteed for Arendt by the fact of human natality—each human being is a unique possibility for a new future—and reborn with each act and word in the space of appearances. Each action uniquely inaugurates its as yet unknown future.

Arendt derives the unpredictability of action from the discrepancy between the 'fleeting moment of the deed' and the retrospective account of its meaning, which is also a time gap. The mobilization of that discrepancy is not particular to Arendt's theorization but calls on the standard modern distinction between lived history (*Geschichte* in German) and the historical record (*Historie*) or historiography. Yet, as Reinhart Koselleck contends, it is not the primacy of action that requires a belated recounting as Arendt proposes, but precisely the opposite: the modern conception of action is a *consequence* of a specific formation of distinction between the two notions of history. More exactly, Koselleck notes, it was only around 1780, 'following the emergence of history as an independent and singular key concept', that the previous two millennia old Occidental notion of history as recounted stories (*Geschichten*) transformed into one of a history that could also be made, which, as Arendt reiterates in her own way, is the inauguration of modernity as the making of history by human action.[6]

Koselleck's principal contention is that this transformation was itself a consequence of a long-term semantic 'convergence' in the distinct terms for history in German (amongst other European national languages).[7] With that semantic shift,

> history as reality [*Geschichte*] and the reflection upon this history [*Historie*] were brought together in a common concept, as history in general. The process of events and of their apprehension in consciousness converged henceforth in one and the same concept.

Though apparently arcane, it is this conceptual identification of two notions of history by a 'history in general' that leads to the inauguration of modernity. For three main reasons:

‒ For Koselleck the well-remarked 'division of labour' of history-making points not to their incongruity but to an underlying semantic unity:

> It clearly is a matter of the same history which is made on the one side and written down on the other. History seems to be disposable [*verfügbar*] in a dual fashion: for the agent who disposes of the history that he makes, and for the historian who disposes of it by writing it up. ... The scope for the disposition of history is determined by men.

'Disposable' here captures two of Koselleck's main theses: the immediate one is that the understanding of history being made, which is new with modernity and defining of it, is *contiguous with* the writing of history rather than opposed to it. Despite the apparent discrepancy between lived and written histories mobilized by Arendt, her theorization of action's unpredictability is consistent with Koselleck on this point: though action is unpredictable because its meaning is incomplete, the historical record gives the meaning of the action, which presumes the *semantic* unity between history being made and its subsequent account.[8]

    – The second 'disposition' and main thesis Koselleck highlights as providing the conditions for the emergence of modernity is that the semantic convergence of the two senses of history in the mid-eighteenth century subordinates its writing to its enacting. The then-new formation of the concept of history therefore meant that particular recounted histories and experiences came to be subordinated to a 'history in general', a 'singular' and common history of realization with action having the conceptual priority. Two transformations to the previous concept of history follow: (i) the recounting of history [*Historie*] is 'diminished': singular events and experiences can then be localized and framed in terms of a new concept of world history and also of a world-making. And (ii) history is directed instead to the 'social and political planes for planful activity that points to the future'. In short, history 'became a concept of *action*' with a horizon of expectation.[9] Because it is actionable, 'one is increasingly capable of planning and also executing history'.

    – Combined, and to deploy a term that is not Koselleck's, these partial results lead to the conclusion that world history is an *anthropogenic* history. More specifically, the recomposition of history according to 'history in general' sanctions the making of history according to an encompassing anticipation, foresight, and planning, which is to say according to an anthropogenic horizon of expectation.[10] In this sense, as with Arendt, action is

anthropogenic future-facing history-making. Arendt incarnates anthropogenic history-making by allocating it to the birth of each human individual, to 'the naked fact of [its] original physical appearance'. And the complete Arendtian sense of the term, in which the action is constituted by human freedom and autonomy alone, is the realization of the modern recomposition of history according to the anthropogenic horizon of expectation, a historically specific modernity that Arendt then transcendentalizes as a transhistorical 'space of appearances', precisely as the generality of anthropogenic world history mandates.

That recomposition of history for action is specifically modern because of its anthropogenics, which breaks from the previous Christian ecclesiastical ordering of history. Actionable history, Koselleck notes, means

> an implied renunciation of an extrahistorical level. The experience or apprehension of history in general no longer required recourse to God or nature. In other words, the history that was experienced as novel was, from the beginning, synonymous with the concept of world history itself. It was no longer a case of a history that merely took place through and with the humanity of the Earth. In Schelling's words of 1798: man has history 'not because he participates in it, but because he produces [*hervorbringt*] it'.

That history is 'produced' by the 'humanity of the Earth' as a world history again recalls Arendt's species identification of humanity as uniquely able to act. But that intrinsic universalism is itself historically placed with the 'renunciation of an extrahistorical level' for which human history would merely be the mundane manifestation. Koselleck's derivation of modernity on the basis of this 'renunciation' is crucial to the following discussion, in particular because it provides the schematics for how and why configurations of the new future determine not only the inauguration of modernity qua anthropogenic world history—action, as Arendt calls it—but also its successors.

### Modernity

What is renounced with the emergence of the concept of actionable history is the Christian eschatology constituting European orthodoxy up until the mid-seventeenth century. Guaranteeing that

divine justice would eventually arrive, the terminal *trans*historical scheme of the Last Judgement preset the terms and conclusion of all experience and expectation, meaning that 'nothing fundamentally new would arise', validating the drawing of 'conclusions from the past for the future'.[11] By contrast, anthropogenic history as a world history—a world that will then be an anthropogenic world—abrogates the 'constant expectation of the imminent arrival of doomsday', which in turn 'revealed ... a temporality ... that would be open for the new and without limit'.[12] That is, anthropogenic action afforded by the semantic recomposition of history, as the making of world history, 'reveals' a temporality for which the limitlessly new is a historical possibility. While the renunciation of the Eurochristian eschatological horizon of expectation by anthropogenic history does not change the future orientation of history, it does recompose that futurity as a temporality rather than divine justice. This temporality of anthropogenic history is comprised of the future of new.

Time is then the historical opening to a new history, a historicity instigated by action. And, as Arendt argues, it is intrinsic to that historicity of time that it *continues* to mandate new futures—which may or may not bring justice, depending now *only* on the anthropogenic actions taken from now into the future. The terminal premise of Eurochristian history, humanity and its cosmic composition are thereby abolished.[13] More significantly, and what inaugurates modernity, is that *because* what can happen in the future will be new, the future is *now* transformable and *in fact* unknown, distinct then from what Koselleck calls the horizon of experience, which is configured according to the present and the past.[14]

Koselleck traces the emergence of an explicit modernity (*Neuzeit*) through a lexical development by which the migration of historicity to time becomes an epochal characteristic. In brief, the supplanting of Eurochristian historical organization means that time 'is no longer simply the medium in which all histories take place; it gains a historical quality'.[15] More exactly, 'history no longer occurs in, but through, time. Time becomes a dynamic and historical force in its own right'. Time is, in other words, the historicity of the new future.[16] Contrasted to its Eurochristian organization up to the mid-eighteenth century, the time of anthropogenic history is itself a new time (*neue Zeit* in German). New, because it mandates the anthropogenic new future and also

because it distinguishes the present in which action is instigated against both the past and the future, 'the *neue Zeit* of history was also impregnated with the difference which was torn open between one's own time and that of the future, between previous experience and the expectation of what was to come'.[17] That is, the future is new because it is distinct from both past and present. Action per the historicity of the new time is then historical freedom.

The epochal characterization of the *neue Zeit* of history follows from the resetting of the past too, according to the dimension of the new time. The disjuncture of the horizon of experience and the horizon of expectation by action in the present modifies not just what the future can be but also recorded history (*Historie*), which is 'temporalized in the sense that, thanks to the passing of time, it altered according to the given present'.[18] To be clear: the modification of the past Koselleck identifies is not primarily that recorded events are revised by current historians because of the demands of actions in the present; rather that the historicity of time means that 'the *nature* of the past also altered'.[19] What the past *is* in relation to the present and future is determined on the basis of the freedom of anthropogenic action, not their continuity or the constraints that the past places on the present and future, which is traditionalism.

The general resetting of time as the historicity of the present qua anthropogenic action is, then, the historicity of the past. More than the possibility of the present being different to the past, the *neue Zeit* 'is indicative of new events never before experienced in such a fashion'.[20] Accordingly, the *neue Zeit* is 'new in the sense of completely other' to the eschatological *continuity* of time and history, instead 'assum[ing] an emphasis that attributes to the new an epochal, temporal character'. And by the late-nineteenth century that 'epochal, temporal' character of the new gives the *neue Zeit* a common name that belatedly yet precisely registers the time-condition of the open future: *Neuzeit*, modernity.[21]

### Contemporaneity

Modernity, *Neuzeit*, means, in sum, that the future of the new can be a new future, and the past is a new past, configured by a future-facing anthropogenic history-making, by action. To adapt Arendt's title, modernity is the 'human conditioned'. The cogent inauguration and maintenance of modernity requires coherent integration of these terms—the time of open futurity, the pres-

ent, action, historicity—in a logic of anthropogenic history. That logic and its supplanting by contemporaneity is demonstrated with particular clarity by the avant-gardism of art declared to be 'modern' in the North Atlantic region from the late-eighteenth century on, just as the term modernity came to prevail as the defining name for the epoch defined by anthropogenic history. Peter Bürger's mid-1970s criticism of Theodor Adorno's staunch advocacy of modernity crystallizes the key issues here.[22] Bürger contests Adorno's characterization of art in general through Modernism, itself defined on the basis of the category of the new against tradition. That is, Adorno specifies Modernism to be the counter-traditionalism of modernity vectored through aesthetics; a counter-traditionalism that Koselleck for his part identifies as a consequence of the inauguration of modernity qua anthropogenic history. Art is modern for Adorno in that 'the authority of the new [is] historically inevitable' for it.[23] Bürger highlights that the new here does not mean new styles, techniques, media, and other various innovations that in fact comprise the history of artistic development, but the futural new of art. Furthermore, following Marxist doctrine characterizing 'essentially non-traditionalist societies' as 'bourgeois', Modernism 'ratifies the bourgeois principle in art'.

That the artistic avant-garde is exemplarily Modernist is a truism, but Bürger's criticism elucidates two features in the historical development of Modernism that serve to demonstrate how, despite its definition by the new future to come, the logic of modernity is terminal, and also how its terminal state is configured. Adorno's own criticism of aesthetics is premised on art's constitutive autonomy in bourgeois societies. Avant-garde art attacking art's bourgeois institutionalization must then seek to abolish artistic autonomy, 'to do away with art as a sphere that is separate from the praxis of life'.[24] Yet, insofar as the overcoming of bourgeois institutionalization *has become* the Modernist history of art as a history driven by and for the new, the continued corrosion of the autonomy of art by the avant-garde serves to *reproduce* that modern institutionalization. As Bürger remarks, 'the procedures invented by the avant-garde with anti-artistic intent are being used for artistic ends', not least the entrenchment of the extant institution of artistic autonomy.[25] Bürger identifies this reversal or inversion of the 'intention' of the avant-garde to be the 'neo-avant-garde':

> the neo-avant-garde institutionalizes the avant-garde as art and this negates genuinely avant-gardist intentions. ... Neo-avant-gardist art is autonomous art in the full sense of the term, which means that it negates the avant-gardist intention of returning art to the praxis of life.

That is, the metahistorical maintenance of 'the new' configuring avant-garde strategies led to the reversal and negation of its historically situated aims, recuperating the artistic autonomy it disclaims in the name of avant-gardism. And for Bürger this reversal is the perverse success of the avant-garde:

> the procedures invented by the avant-garde with anti-artistic intent are being used for artistic ends. This must not be judged a 'betrayal' of the aims of the avant-garde movements ... but the result of a historical process [wherein] the attack [made] art recognizable as an institution and also revealed its (relative) inefficacy in bourgeois society as its principle.

That is, the neo-avant-garde *demonstrates* the truth of art in bourgeois society: that art is in any case an autonomous institution. And this is the lesson Bürger draws against Adorno's theory of Modernism, which will prove instructive for the Koselleckian definition of modernity as an anthropogenic history set to a new future. For Bürger, Adorno confounds the 'historically unique break with tradition that is defined by the historical avant-garde movements' with 'the developmental principle of modern art as such'. The latter is a 'category of the new' that Adorno 'fails to properly historicise'.[26] That is, Adorno mistakes the historical emergence of the avant-garde to be the transcendental principle of modern art. And it is this category mistake of basing historically situated artistic ambitions on the metahistorical and empty category of the new—effectively positing modernity as a formal category (of the new as a void or an empty signifier)—that leads to the reversal of the aims of modern art, from the abolition of its autonomy (the avant-garde) to its vindication (the neo-avant-garde).

Bürger validates the historical avant-garde by delimiting the historically specific necessity of its newness, adequate then to the task of negating art's bourgeois condition *for a period*. But it is his elaboration of the consequences of Adorno's generalization of

the new as principle of modern art that, first, correctly forecasts the subsequent development of art since the 1970s—its transmutation into contemporary art (CA)—and, second, gives the instructive example for the consequences of modernity as anthropic history—its transmutation into contemporaneity. These conclusions follow from Bürger's primary complaint that Adorno's mistaken definition of modern art means that any such determination of the new 'provides no criteria for distinguishing between faddish (arbitrary) and historically necessary newness'. As a formal metahistorical premise, the historical significance of any particular instance of newness cannot be apprehended. Consequently, Adorno's only recourse for determining the category of the new is the paradigm of commodity society, which is perpetuated by the consumer good. What is new in and for art is then indistinct from another option in the common dimension of commodity exchange, an item of consumption organized by difference rather than historical necessity. Consequently,

> through the avant-garde movements ... the historical succession of techniques and styles has been transformed into a simultaneity of the radically disparate [*Gleichzeitigkeit des radikal Verschiedenen*]. The consequence is that no movement in the arts today can legitimately claim to be historically more advanced as art than any other.

The 'simultaneity of the radically disparate' means that the neo-avant-garde, perpetuating a schematic avant-gardism, spells the end to any notion of artistic progress. A history of artistic development is replaced by the simultaneity of inchoate new art indistinct from expanding commodity markets. The inchoate simultaneity and commodity-equivalence of an art that endorses its social autonomy is a concise summary of the sociohistorical development of CA subsequent to Bürger's identification of the neo-avant-garde. For Peter Osborne, such a simultaneity comprises the contemporaneity of contemporary art.[27] While the conversion of the new from a historically situated criterion to an empty category means that CA is distinct from modern art, it is for that reason also the continuation of the logics and historicity of modern art, be they over-extended and now set against the latter (and this holds for Adorno's own theorization of aesthetic theory too).[28]

### Posthistory

Adorno's mistake as Bürger identifies it cannot however be dismissed as a category error or particularized as the limitation of his philosophical system. If, following Koselleck, modernity is the epoch of the constant inauguration of anthropogenic history in a time that mandates the new as a formal and general category, the Modernism of the avant-garde as Adorno determines it *is* the art adequate to modernity. Bürger's criticism of the neo-avant-garde's reversing into the perpetuation of commodity societies indexes through art the closing of the epoch of modernity, which afforded the freedom and autonomy of action qua anthropogenically initiated futurity. That epoch is concluded by being continued in modified form as contemporaneity, a new epoch subsequent to modernity whose characteristics are in part now outlined by generalizing the case of art's conversion from modernism. This characterization leads to the determination of the contemporary as a distinct postmodern formation of time-sequencing and history together, for which the future is not the condition of history but is instead 'cancelled'. But it also mandates the critique of that now standard determination of postmodernity to be a modernist misdiagnosis of how the epoch consequent to modernity in fact configures time and historicity.

The distinction between contemporaneity and modernity as Koselleck derives it (and Adorno assumes with him) can be demonstrated by directly comparing the transformation of 'the historical succession of techniques and styles ... into a simultaneity [*Gleichzeitigkeit*] of the radically disparate', which defines contemporaneity in art, to simultaneity in modernity as it is identified by Koselleck. Recall that for Koselleck time in modernity is distinct from the historical equivalence between one time and another set by the horizon of expectation of Eurochristian eschatology. Modernity orders history according to an anthropogenic horizon of expectation in time alone. That time ordering is not only clearly sequential—the past, then the present, then the future—but also a prioritization of the new over the extant or past historical conditions. The received name for such a historicizing time-ordering, reiterated by Koselleck, is *development*: 'From the seventeenth century on, historical experience was increasingly ordered by the hierarchy produced through a consideration of the best existing constitution or the state of scientific, technical, or economic development [*Entwicklung*]'.[29]

This developmental ordering intrinsic to modernity is key to its geohistorical expansion. Because the anthropogenic history defining modernity is *intrinsically* and necessarily a world history, modern societies mandate themselves to calibrate others according to their own developmental hierarchy:

> The geographical opening up of the globe brought to light various but coexisting cultural levels which were, through the process of synchronous comparison, then ordered diachronically. ... Comparisons promoted the emergence in experience of a world history, which was increasingly interpreted in terms of progress.[30]

The comparison of cultures according to a specifically Euromodern hierarchization of historical development sanctions the racism of North Atlantic modernity, as Koselleck highlights in the ellipsis of the preceding quote: 'Looking from civilized Europe to a barbaric America was a glance backward.' Based on the diachronic ordering of geospatial distinct cultures according to an integrating time-line of historical development, Euromodern racism has been the structuring organization entitling extraction and subjugation by the self-mandated actors of progress.

In its historical composition, the 'fundamental experience of progress' structuring Euromodernity requires the convening of diverse cultures that are disparate to one another, of 'non-contemporaneities [*Ungleichzeitigen*] that exist at a chronologically uniform [*gleicher*] time'. That is, Euromodern geoterritorial expansion convenes otherwise heterogeneous and unconnected cultures as 'non-contemporaries' in modernity by situating them in the common time of progress, which is the unified time defined by anthropogenic history that mandates a new future. Koselleck calls it the time of contemporaneity:

> The contemporaneity of the noncontemporaneous [*Gleichzeitigkeit des Ungleichzeitigen*], initially a result of overseas expansion, became a basic framework for the progressive construction of a world history increasingly unified since the eighteenth century. Toward the end of that century, the collective singular 'progress' was coined in the German language, opening up all domains of life with questions of 'earlier than', or 'later than', not just 'before' and 'after'.[31]

Despite its commonality across both Koselleck's and Bürger's theorizations, the use of 'contemporaneity [*Gleichzeitigkeit*]' to signify the presentation of otherwise disparate particulars in an overarching configuration should not however lead to their semantic identification. The two uses of contemporaneity are distinct in that while disparate cultures are calibrated in modernity by a 'chronologically uniform time' according to a 'progressive construction of world history'—as Koselleck specifies and Adorno stipulates for Modernism in general and the avant-garde in particular—Bürger contends that the simultaneity of 'radically disparate' art movements characteristic of the neo-avant-garde is such that none can 'legitimately claim to be historically more advanced as art than any other'.[32] Distinct to modernity, the contemporaneity of the neo-avant-garde is progress-less, a proliferation of new art absent of development.

Put otherwise, the contemporaneity of the radically disparate characterizing the neo-avant-garde is distinct from Koselleckian modernity in that the proliferation of new art in the neo-avant-garde is not the enactment of an anthropogenic history organized by a future—it is not action in the modern (Arendtian) sense—but rather the proliferation of new art simultaneous and disparate to what is, has been, and will be. In this logic of the update, art is then only ever current (*Zeitgenössische*, which is the German term for what in English is the 'contemporary' of contemporary art). With regard to the characteristically Euromodern composition of history identified by Koselleck, and as the broad metastable transformational dynamic of CA demonstrates, the contemporaneity of CA is then posthistorical and, in this nontrivial sense, therefore postmodern.[33]

Posthistory does not mean that there is nothing new, different, singular, no further simultaneous disparities. On the contrary: the proliferation CA validates and perpetuates is what Koselleck calls the horizon of experience—memory, lived experience, the archive, the present—and each new experience of art adds to and embellishes experience as a whole. Posthistory designates the contemporaneity of additive yet progress-less anthropogenic experience. Contrary then to the future-conditioned time of modern historicity, the proliferation of *concurrent* pasts, presents, and futures are sequenced in a contiguous and seamless experience, happening before or after one another as alterations of contemporaneity. The ordered distinction of the time sequence is

corroded in favour of their simultaneity. And this vitiation of the time order of modernity means not only the dehistoricization of the new, but also the dehistoricity of time.

### Defuturity

Incorporating the horizon of expectation into the horizon of experience, contemporaneity entails the destruction of the former in its modern sense. Progress-less, defuturing both the present and the new (even as a formal category), the posthistory of contemporaneity is comprehensively postmodern, and terminally so. Franco 'Bifo' Berardi and Mark Fisher both characterize the period since the early-twenty-first century along these lines, as an epoch of posthistorical contemporaneity. For Berardi, it is a sentimental-phenomenological existential distortion by the neoliberal formation of labour and economy, which undoes the political possibility of the transformative future; for Fisher, these conditions are firstly socio-culturally implemented by the neoliberalization of institutions, including digital reproduction technologies:

> Franco 'Bifo' Berardi refers to 'the slow cancellation of the future [which] got underway in the 1970s and 1980s'. 'But when I say "future" [he elaborates] I am not referring to the direction of time. I am thinking, rather, of the psychological perception, ... the cultural expectations that were fabricated during the long period of modern civilization ... shaped in the conceptual frameworks of an ever-progressing development.' The slow cancellation of the future has been accompanied by a deflation of expectations. ... The very distinction between past and present is breaking down. In 1981, the 1960s seemed much further away than they do today. Since then, cultural time has folded back on itself, and the impression of linear development has given way to a strange simultaneity.[34]

Which is to say: contemporaneity, extended now beyond its derivation in CA to the entirety of the sociocultural composition, which can then be called contemporary societies.

Taking into account Fredric Jameson's contribution to this determination of postmodernity (elaborated below), the 'slow cancellation of the future' can be called the Berardi–Fisher–Jameson (BFJ) thesis of posthistorical contemporaneity. Identified as the

defuturing of the new, the BFJ thesis however requires amendment. Specifically, as the dehistoricity of modernity, contemporaneity *does* refer to the 'direction of time': contemporaneity vitiates time qua historicity. Furthermore, contemporaneity is the supplanting of the horizon of expectation by the adventure of new experience, and the dehistoricity of time does not wholly abolish a time sequence but rather rebases it as a simultaneous disparity of befores and afters in a posthistorical metastable experience. There is only a meantime: duration. The 'deflation of expectations' marking contemporaneity is not then the eradication of modernity but rather its depletion. Two corollaries:

(i) Taking up Koselleck's terms, such a depleted modernity happens 'after' modernity—or there was a modernity 'before' it—and modernity is for that reason part of contemporary experience. Put otherwise, contemporaneity is not modern but modernity is *still* contemporary. Modernity is not then earlier than the contemporary, an irrecuperable past of the contemporary as a societal composition, but rather only a part of its present that may be incongruous to other aspects of the contemporary but is not thereby overcome and cannot overcome it.

(ii) The dehistoricity of the past, present, and future in contemporaneity is a symmetrical secular obverse to the Eurochristian eschatology revoked by modernity. Recall that the terminal transhistorical scheme of Eurochristian eschatology preset the terms and conclusion of all experience and expectation such that 'nothing fundamentally new would arise'. The dehistoricity defining contemporaneity replicates that transhistorical determination, yet it amplifies the renewal of a contiguous experience with nothing fundamentally new arising in its stead. Moreover, these two dehistoricizations on either side of modernity are symmetrical inversions of one another: while Eurochristian eschatology bases present experience on the given horizon of expectation of the Last Judgement—a future that is not new but guaranteed and known in premodern Eurochristianity—contemporaneity on the other hand rebases expectation on the basis of a now present experience.

Both of these transhistorical formations propose a terminal extrahistorical organization of history, yet distinctly so: for Eurochristian eschatology that ahistorical terminus is the divine order of the Last Judgment; for contemporaneity, as the BFJ thesis highlights, the posthistorical terminus is the mutable present

itself—or, to complete the symmetry with Eurochristian eschatology, its extinction. Elaborating these two terminations of contemporaneity in turn demonstrates how, as for the neo-avant-garde with respect to the bourgeois condition of art, the BFJ critique of contemporaneity reverses into and promulgates the condition it claims to repudiate. The two terminations are:

– *The terminal present.* Fisher's thesis of capitalist realism announces the socioeconomic rendition of terminal contemporaneity: 'The widespread sense that not only is capitalism the only viable political and economic system, but also that it is now impossible even to imagine a coherent alternative to it.'[35] This impossibility is, as Jameson contends, the elimination of a horizon of expectation that is not an extension of present experience, which experience is then the terminal condition of all futurity. It is the absenting of anthropogenic history, of a historicity directed to a new future.[36] The 'cancellation' of a new future different to the present configures an end-time of present, past, and future in the contiguity of variation of experience, without the finality of Eurochristian eschatology; the ceaseless contemporaneity of an endless-meantime.

– *The extinction of the present.* Yet eschatological finality *does* return to this composition of contemporaneity—with the BFJ critique itself. The slogan that 'it is easier to imagine the end of the world than it is to imagine the end of capitalism', attributed to Jameson, implicitly contends that contemporaneity can be exited or overcome, but only by the end of either capitalism or the world (through eco-catastrophe, for example).[37] While the imagining of the end of the world entrenches the impassability of capitalism, the end of capitalism represents the utopian possibility of the surpassing of the contemporary. Jameson: 'For the moment and in our current historical situation, a sense of history can only be reawakened by a Utopian vision lying beyond the horizon of our current globalized system, which appears too complex for representation in thought.'[38] Only a radically new future such as the end of the world or the end of capitalism can overcome the current condition. Jameson contends that such a 'reawakening' would be a 'genuine historicity' which, with Koselleck, would define it to be a modernity. What is then more significant than the end of the world is that the BFJ thesis posit such terminations—of the planet, capitalism, and other conditions—as transformed futures distinct from the present and the

continuation of experience. These various eschatons are the price of the postcontemporary qua modernity redux.

Jameson's appeal to historicity as an exit strategy from contemporaneity is a typically modernist recourse. As noted, however, modernity is anyway accommodated within contemporary as another of its disparate moments. Among other utopias, then, contemporaneity dictates that the modernity of the BFJ thesis, as a call for a new future of postcapitalism, is itself depleted; yet another future fiction constrained by a disparate posthistorical contemporaneity. Accordingly, the BFJ thesis does not just diagnose the contemporary as a condition and structure of dehistoricity; it also rehearses and is depleted by the contemporaneity that it aims to revoke. A modernist critique of contemporaneity, the BFJ thesis reprises the neo-avant-garde's signature reversal of Modernism, scaled up from the specific institution of art's autonomy in bourgeois societies to the generality of contemporaneity configured by the socioeconomic totality of capitalism.[39]

### Risk

Together, modernity and contemporaneity can then be retrospectively identified as the history (*Historie*) of the emergence and depletion of anthropogenic historicity in time according to a matrix set by Eurochristian eschatology, which is their common precursor. It is the history of the migration of the 'extrahistorical' determination of time from the divine to depleted new experiences of the posthistorical present, the termination of their common history in the anthropic mundane. Having identified this matrix of secularized Eurochristian eschatology, the concluding argument of this chapter is that it is however in fact supplanted by another postmodern configuration, one misrecognized by the identification of contemporaneity and its BFJ critique. What is then theoretically available is a composition of the future distinct from that which has prevailed over its history since the dominance of Eurochristianity in the North Atlantic and Euromodernity as world history, a new future for the future.

The premise for the counterpostmodernity proposed here is the development in the scales of economy, organization and logistics adequate to globalization, including the advance of technical and symbolic intermediation, and the coordination of increasingly complex social, economic, and legal-regulatory organization. These developments of large-scale integrated complex

societies (LaSICS), as they are designated here in their generality, are the material, symbolic, and infrastructural configurations wrought by the geo-economic expansion of Euromodernity initially by colonialism, and then by a planetary capitalism that has to date also been concentrated in the North Atlantic.

That development has been intensified since the 1990s by ubiquitous digital computation, yet, as a historico-semantically integrated process, it is mandated by the modernity identified by Koselleck: the result of an anthropogenic history integrated as world history. But whereas modernity is structured by a *horizon* of expectation, a new future to come that is distinct from the present, what is by comparison distinct to LaSICS is that the futurity of the new is their functional condition, the *operational* premise for their technical, material, and symbolic organization and development. This identification of the time ordering of LaSICS identifies, for example, the rapid expansion of credit as the basis for economic and monetary operation since the deregulation of financial institutions in the 1980s: while credit has always calculated a loan on the basis of the future income that can be made from it to accrue repayment with interest, financialization sets that premise as the basis for economic expansion at all scales.[40] Equally, transnational infrastructures of insurance, health, energy, and agriculture (all of which are intensively corporatized) are also all typical of LaSICS, as they are of other basics of social provision such as housing, social welfare, managing climate change, long logistics chains, and the anticipatory models governing security and military configurations. These and other such components of the dynamic and transformative structuring of LaSICS are comprised of anticipations of the future *not* as a horizon of expectation but rather as the present and actual *premise* of their current technical, economic, social, and symbolic operations.

The summary point here is that the *unknown* future—which may or may not be new—is the precondition of the present in LaSICS, their defining feature. And the principal theoretical point is that the future as it is operationalized and manifest in LaSICS is then not the eschaton of a new future to come, as it is for modernity, but a material-symbolic precondition for the calculation of the unknown future, a speculative composition of the present. And contrasted to the equivalences of past, present, and future in a continuity of new experiences configuring contemporaneity, LaSICS *operationalize* the future as unknown and distinct from

the horizon of experience. That is, LaSICS supplant the depleted time structure of 'before' and 'after' characteristic of contemporaneity with the operational 'earlier than' and 'later than' which are intrinsic to their functional composition. Only that in this configuration the future is operationally, structurally, and systemically 'earlier than' the present. In its logic and time ordering, the future is the past, and this reorganizes what the future can be. Equally, the present is 'later than' the future, the future of the future.

The complex configuration wherein the future transforms the present and the future even before the present has happened, and the present is the occasion of an unknown future, is the speculative time-complex (STC).[41] A reordering of the time sequence, the STC maintains the modernity of the irreducibility of the future to the present and the past, countermanding the depletion of time ordering defining contemporaneity. Yet it also countermands the eschatological structure of modernity, for which the new future is an absent yet known eschaton. The STC is the schematic configuration of the unknown future as the operational *prior* condition of the present configured by LaSICS.

Call the present that *internalizes* futurity as its intrinsic material-symbolic-systemic premise the speculative present. Speculative, in part because the STC intensively and extensively exacerbates the futural historicity defining modernity, but without the security of its semantic ordering. That is, the operational premise of the uncertain future at once stipulates and undermines the task of anthropogenic history identified by Koselleck as 'social and political planes for planful activity that points to the future'. That futural historicity is intrinsic to the speculative present, its basis, which is also the modification of modern futurity with regard to the intensive and extensive dimensions of the present:

– *Intensive futurity.* Migrating from a horizonal ordering of anthropogenic history to the *intrinsic* operational premise of LaSICS, time is *intrinsically* comprised by its futural historicity. Consequently, the historicity of the unifying eschaton of the new future defining modernity as a cogent task dis-integrates. There is instead the multiplicity of specific speculative mobilizations of futures comprising each present. Each present time of the STC is then internally comprised of the proliferation of multiple, dis-integrative historicities. Calling the socially and systemically ingrained futural historicity of time in the STC *ultrahistoricity* serves to demarcate it from its modern precursor.

– *Extensive futurity*. The operational condition of the speculative present is the inherent uncertainty of the future. The resulting necessary intrinsic limitation and constraint on extrapolations into the future by calculation or planning means that actions and designs made in the speculative present are at best a risk, and such risks proliferate with the dis-integration of the new future. Moreover, risk is not only the premise of the speculative present; it is also instantiated again and recomposed with each instantiation of the STC. Comprised by risk and its proliferation, LaSICS are but an extension of what Ulrich Beck and others have since the mid-1980s called risk societies—societies for which the consequences of knowledge and action are constitutively incomplete at the point they are drawn up.[42]

Decisions taken at any given present in risk societies are vulnerable to eventualities that can only be partially planned. Such limitations are for Beck imposed by empirical and anthropological constraints: risks are not only the unknown consequences of present action but are also systemic, integrated and open-ended. Beck identifies three concomitant dimensions of such a 'delocalization':

> a) spatial: the new risks (e.g. climate change) are spreading over national borders, and even over continents;
> b) temporal: the new risks have a long latency period (e.g. nuclear waste), so that their future effects cannot be reliably determined and restricted; moreover, knowledge and non-knowing are changing so that the question of who is affected is itself temporally open and remains disputed;
> c) social: since the new risks are the result of complex processes involving long chains of effects, their causes and effects cannot be determined with sufficient precision (e.g. financial crises).[43]

In one sense, the theory of risk societies makes the trivial point that, as a futural anthropogenic history, modernity is intrinsically subject to future contingencies, the actuality of which are unknown at the time of action. This triviality does however indicate the significant result that risk resets the futural *historicity* of time from its modern configuration, definitively separating the time-historicity of the STC away from the secular composition of Eurochristian eschatology, which matrix configures the modernity of which the STC is the historical result. Elaboration of this

result will lead to the concluding identification of the conditions for a politics and an art adequate to the STC, which is also the revocation of contemporaneity, and the recomposition of what politics and art must then be.

### Contracontemporary

Risk societies are those for which the new future that defines anthropogenic history—the plan—is itself susceptible to future contingencies that can partly be accounted for (by risk management) but also contingencies that can not. The ultrahistoricity of the speculative present vitiates the secular-eschatological conditions of modernity, including anthropogenic history, and the futural historicity of the speculative present is instead *itself* contingent in time. The speculative present is then contramodern. The future is *only* the premise for uncertainty in the present. Which is not to proscribe the possibility of the contentful plan or anthropogenic history. To the contrary, the STC mandates that the future can be reset. But if the risk is too great, any definitive new future is untenable. In exacerbating the historical dynamic of time qua historicity via the systemic social integration comprising LaSICS, the risk composition of the STC is definitively separated from modernity. Yet, in that LaSICS are themselves a result of the comprehensive world history and its development mandated by modernity, risk societies are definitively postmodern.[44]

Equally, however, the priority in the STC of a delocalized futurity unknown to experience means that modernity as it is defined by the horizon of expectation is supplanted for the speculative present not by the horizon of experience, as it is for contemporaneity, but by its intrinsic and contingent time historicity. That is, though the scrambling of the standard time sequence of past, present, and future is common to both contemporaneity and the STC, the former is characterized by the depletion of time-ordering in favour of the contiguity of experience, while the ultrahistoricity of the STC maintains but reverses the time distinction of modernity, exacerbating rather than depleting the futurity of the present. The postmodernity of the speculative present is then contracontemporary as well as countermodern, as are the LaSICS operationalized on this premise.

Being both countermodern *and* countercontemporary, the operational risk characteristic of the speculative present corresponds to neither subvariant of secularized eschatology. The STC

maintains and extends the futural historicity inaugurating modernity, of the modern composition of the new and of futures, but now wholly detached from residual Eurochristian configuration, mandating instead the configuration of futures that are comprehensively global. The historicity of the speculative present exacerbates its modern dynamic but at delocalized scales and with no set future.[45] To deploy Jean-François Lyotard's terms, the 'grand narrative' characteristic of modernity is not only supplemented by any number of calculative cautions against contingencies, but history-making according to that plan is itself obfuscated by delocalized risk and the contingent and provisional 'small narratives' of its administration.

Which is to reiterate that risk societies and the speculative present are large-scale, integrated, complex—and futural. The postmodernity of the STC is not then the 'cancellation of the future', as the BFJ thesis contends, but the reverse-ordering of the time-sequence of modernity's secular eschatology. More precisely, while risk-postmodernity vitiates the commanding future organizing modernity, that 'cancellation' is not because of the absenting or withdrawal of futurity, as per the BFJ thesis, but instead because of a contracontemporary *surfeit* of futurity. Modernity is exacerbated such that it is usurped by the counter-postmodernity of the STC. That is, theorized outside of the logic of the BFJ thesis, the future is 'cancelled' not because it is absented or withdrawn but because there is too much futurity, too much risk, to secure a future—anthropogenic history qua action—over any other. The futural plan typical of the modern task of anthropogenic history loses its way. Another plan will always be needed because no plan is adequate.

Indexed to a specifically anthropogenic condition alone, as Arendt stipulates, the surfeit of the future must however be revoked. Recall that modernity is defined by the future-making of anthropogenic history, which condition for the new is a doctrine of action, and that Arendt incarnates this condition for each human. The delocalization of risk societies however supplants this anthropogenic condition and, with it, Arendt's prioritization of politics as *anthropogenic* futurity. Specifically:

– Scale: as Beck contends, the intermediation of LaSICS mean that decisions and consequences are delocalized, which is to say greater than the capacity of any Arendtian 'space of appearances' of direct interpersonal engagement.[46]

– Integration: action for Arendt leads to the new, the unexpected, because it is each time unique, a uniqueness conferred to each human at birth; but unexpectedness is intrinsic to the speculative present characteristic of LaSICS, for which the uncertainty of the consequences of actions are configured as risks. Comprised by and subordinated to the ultrahistoricty of the speculative present as risk is, human uniqueness is unnecessary to the composition of unexpected consequences.

– Complexity: for Arendt action is unpredictable because its meaning is not disclosed until its subsequent account; yet if the unknown future precedes the present in the STC, and if the future that results from any act is in fact a new composition of risks, then there cannot be a determinate culmination or completable sequence for any act, nor any completed meaning. Ultrahistoricity means instead that the recording of history is nonterminal, and that unpredictability precedes action as its premise.

That is, each of Arendt's anthropogenic determinations of action is inadequate to the contramodernity of the STC. Overall, her theory of politics is insufficient to the speculative present. More generally, the surfeit of the future in risk societies means that *anthropogenic* action is an insufficient and inadequate basis for forging the future. Assuming the residual validity of modernity as its theoretical and political scheme, the BFJ thesis of the cancellation of the future misidentifies that the future is forged according to a speculative present whose futurity erodes the ultimacy of anthropogenic history. To be clear: action cannot overcome risk in the comprehensive postmodernity of LaSICS because risk comprises the preconditions and consequences of action. Rather, forging *a* future in the speculative present by action first requires a delimitation of the futurity of the speculative present, which means (i) the constraining of risk, and also (ii) the redetermination of action itself distinct from its modern anthropogenic determination. Elaborating these requirements in turn provides the concluding derivation of a contracontemporary politics—the setting of the future of the future—and of an art adequate to the delocalized speculative present comprising LaSICS.

– *Risk Constraint.* If the making of *a* specific future is not to be 'cancelled' by the surfeit of the future, the risk composition of the speculative present must be constrained. Such constraints can include various kinds of security, insurance, social provision, and capital; or, on the other hand, by regressions such as

the reimposition of linear calibrations of progress or eschaton, or the highly bounded and stabilized semantic structures and consequent social organizing effects of traditionalisms. The theoretical generalization of these measures is that constraining or abating risk in order to direct a course of action—to initiate a future—presumes a selection of risk, contingent on the specifics of the speculative present in each instance and the specific future to be set. Yet, all such constraints are themselves only incomplete and uncertain in the STC, only partly knowable in their consequences and delocalized effects. The constraints to risk are themselves risks. Moreover, the selection of what risks are to be abated is to select various possible future outcomes over others, a provisional—and only ever provisional setting—of the future of the future. And that is a politics, one that is prior to anthropogenic action.

    – *Action redux.* Because the risk intrinsic to the STC is not uniquely a consequence of individual actions but a situated compositional requirement of LaSICS, the constraining of risk is a systemic condition to provide the *social* capacity to enact the future—'social' here meaning the configuration of LaSICS, not the interpersonal engagement in a space of appearances. To be clear: it is not that anthropogenic action and interventions are eliminated in LaSICS. Rather that, configured by the STC, anthropogenic action is configured by the delocalized *socius* of LaSICS. That *socius* is definitionally more expansive and at scales of systemic integration and interconnection greater than individual or socially segmented anthropogenic capacity.

    That is, LaSICS supplant the anthropogenesis of history defining modernity, including action and art, with a *sociogenic* enacting of the future defined by the irreducible consequences of that modernity. Action, because it is not the 'human condition' or history (*Historie*) or the horizon of experience that provides the basis for action in the speculative present of LaSICS, or of what its capacity of the new is, but instead a meta-anthropic—or, abbreviated, metanthropic—affordance of LaSICS.[47] To reiterate: the metanthropic condition of action does not eliminate anthropogenic history but encompasses it and deprioritizes it as a provisional semantic constraint to risk, but a constraint which, for that reason, comprises further sociogenic risks. And that deprioritization stipulates the resetting of art too. In particular, the sociogenic enacting of the future supplants both the premise and the results of

art since the avant-garde; the premise being the historico-political freedom of anthropogenic history-making, and the result being the consolidation and reinforcement of the 'bourgeois institution' of artistic autonomy qua CA. Two requirements for such a comprehensively sociogenic art highlight its distinction from art since the avant-garde. First, contrasted to an art that is in each instance an individuated opening of meaning without finality—typical of the avant-garde artwork in Modernism as it is when resituated to the open-ended interpretive task of the addressee in CA—'the new' of an art adequate to the speculative present is configured not by the freedoms demonstrated by such semantic indeterminacy but instead by its *specification* of a future. And such a specification is in each case a historico-systemically situated constraining of risk intrinsic to the speculative present. 'Historico-systemically situated' here rephrases that the speculative present is comprised sociogenically; that specifying a future by constraining risk is a sociogenic operation. Second, then, the art adequate to the risk composition of LaSICS is a situated component in the socially integrated composition of the speculative present and its risk. So, comprised, art's autonomy is abrogated.

Two consequences follow, which, though contradictory in Modernism, are in fact aspects of the one requirement for an art adequate to the speculative present: (i) the ambition of the avant-garde according to Bürger, to rescind art's bourgeois institutional autonomy from the social totality, is realized—but not as an artistic or political-critical imperative motivating the avant-garde. On the contrary, artistic avant-gardism is completed and supplanted because art is one component institution of risk constraint in the sociogenic specification of a future in the speculative present. Accordingly, (ii) the art adequate to the speculative present has no priority or privilege as an institutional format for the future of the new. Configured by the speculative present, the criticism Bürger makes of Adorno's commodity paradigm for the future of the new of art is reversed: the future of the new that was once the prerogative of art since the avant-garde is instead a ubiquitous feature of LaSICS, including but not limited to commodities. Art is then one among other component aspects in an economy of risk constraint in LaSICS.[48] Conversely, while defending art's autonomy qua Modernism or CA from the comprehensively sociogenic composition of the speculative present also constrains the more general and systemic sociogenic risk it is imbricated in—by insisting for

example on its historical formats of individuated, personalized, and subjective presentation and interpretation—such constraints limit risk by repudiating all but microscale operations. For that very reason, however, such art cannot attain the multi-scalar operability or situate the *sociogenic* specificity of its risk constraint in the surfeit of futurity. The defence of art since the avant-garde cannot then configure one future over another. And without the sociogenic constraint of risk, such art is limited to the proliferation of simultaneous disparate semanticizations, which is the defuturity of CA.

As cases of anthropogenic history, variants of the uniquely human capability to enact a new future, both art since modernity and action as Arendt proposes it are supplanted by the risk politics of the metanthropic-sociogenic speculative present. If, then, they are to continue to meet the task of setting a future, both art and politics have to be reset by the risk politics of delimiting the surfeit of futurity so as to set *a* future. And while the sociogenic resetting of the conditions of anthropogenic history has been somewhat adopted by various generalizations of anthropogenic incarnation as condition of action and semanticization—such as (but not limited to) posthumanism, transhumanism, antihumanism and inhumanism—these are but conversions of the historical modernity of development, particular subordinate components of the sociogenic generality of risk-politics enabling action in the speculative present. Unconstrained from these residual anthropogenic determinations, metanthropic development is instead the uncertain future of sociogenic contingencies, which means the uncertainty of development distinct from modernity. That postmodernity, initiated by LaSICS, operationalized qua the STC, is a global historical development distinct not just from Euromodernity but moreover from any anthropogenic future; a future that is unpredictable because it can have no semanticizing account, no adequate *Historie*. A development comprised instead by a future in the future.

# Notes

1   The distinction between the present future—the future for the present—and the future present—the present that is in the future—is made in Elena Esposito, *The Future of Futures: Time of Money in Financing and Society* (Cheltenham: Edward Elgar, 2011 [Italian: 2009]), 126ff.

2   Hannah Arendt, *The Human Condition (Second Edition)* (Chicago: University of Chicago Press, 1998 [1958]), pp. 177–178.

3   Arendt, *Human Condition*, p. 198.

4   Ibid., pp. 176–177.

5   Ibid., pp. 191–192.

6   Reinhart Koselleck, *Futures Past: On the Semantic of Historical Time*, trans. Keith Tribe (New York: Columbia University Press, 2004 [German: 1979]), p. 195.

7   Unless otherwise indicated, all citations from Koselleck in this section are from *Futures Past*, pp. 193–196.

8   Arendt is compared against Koselleck for the sake of the present argument. The historical attribution is in fact the reverse: for Arendt's influence on Koselleck's thinking of totalitarianism in the 1950s see Niklas Olsen, *History in the Plural: An Introduction to the Work of Reinhart Koselleck* (Oxford: Berghahn Books, 2012), p. 88 n. 8; and, more substantially, Stefan-Ludwig Hoffman, 'Koselleck, Arendt, and the Anthropology of Historical Experience', trans. Tom Lampert, *History and Theory* 49, no. 2 (May 2010), pp. 212–236.

9   Koselleck, *Futures Past*, p. 196; see also p. 132. And, 'historical time, if the concept has a specific meaning, is bound up with social and political actions, with concretely acting and suffering human beings and their institutions and organizations' (p. 2). About a century after the period Koselleck is examining, Friedrich Nietzsche presents a typography of the degrees history mandates and debilitates action—or 'life' as Nietzsche designates the term of present development: see 'On the Uses and Disadvantages of History for Life', trans. R.J. Hollingdale, *Untimely Meditations* (Cambridge, MA: Cambridge University Press, 1997 [1876]).

10  For a recent counterintuitive example of history-making according to a horizon of expectation—a horizon marked in this case by the *inhuman* as the *ratio*genic transformation of intelligence currently vectored through the human as its historical basis but to be freed from it—see Reza Negarestani, 'The Labor of the Inhuman', in *#accelerate: The Accelerationist Reader*, ed. Robin Mackay and Armen Avanessian (Falmouth: Urbanomic Press; Berlin: Merve, 2014), pp. 427–466.

11  Koselleck, *Futures Past*, p. 196.

12  Ibid., p. 232; syntax rearranged.

13  The supplanting of Eurochristian eschatology by anthropogenic history is explicitly dramatized a century or so after the semantic convergence Koselleck identifies by various European existential tracts on the Death of God—notably including Nietzsche, for whom the divine eschaton is replaced by the *Übermensch*, the overman. Following Koselleck's lead, the *Übermensch* is but the replacement of the historical condition of the divine eschaton by *anthropos* as its anthropogenic term. See Friedrich Nietzsche, *Thus Spoke Zarathustra*, trans. Adrian Del Caro (Cambridge, MA: Cambridge University Press, 2006 [1883–1892]), p. 5. The replacement of God as the condition of historical structuring by an anthropogenic stipulation is previewed slightly earlier by Nietzsche in *The Gay Science*, trans. Josephine Naukhoff (Cambridge, MA: Cambridge University Press, 2001 [1882]), §125.

14  For the distinction between the horizons of experience and expectation, see Koselleck, *Futures Past*, p. 2.

15  Ibid., p. 236.

16  Fredric Jameson identifies historicity with 'true futurity' in 'The Aesthetics of Singularity', *New Left Review* 92 (March–April 2015), p. 120.

17  Koselleck, *Futures Past*, p. 241.

18  Ibid., p. 240.

19  Ibid., p. 240; emphasis added.

20  Ibid., p. 228, for the following quote too.

21  Ibid., p. 224, also p. 228: '*neue Zeit* ... can signify in a simple fashion that the contemporary *Zeit* is, by contrast with one previous, "new", whatever the mode of graduation. It is in this sense that the term *modernus* was coined, which has not, since then, lost the meaning of "today"'.

22  Peter Bürger, *Theory of the Avant-Garde*,

trans. Michael Shaw (Minneapolis, MN: Minnesota University Press, 1984 [German: 1980² (1974)]).

23   Ibid., p. 29, translation modified to accord with Theodor Adorno, *Aesthetic Theory*, trans. Robert Hullot-Kentor (London: Continuum, 2002 [German: 1970]), p. 21.

24   Bürger, *Theory of the Avant-Garde*, p. 53.

25   Unless otherwise noted, all citations in this section are from Bürger, *Theory of the Avant-Garde*, pp. 57–63.

26   Ibid., p. 60–61, syntax modified.

27   Peter Osborne, *Anywhere or Not at All: Philosophy of Contemporary Art* (London: Verso, 2013), Ch. 1; *The Postconceptual Condition* (London: Verso, 2018), Part One.

28   Bürger, *Theory of the Avant-Garde*, p. 63.

29   Koselleck, *Futures Past*, p. 238.

30   Ibid., p. 238; for the next quote too.

31   Ibid., p. 246.

32   Bürger, *Theory of the Avant-Garde*, p. 63.

33   See Arthur C. Danto, *After the End of Art: Contemporary Art and the Pale of History* (Princeton, NJ: Princeton University Press, 2014² [1997¹]). Danto proposes the posthistory of art consequent to its 'end': 'contemporary art ... has no brief against the art of the past, no sense that the past is something from which liberation must be won, no sense even that it is at all different as art from modern art generally. It is part of what defines contemporary art that the art of the past is available for such use as artists care to give it' (p. 5). Danto's thesis was first published in explicit form in 1984, acknowledging Hans Belting's 1983 argument for the end of art, on the basis that the 'grand narrative' of artistic development is irredeemable. See Hans Belting, *The End of the History of Art*, trans. Christopher S. Wood (Chicago, IL: University of Chicago Press, 1987 [German: 1983]). Belting's characterization recalls Jean-François Lyotard's breakthrough conception of postmodernism in 1979 as the 'incredulity' towards grand narratives of progress, replaced then by small narratives without overarching developmental logic. See Jean-François Lyotard, *The Postmodern Condition: A Report on Knowledge*, trans. Geoff Bennington and Brian Massumi (Minneapolis, MN: University of Minnesota Press, 1993 [French: 1979]).

34   Mark Fisher, *The Ghosts of My Life: Writings on Depression, Hauntology and Lost Futures* (Alresford: Zero Books, 2014), pp. 7–8, ellipses added. Fisher cites Franco 'Bifo' Berardi, *After the Future*, trans. Arianna Bove et al. (Oakland, CA: AK Press, 2011), pp. 18–19. Fisher's characterization of the folding back of (pop) cultural time relies on Simon Reynolds, *Retromania: Pop Culture's Addiction to its Own Past* (New York: Faber and Faber, 2011). For William Gibson, calling on 'whatever relevant kinds of historical literacy, and fluency in recombinance' is an 'atemporality' (@GreatDismal, Twitter, 25 May 2009 [twitter.com/GreatDismal/status/1918556578]; accessed March 2018).

35   Mark Fisher, *Capitalist Realism: Is There No Alternative?* (Alresford: Zero Books, 2009), p. 2.

36   This is a constant in Jameson's writing on postmodernity. See for example the summary statement in 'The Aesthetics of Singularity': 'the very heart of any account of postmodernity ... [is] a dissolution of past and future alike, a kind of contemporary imprisonment in the present...[,] an existential but also collective loss of historicity in such a way that the future fades away as unthinkable or unimaginable, while the past itself turns into dusty images.' Jameson oddly calls this condition a 'volatilization of temporality' (p. 120) rather than its depletion.

37   Fredric Jameson, 'Future City', *New Left Review* 21 (May–June 2003), p. 76. Jameson here refers to J.G. Ballard as the 'better coordinate' than cyberpunk for the apocalyptic imaginary of the 'churning pseudo-temporality of matter ceaselessly mutating all around us' designated 'junkspace' by Rem Koolhaas. Jameson's statement is a paraphrase without attribution of H. Bruce Franklin's criticism of Ballard as being limited to 'project[ing] the doomed social structure in which he exists' instead of a utopian project of a new world: 'What could Ballard create if he were able to envision the end of capitalism as not the end, but the beginning, of a human world?' See H. Bruce Franklin, 'What Are We to Make of J. G. Ballard's Apocalypse?', in *Voices For The Future: Essays On Major Science Fiction Writers, Vol. 2*, ed. Thomas D. Clareson (Bowling Green, OH: Bowling Green University Popular Press, 1979), pp. 82–105

(also available at [www.jgballard.ca/criticism/ballard_apocalypse_1979.html]).

38    Jameson, 'Aesthetics of Singularity', p. 121.

39    This because the thesis is Marxian, meaning that it enjoins a horizon of communism, which is precisely a horizon of expectation structuring the present as directed to a new future distinct from it. On this eschatological format, elaborated in a moment in the main text, see Jacques Derrida, *Specters of Marx: The State of the Debt, the Work of Mourning, and the New International*, trans. Peggy Kamuf (New York: Routledge, 2006 [1993]). Derrida identifies Marxism as 'messianic without messianism', which is to say that it proposes 'a certain experience of the emancipatory promise' according to 'the formality of a structural messianism' (p. 74). For Derrida, this messianic structure, to be absolutely endorsed in Marxism, is demarcated from messianism, which is a 'metaphysico-religious determination' that gives specific identity to the term of that promise (p. 111). In that Derrida's messianic structure of emancipation proposes a formal and metahistorical determination of justice via Marxism, his theorization is subject to precisely the same criticism Bürger puts to Adorno regarding the transcendentalization of the new of Modernism, now only with regard to capitalism as a whole, as socioeconomic contemporaneity, which, accordingly, is then effectively reinforced by its Marxist criticism and, more so, by what is 'undeconstructible' of deconstruction (p. 33).

40    See Greta R. Krippner, *Capitalizing on Crisis: The Political Origins of the Rise of Finance* (Cambridge, MA: Harvard University Press, 2012); and Martijn Konings, *Capital and Time: For a New Critique of Neoliberal Reason* (Stanford, CA: Stanford University Press, 2018).

41    Armen Avanessian and Suhail Malik, 'The Speculative Time Complex', in *The Time Complex: Post-Contemporary*, ed. Armen Avanessian and Suhail Malik (Miami: [NAME], 2016), 5-56 (also available at [dismagazine.com/discussion/81924/the-time-complex-postcontemporary/]).

42    Ulrich Beck, *Risk Society*, trans. Mark Ritter (London: Sage, 1992 [1986]); Ulrich Beck, *World at Risk*, trans.

Ciaran Cronin (Oxford: Polity, 2008 [2007]); and Ulrich Beck and Elisabeth Beck-Gernsheim, *Individualization: Institutionalized Individualism and its Social and Political Consequences*, trans. Patrick Camiller (London: Sage, 2002). Other theorizations of risk societies are also provided by: Anthony Giddens, *The Consequence of Modernity* (Stanford, CA: Stanford University Press, 1990); Niklas Luhmann, *Risk: A Sociological Theory*, trans. Rhodes Barrett (New York: Routledge, 2017 [1991]); and Esposito, *The Future of Futures*.

43    Beck, *World at Risk*, p. 52.

44    In the early 1990s, Giddens proposed that what was then often called postmodernity was not the overcoming of modernity but 'modernity coming to understand itself', its 'radicalization'. See Giddens, *Consequences of Modernity*, pp. 48–52. The convergence of Giddens' argument with the characterization of contracontemporary postmodernity is however blocked by Giddens' characterization of prereflexive modernity (characterizing the Enlightenment for Giddens) as inheriting the preceding premodern composition of 'divine providence which is replaced by providential progress' according to reason, thereby 'replac[ing] one type of certainty by another' (p. 48, syntax modified)— providing then a basis for European validation of its colonial dominance, as Koselleck also notes. Koselleck's thesis, however, is that history can be remade qua modernity precisely because even though its format is eschatological, *all* extrahistorical determinations are renounced. What Giddens calls reflexive modernity is just modernity anyway according to Koselleck. Only that (i) reflexive modernity proposes that historicity is open without any eschatological configuration—which is postmodernity according to the main argument here; and (ii) such a postmodernity itself takes two formats—contemporaneity and the contracontemporary composition of the STC, which distinction is unavailable to Giddens for historical and theoretical reasons.

45    Benjamin Bratton's characterization of 'planetary computation' as an 'accidental megastructure' provides a salient example for the construction of LaSICS: see *The Stack: On Software*

*and Sovereignty* (Cambridge, MA: MIT Press, 2016), §2. Climate change and the Anthropocene provide another example of global-scale future qua risk: see Ulrich Beck, *The Metamorphosis of the World: How Climate Change is Transforming Our Concept of the World* (Cambridge, MA: Polity Press, 2016). The necessity of integration and complexity are also demonstrated by the conjunction of these two global-scale configurations: addressing climate change and the Anthropocene historically, prospectively and politically requires planetary orders of computation in modelling, observation (not least through satellite-based imaging), and communication networks.

46 Suhail Malik, 'The Onto-Politics of the Spectacle and the Abu Ghraib Images', in *Episode: Pleasure and Persuasion in Lens-based Media*, ed. Amanda Beech, Jaspar Joseph-Lester, and Matthew Poole (London: Artwords Press, 2008), pp. 105–116.

47 Metanthropic here, signifying the sociogenic rather than individuated and corporeal basis of action in LaSICS, is distinct from 'metanthrope' used by both Raphael Lepuschitz and Charles Stross, both of whom deploy the term to mark technical transformations of the human body, a recomposition more regularly designated by 'transhumanism'. See Raphael Lepuschitz, *Der Metanthrop: Von Menschen und Maschinen* (Saarbrücken: VDM Verlag, 2010); and Stross' one mention of the term in *Accelerando* (London: Orbit, 2005), p. 288. There is by definition no 'metanthrope' as individuated subject of the metanthropic operation proposed in the main text here. The latter is much closer to Gidden's notion of 'structuration' but one configured in a speculative present, meaning that structuration is also a destructuration. See Anthony Giddens, *The Constitution of Society: Outline of the Theory of Structuration* (Cambridge: Polity, 1986).

48 See Diann Bauer, Suhail Malik, and Natalia Zuluaga, 'Operationalizing Real Abstraction: Art and the General Abstract Image', in *In the Mind but not from There: Real Abstraction and Contemporary Art*, ed. Gean Moreno (New York: Verso, forthcoming).

# Contributors

**Lietje Bauwens** (1990) studied philosophy at the University of Amsterdam and writes for various cultural platforms. Under the name '431', she and Wouter De Raeve initiate curatorial frameworks for research projects such as 'Perhaps it is high time for a xeno-architecture to match' and, upcoming, 'The New Local' and 'WTC, A Love Story'. She was the co-editor of *Perhaps it is high time for a xeno-architecture to match* (2018) and is currently artist in residence at the Jan van Eyck Academy, Maastricht, 2018-2019.

**Franco 'Bifo' Berardi** (1948) is a philosopher and media-theorist based in Bologna. He was one of the founders of the pirate radio station Radio Alice, of the magazine *A/traverso* and of the political movement Autonomia. He lectured at the Academy of Fine Arts in Milan. His latest books include *The Soul at Work: From Alienation to Autonomy* (2009), *After the Future* (2011), *Heroes: Mass Murder and Suicide* (2015) and *Futurability: The Age of Impotence and the Horizon of Possibility* (2017).

**Robin Celikates** (1977) is Associate Professor of Political and Social Philosophy at the University of Amsterdam, where he directs the research project 'Transformations of Civil Disobedience'. He is also an Associate Member of the Institute for Social Research in Frankfurt am Main. He has held visiting positions at Columbia University, Paris Nanterre, and the Institute for Advanced Study in Princeton. His publications include *Critique as Social Practice* (2009; Engl. transl. 2017) and *Sozialphilosophie* (2017, co-authored with Rahel Jaeggi).

**Wouter De Raeve** (1982) studied landscape architecture and visual arts. Under the name '431', he and Lietje Bauwens initiate curatorial frameworks for research projects such as 'Perhaps it is high time for a xeno-architecture to match' and, upcoming, 'The New Local' and 'WTC, A Love Story'. De Raeve is initiator of the lecture-series État des Lieux, co-editor of *On Tempelhofer Feld* (2016) and *Perhaps it is high time for a xeno-architecture to match* (2018).

**Elena Esposito** (1960) is Professor of Sociology at the University Bielefeld (D) and at the University of Modena-Reggio Emilia (I). She has

published many works on the theory of social systems, media theory, memory theory, and sociology of financial markets. Her current research projects focus on a sociology of algorithms. Esposito's recent publications include 'Artificial Communication? The Production of Contingency by Algorithms', *Zeitschrift für Soziologie*, 46 (2017) no. 4; 'Algorithmic Memory and the Eight to Be Forgotten on the Web', *Big Data & Society* 4 (2017) no. 1; 'Critique without Crisis: Systems Theory as a Critical Sociology', *Thesis Eleven* 143 (December 2017).

**Boris Groys** (1947) is a philosopher, art critic, and curator. He studied in Leningrad and Moscow and did his PhD in Münster. He has lectured in Vienna and Karlsruhe, and since 2005 is Global Distinguished Professor in the Faculty of Arts and Science, New York University. He published numerous books, including *The Total Art of Stalinism* (1992), *Art Power* (2008), *Introduction to Antiphilosophy* (2012), and *In the Flow* (2016).

**Alice Haddad** (1986) is a researcher and practitioner in the fields of arts and architecture. She studied architecture at ISACF La Cambre and the Free University of Brussels and co-initiated the Brussels-based research project *Perhaps it is high time for a xeno-architecture to match.* She has collaborated with various cultural institutions and organizations, including Rotondes (LU), Archis Foundation/Volume Magazine (NL) and the Canadian Centre for Architecture (CA), and is currently part of the think-and-do tank Architecture Workroom Brussels, which is dedicated to developing innovative approaches in spatial design and urban planning.

**Akiem Helmling** (1971) is partner and co-founder of the type-collective Underware and co-founder of the art centre West Den Haag. He studied graphic design at the FH Mannheim and type design at the Royal Academy of Art, The Hague. He was a regular teacher at the Royal Academy of Arts, The Hague, the Willem de Kooning Academy, Rotterdam and the Masters of Photography, at Leiden University. He is regularly lecturing about type, design, and art at universities and events worldwide. With Underware he was awarded

numerous international prizes for their work, including TDC New York, TDC Tokyo, Schönste Bücher aus aller Welt, Leipzig, and the Dutch Design Awards. Underware also produces and publishes books and records about typography that have been exhibited worldwide. Recent publications include short essays on typography like *Bing Bang* (2017), *Font Fiction* (2018) and *The Tail of the Cat – Looking at Language* (2018). As a critical advisor within the art centre West and together with Thijs Lijster he initiated the IKK Instituut voor Kunst en Kritiek (Institute for Art and Critique).

**Bojana Kunst** is a philosopher, dramaturge and performance theorist. She studied philosophy and comparative literature in Ljubljana and for many years has worked as a dramaturge, artistic collaborator and teacher in various artistic and academic environments in Europe. Currently she is a professor and director of the Institute for Applied Theatre Studies at Justus Liebig University Giessen. She is a member of the editorial boards of *Maska Magazine*, *Amfiteater* and *Performance Research*. Her last book is *Artist at Work: Proximity of Art and Capitalism* (2015).

**Thijs Lijster** (1981) is Assistant Professor in the Philosophy of Art and Culture at the University of Groningen and postdoctoral researcher at the Culture Commons Quest Office of the University of Antwerp. He studied philosophy in Groningen and New York and obtained his PhD at the University of Groningen in 2012. He published *De grote vlucht inwaarts* (2016) and *Benjamin and Adorno on Art and Art Criticism* (2017) and was co-editor of the book *Spaces for Criticism: Shifts in Contemporary Art Discourses* (2015).

**Suhail Malik** is Co-Director of the MFA Fine Art, Goldsmiths, London, where he holds a Readership in Critical Studies, and from 2012–2015 he was Visiting Faculty at CCS Bard, New York. Recent and forthcoming publications include, as author, *On the Necessity of Art's Exit from Contemporary Art* (forthcoming) and 'The Ontology of Finance' in *Collapse 8: Casino Real* (2014), and, as co-editor, *Realism Materialism Art* (2015), *Genealogies of Speculation* (2016), *The Time-Complex. Postcontemporary* (2016), a special issue of the journal *Finance and Society* on 'Art and

Finance' (2016), and *The Flood of Rights* (2017).

**Benjamin Noys** is Professor of Critical Theory at the University of Chichester. His books include *The Persistence of the Negative* (2010) and *Malign Velocities* (2014).

**Hartmut Rosa** (1965) is Professor of Sociology at Jena University and Director of the Max Weber Centre for Advanced Cultural and Social Studies in Erfurt. He is one of today's leading social theorists and the author of several books. Recent publications: *Resonanz: Eine Sociologie der Weltbeziehung* (2016), *Social Acceleration: A New Theory of Modernity* (2015) and *Alienation and Acceleration* (2010).

**Nick Srnicek** (1982) is currently a lecturer in Digital Economy at King's College London. He is the author of *Platform Capitalism* (2016). Together with Alex Williams he wrote the *#ACCELERATE MANIFESTO for an Accelerationist Politics* (2013) and the book *Inventing the Future: Postcapitalism and a World Without Work* (2016).

**Carolyn F. Strauss** is a curator, educator, and creative facilitator whose experience traverses the fields of architecture, design, contemporary art, emerging technology, and social and environmental activism. She is the director of Slow Research Lab, a multidisciplinary creative and curatorial platform based in the Netherlands. There she engages a dynamic collection of thinkers and practitioners in a spectrum of local and international research activities—exhibitions, publications, workshops, in-situ dialogues, and immersive study experiences—realized in collaboration with academic, institutional, and non-profit partners. She is co-editor of the publication *Slow Reader: A Resource for Design Thinking and Practice* (2016), and recently served as one of the main mentors of the De Appel Curatorial Program.

**Rolando Vázquez** teaches sociology at the University College Roosevelt and is affiliated to Gender Studies and ICON at the University of Utrecht. He curated the workshop: 'Staging the End of the Contemporary' for MaerzMusik at the Berliner Festspiele. With Walter Mignolo he has coordinated the Middelburg Decolonial Summer School since 2019.

They co-authored the seminal article 'Decolonial Aesthesis: Colonial Wounds/ Decolonial Healings'. In 2016, with Gloria Wekker et al., he wrote the report of the Diversity Commission of the University of Amsterdam. His work seeks to transgress the dominion of contemporaneity, heteronormativity and modernity/coloniality. Through the question of precedence and relational temporalities he aims to contribute to decolonizing institutions, epistemology, aesthetics and subjectivity.

**Alex Williams** is currently lecturer in Digital Media & Society, School of Politics, Philosophy, Language and Communication Studies at the University of East Anglia. His upcoming publications include *Hegemony Now* (2019) and *Political Hegemony & Social Complexity* (2019). Together with Nick Srnicek he wrote *the #ACCELERATE MANIFESTO for an Accelerationist Politics* (2013) and the book *Inventing the Future: Postcapitalism and a World Without Work* (2016).

Contributors

283

# Index

# Antennae-Arts in Society Book Series

### Antennae-Arts in Society Series

Antennae-Arts in Society is a peer-reviewed book series that validates artistic, critical, speculative and essayistic writing as a full academic publishing method. Contributions to the series look upon the arts as 'antennae', feelers for the cultural interpretation and articulation of topical political, economic, social, technological or environmental issues.

The books in this series bring together audiences of diverse backgrounds: artists and other creative makers, academics and researchers from various disciplines, critics, writers, journalists, politicians, curators, and institutional parties, who wish to broaden their view in different political, social and other contexts.
Proposals for book concepts in all artistic and scientific disciplines that take culture as the base of interpretation for the social fabric of our contemporary lives are welcomed and will be considered for publication by the academic board.

# IKK–Institute for
# Art and Critique

### IKK—Institute for Art and Critique

These are times of radical complexity. Traditional institutional and geopolitical logics are under pressure as globalization and digitalization, accelerated by technological progress, disrupt societal conventions. Concurrently, threats associated with anthropogenic climate change compel us to take a critical look at how we live.

The Institute for Art and Critique (IKK) reviews this terrain which has suddenly become uncertain and unfamiliar and examines the implications for society in general, and the arts in particular. Like the IKK itself, the results of this exploration are hybrid and may take the form of art-theoretical and philosophical essays but also of artistic projects.

The IKK wants to reflect on the forms of critique that are already present within the arts and art discourses. By crossing the boundaries between theory and practice, between thinking and making, the IKK wants to introduce alternative approaches to engaging with social transformation: a practice that is thinking through art. The IKK initiates debates through publications and by organizing symposiums, summer schools, and other events.

The IKK is a collaboration between West Den Haag and the research centre Arts in Society of the University of Groningen.

www.kunstenkritiek.nl

# Colophon

# Colophon

**The Future of the New**
*Artistic Innovation in Times of Social Acceleration*

*Editor*
Thijs Lijster

*Commisioning Editor*
Marie-José Sondeijker

*Contributors*
Lietje Bauwens
Franco 'Bifo' Berardi
Robin Celikates
Wouter De Raeve
Elena Esposito
Boris Groys
Alice Haddad
Akiem Helmling
Bojana Kunst
Thijs Lijster
Suhail Malik
Benjamin Noys
Hartmut Rosa
Nick Srnicek
Carolyn F. Strauss
Rolando Vázquez
Alex Williams

Antennae-Arts *in* Society Series N° 26
by Valiz, Amsterdam

*Translation Dutch-English*
Leo Reijnen

*Copy Editing*
Leo Reijnen, Els Brinkman

*Proofreading*
Els Brinkman

*Index*
Elke Stevens

*Design*
Metahaven

*Paper Inside*
Munken Print 100 gr 1.5

*Paper Cover*
Bioset 240 gr

*Printing and Binding*
Bariet Ten Brink, Meppel

*Co-Publisher*
— IKK—Institute for Art and Critique

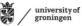

www.kunstenkritiek.nl

— West Den Haag

**West**

www.westdenhaag.nl

— University of Groningen, Faculty of Arts, Arts *in* Society

*Publisher*
Valiz, Amsterdam, 2018
www.valiz.nl

ISBN 978-94-92095-58-9

*West Den Haag is supported by*
Ministry of Education, Culture and Science

Ministry of Education, Culture and Science

Municipality of The Hague

**The Hague**

*The Faculty of Arts, Arts in Society of the University of Groningen is supported by*
FWO, Fonds Wetenschappelijk Onderzoek

The authors and the publisher have made every effort to secure permission to reproduce the listed material, illustrations and photographs. We apologise for any inadvert errors or omissions. Parties who nevertheless believe they can claim specific legal rights are invited to contact the publisher.

Distribution:
USA/Canada/Latin America: D.A.P., www.artbook.com
GB/IE: Anagram Books, www.anagrambooks.com
NL/BE/LU: Centraal Boekhuis, www.cb.nl
Europe/Asia: Idea Books, www.ideabooks.nl
Australia: Perimeter Books, www.perimeterdistribution.com

ISBN 978-94-92095-58-9

Printed and bound in the Netherlands

**Antennae**

## Antennae Series

Antennae N° 1
**The Fall of the Studio**
*Artists at Work*
edited by Wouter Davidts & Kim Paice
Amsterdam: Valiz, 2009 (2nd ed.: 2010),
ISBN 978-90-78088-29-5

Antennae N° 2
**Take Place**
*Photography and Place*
*from Multiple Perspectives*
edited by Helen Westgeest
Amsterdam: Valiz, 2009,
ISBN 978-90-78088-35-6

Antennae N° 3
**The Murmuring of the**
**Artistic Multitude**
*Global Art, Memory and Post-Fordism*
Pascal Gielen (author)
Arts *in* Society
Amsterdam: Valiz, 2009 (2nd ed.: 2011),
ISBN 978-90-78088-34-9

Antennae N° 4
**Locating the Producers**
*Durational Approaches to Public Art*
edited by Paul O'Neill & Claire Doherty
Amsterdam: Valiz, 2011, ISBN 978-90-78088-51-6

Antennae N° 5
**Community Art**
*The Politics of Trespassing*
edited by Paul De Bruyne & Pascal Gielen
Arts *in* Society
Amsterdam: Valiz, 2011 (2nd ed.: 2013),
ISBN 978-90-78088-50-9

Antennae N° 6
**See it Again, Say it Again**
*The Artist as Researcher*
edited by Janneke Wesseling
Amsterdam: Valiz, 2011, ISBN 978-90-78088-53-0

Antennae N° 7
**Teaching Art in the**
**Neoliberal Realm**
*Realism versus Cynicism*
edited by Pascal Gielen & Paul De Bruyne
Arts *in* Society
Amsterdam: Valiz, 2012 (2nd ed.: 2013),
ISBN 978-90-78088-57-8

Antennae N° 8
**Institutional Attitudes**
*Instituting Art in a Flat World*
edited by Pascal Gielen
Arts *in* Society
Amsterdam: Valiz, 2013, ISBN 978-90-78088-68-4

Antennae N° 9
**Dread**
*The Dizziness of Freedom*
edited by Juha van 't Zelfde
Amsterdam: Valiz, 2013, ISBN 978-90-78088-81-3

Antennae N° 10
**Participation Is Risky**
*Approaches to Joint Creative Processes*
edited by Liesbeth Huybrechts
Amsterdam: Valiz, 2014, ISBN 978-90-78088-77-6

Antennae N° 11
**The Ethics of Art**
*Ecological Turns in the Performing Arts*
edited by Guy Cools & Pascal Gielen
Arts *in* Society
Amsterdam: Valiz, 2014, ISBN 978-90-78088-87-5

Antennae N° 12
**Alternative Mainstream**
*Making Choices in Pop Music*
Gert Keunen (author)
Arts *in* Society
Amsterdam: Valiz, 2014,
ISBN 978-90-78088-95-0

Antennae N° 13
**The Murmuring of the Artistic**
*Global Art, Politics and Post-Fordism*
Pascal Gielen (author)
Completely revised and enlarged
edition of Antennae N° 3
Arts *in* Society
Amsterdam: Valiz, 2015,
ISBN 978-94-92095-04-6

Antennae N° 14
**Aesthetic Justice**
*Intersecting Artistic and Moral Perspectives*
edited by Pascal Gielen &
Niels Van Tomme
Arts *in* Society
Amsterdam: Valiz, 2015,
ISBN 978-90-78088-86-8

Antennae N° 15
**No Culture, No Europe**
*On the Foundation of Politics*
edited by Pascal Gielen
Arts *in* Society
Amsterdam: Valiz, 2015,
ISBN 978-94-92095-03-9

Antennae N° 16
**Arts Education Beyond Art**
*Teaching Art in Times of Change*
edited by Barend van Heusden &
Pascal Gielen
Arts *in* Society
Amsterdam: Valiz, 2015,
ISBN 978-90-78088-85-1

Antennae N° 17
**Mobile Autonomy**
*Exercises in Artists' Self-Organization*
edited by Nico Dockx & Pascal
Gielen
Arts *in* Society
Amsterdam: Valiz, 2015,
ISBN 978-94-92095-10-7

Antennae N° 18
**Moving Together**
*Theorizing and Making*
*Contemporary Dance*
Rudi Laermans (author)
Arts *in* Society
Amsterdam: Valiz, 2015,
ISBN 978-90-78088-52-3

Antennae N° 19
**Spaces for Criticism**
*Shifts in Contemporary Art Discourses*
edited by Thijs Lijster, Suzana
Milevska, Pascal Gielen,
Ruth Sonderegger
Arts *in* Society
Amsterdam: Valiz, 2015,
ISBN 978-90-78088-75-2

Antennae N° 20
**Interrupting the City**
*Artistic Constitutions of the Public Sphere*
edited by Sander Bax, Pascal Gielen
& Bram Ieven
Arts *in* Society
Amsterdam: Valiz, 2015,
ISBN 978-94-92095-02-2

Antennae N° 21
**In-between Dance Cultures**
*On the Migratory Artistic Identity of*
*Sidi Larbi Cherkaoui and Akram Khan*
Guy Cools (author)
Arts *in* Society
Amsterdam: Valiz, 2015,
ISBN 978-94-92095-11-4

Antennae N° 22
**Imaginative Bodies**
*Dialogues in Performance Practices*
Guy Cools (author)
Arts *in* Society
Amsterdam: Valiz, 2016,
ISBN 978-94-92095-20-6

Antennae N° 23
**The Practice of Dramaturgy**
*Working on Actions in Performance*
edited by Konstantina Georgelou,
Efrosini Protopapa,
Danae Theodoridou
Arts *in* Society
Amsterdam: Valiz, 2017,
ISBN: 978-94-92095-18-3

Antennae N° 24
**The Art of Civil Action**
*Political Space and Cultural Dissent*
edited by Philip Dietachmaier, Pascal
Gielen
Arts *in* Society
Amsterdam: Valiz, 2017,
ISBN: 978-94-92095-39-8

Antennae N° 25
**Commonism**
*A New Aesthetics of the Real*
Nico Dockx & Pascal Gielen
Arts *in* Society
Amsterdam: Valiz, 2018,
ISBN 978-94-92095-47-3

Colophon